The Best American Food Writing 2021

The Best American Food Writing™ 2021

Edited and with an Introduction
by GABRIELLE HAMILTON

Silvia Killingsworth, Series Editor

MARINER BOOKS
An Imprint of HarperCollins*Publishers*
BOSTON • NEW YORK

marinerbooks.com

ISSN 2578-7667 (print) ISSN 2578-7675 (e-book)
ISBN 978-0-358-52568-4 (print) ISBN 978-0-358-53186-9 (e-book)

Printed in the United States of America
1 2021
4500834625

Contents

Foreword

> I still think that one of the pleasantest of all emotions is to know
> that I, I with my brain and my hands, have nourished my beloved
> few, that I have concocted a stew or a story, a rarity or a plain
> dish, to sustain them truly against the hungers of the world.
>
> —M.F.K. Fisher, *The Gastronomical Me*

GOOD WRITING, LIKE good food, is easy to devour. It is also
satisfying to produce not only because it is a craft at which one can
improve over time but because it can comfort and delight other
people. It can transcend mere diversion and encourage deep re-
flection—perhaps even commitment to memory. (For someone
who forgets so much of what she reads, putting together this
collection has taught me a lot about both discipline and Google
Sheets.)

But for some reason, it is rather more acceptable, depending on
how brave you are, to ask what someone thinks about your cooking
than it is to ask the same about your writing. Did you like it? Was
it satisfying? Was there enough salt, or perhaps too much? When
you cook a meal, you get to watch and listen as your guests enjoy it,
or at least politely pretend to. Shouldn't writers be allowed a bit of
that voyeurism and instant gratification? Except for workshops in
academic settings, the closest thing writers have besides book sales
is trawling Goodreads (and that's only if you've published a book)
or obsessively scanning Twitter, which can leave you feeling empty.

This past year, one of the most anomalous in at least a century,
anyone who managed to publish anything at all deserves recog-

nition. As with writing, so too with meals: So what if you didn't cook your way through a best-selling cookbook and blog engagingly about it? So what if some nights dinner consisted of frozen chicken nuggets? That you managed to put one foot in front of the other day after day is reason enough to celebrate. If you happen to know someone who appeared to thrive, rather than merely survive, please congratulate them earnestly and swiftly. If you read something you liked, find a way to tell the author. In the meantime, awards and anthologies like this one serve as postdated feedback.

I was worried at the start of the pandemic that 2020 would be a lost year for food writing—would the virus be The Only Topic? By summer, we had an entirely new genre of story: requiem for a restaurant. The virus hung around so long it forced us to look past it, and the result is a widely varied anthology. I'm certain this is also a choice, whether conscious or not, by Gabrielle and me both. Pervasive as it was, the coronavirus need not define everything.

I think that's at least in part what makes this collection all the more impressive for being one of the strongest yet; I recognized no dip in quality or quantity of production compared with previous years. I take that as a measure of the triumph of the spirit of the writer. Honest writers write because they have to, because beyond being a mode of expression, writing is a mode of survival. We tell ourselves stories for the same reason we cook dinner: we have to, one way or another.

It was a difficult year in which to write, but it was also one of the most urgent. While making my way though my spreadsheet, I thought often of Mary Frances Kennedy Fisher's *How to Cook a Wolf,* a wartime volume dedicated to making do with whatever you've got left, in the cupboard and in spirit. It is a survival manual, which relies less on recipes than it does wit and wisdom. It is an absolute triumph, and a testament to the fact that good and engaging writing can sustain us for years to come. It is also a reminder that we have been through tough times before—we likely will again—and there are others who have gone before us, confronted these same thoughts of desperation, isolation, and loneliness.

There are those who believe that cataclysmic events create the right conditions for great art. Wars, genocides, economic depressions, famines. Take your pick, and there are whole genres of fine art, novels, and films to point to in their wake. I don't yet know if

we will look back on the coming years and recognize the era as distinctly post-virus. Perhaps, as some predict, we're in for a second installment of the Roaring Twenties. But as of this writing, the world has crossed the threshold of three million dead. There is no way to avoid that being imprinted upon the collective consciousness, and no way to overlook the grief and loss.

In addition to the traumatic loss of life, many also experienced loss of livelihood and income. Some of the worst virus outbreaks in the country happened in meatpacking plants. Thousands of small food businesses shuttered, and food insecurity skyrocketed. The half-life of a restaurant is already short, but to see so many shut down so fast was gutting: a mass extinction event. New ones will replace them eventually, and maybe someday we'll even take down all the plexiglass sneeze guards. Once again, we will hunch around tiny tables and scoot across booths for the ultimate luxury of someone else cooking for a change. But hopefully this time we will be more grateful than ever to those who serve us, and those who grow and cook our food.

If food is an essential and universal aspect of human culture, then food writing is an act of preservation. By its nature, food is transitory. It is an experience, an event that can be as mundane as it can be life-altering. The stories of, in, and around food, and of everyone and everything that brings it into being, are an enormous cultural project to which I'm proud to contribute every year. The very best writing, like the very best food, can nourish you. This year's menu is varied, hearty, and warm. With apologies to Mary Frances, we serve it forth! Please send me your submissions for next year's volume by December 31, 2021, at silvia.killingsworth@gmail.com.

<div align="right">Silvia Killingsworth</div>

Introduction

EVERY ONCE IN a while in my work in the restaurant world, there will be a customer who shows up at the door for whom something is going wrong and who isn't being given what they want or need or feel they were promised or deserve. And even though you'd think by now it would be universally understood to be the most douchey, risible move one could possibly make, archaic and out of step, this customer right there in front of the whole dining room will bellow: "DO YOU HAVE ANY IDEA WHO I AM??" And then huffs out, promising you hell and ruin. Somehow this customer still exists.

In the writing world, where I also work, you are sometimes faced with the same type of person. Not a hungry customer but rather an *author* who shows up to the literary panel to which you have both been invited and who seems to feel that your very presence there, a *food* writer, at the same skirted banquet table with your own microphone and name tag, is a sign that something is going wrong and that they are not being given what they feel they were promised. This guy, incredibly, even though you think it would be universally understood by now to be the most douchey, risible move one could possibly make, persists in offering his limp hand when being introduced to you by the moderator in the green room backstage and says to you: "A food writer? Oh, I have a marvelous recipe for crab salad that I must share with you."

Of course—yes, as you would expect—as soon as that preposterous customer is at the curb and as soon as that blowhard panel ends, you turn immediately to your kindred folks and all nearly

spastically fall apart in peals of ridicule; you pantomime pinching your fingers together to remove the annoying winged insect from your neck and send it to the ground with one short *ppfftt* of your mighty breath. Hours later that night you find yourself spitting like a llama about it all over again. *What a jackass!*

But something else happens too, and I had never quite noticed it until this year. There was never a purple bruising or a frank bleeding, so I never thought of those little "I'm Somebody and You're Nobody" jabs like a hypochondriac might, thinking their every insect bite is a melanoma and overreacting as such. Certainly not; after we've had our mighty laugh at the jerk's expense over a couple of cocktails at the end of the night, it's out of our system. What is it exactly, though? What had I done with such little occasional bee stings whose microdoses of venom had accreted in my bloodstream? Had there been an internalized phobia of some kind, a defensive maneuver, a self-loathing?

However it manifested in the dark, coiled recesses of my psyche, it looked like this on my face: derisive eye-rolling to the ceiling about the very two careers I have spent my life devoted to — Cooking Food and Writing About Food. Anyone will have heard me say a thousand times over the decades, at every panel I've been invited to and at every night's dinner service at my restaurant: "Jesus Christ already, let's get a little perspective shall we? It's not brain surgery, people!" and (this old chestnut) "I mean, let's be real, we are not exactly curing cancer over here, folks!"

But suddenly everything we were and everything we did and the way we used to do it was brought to an abrupt and unfathomable halt. Within a matter of days (and just hours in many cases), we were feeding frontline doctors and nurses; and stocking mutual aid refrigerators; and selling coffee through little windows in our front doors and pizzas through holes we cut in our backyard fences; and collecting GoFundMe money and unemployment benefits that we secretly Venmoed to our undocumented workers; and lobbying Congress; and suing the insurance giants; and teaching people at home how to bake, cook, and taste wine on Instagram Live; and putting coolers of bottled water and hand sanitizer and granola bars out for Black Lives Matter demonstrators and opening our bathrooms for pee breaks along the rally route. We were writing urgent, beautiful pieces in our various outlets about all of it: the underlying, underexposed ills of our industry; the fragility

of our food systems, our supply chains; the dangers of our poultry workers' lives; and the perils of our customers' expectations, the indignities of our cooks' wages, and the indecencies of our waiters' experiences long endured.

So I hope I can be permitted and gently forgiven for this wild, pride-drunk, self-congratulatory, grossly immoderate, sock-footed skid across the bare floor with double bird fingers in the air, while bellowing to exactly no one: "Do you have any idea who we are? Do you see what we do around here? We ARE curing cancer and this IS brain surgery, bitches!"

I know. I know. A total crazy person! Overcome with love and admiration and awe for my people, my food-world people, and especially my food-writer people, my tribes; this is the year I became a fully symptomatic lunatic in her dressing gown, showing all the rashes and blotches of a food writer's most common ailment: not being able to gauge an accurate sense of the value of their own work. And yet, I feel stone-cold sober and sharp of mind in so crowing. I suddenly see it's possible that over the years, bug bite by bug bite, I may have taken a hit to my common sense of proportion, my ability to estimate a correct sense of value.

What a tremendous honor it was to select the twenty-four most superb pieces to be included in *The Best American Food Writing* of such a year. A year that presented the strangest admixture of a few months of business as usual, and then nine remaining months of there being both nothing left to write about and there being so overwhelmingly much to write about. What a tricky endeavor, to collect the best pieces from that year when everything shut down. A year that stopped our food world in its tracks. A year that our nation erupted in an explosive conversation about its own racism. A year in which insatiable wildfires ravaged the state where most of our food grows and most of our wine is made. It was a year that crippled, felled, and extinguished. And that sprouted, ignited, and shone.

I may have lost everything I'd been—restaurant shuttered, twenty years of chef-life at a standstill—but what magnificent luck to have received the invitation to select the pieces for this collection in the very year in which I was returned to a self I hadn't been since I'd opened my restaurant and had my kids: a voracious, generous, and practiced reader. What incredible luck to become again the girl who used to read books shoved into the cubby of her desk

during class so the teacher wouldn't see; the one who read on the train and missed her subway stop; who read at the airport gate and missed her flight; who read with a pencil, up all night.

Many people describe being unable to focus and read this year, but I was gratefully not among them. Did I read fifty books this year? Did I read blogs, newsletters, Instagram feeds, Substack articles, magazines, electrician's manuals, recipes, top notes, Italian language textbooks, furniture assembly instructions, philosophy, poetry, architectural theory, short stories, biographies, TV pilot scripts, psychoanalysis, music crit, lit crit, business advice columns, personal essays, advance reader copies not for distribution, fan mail, primary documents, old love letters typed on typewriters, and complex loan applications as well as their corresponding instructions? Yep. Did I also take fifty weeks to carefully read a single, dense book? Yes, that too. What a perfect serendipity to have gotten back into such buff shape as a reader just when my agent sent me the invitation to be this edition's guest editor. I was ready, versed and limber.

But even so, I started with nerves galore! When I was waiting for Silvia to send me the ninety essays I would have to read through to consider for possible inclusion, I had visions of papers stacked up shoulder height on my dining room table, of my eyeballs bloodshot and dangling from springs like on those gag glasses—an image lodged forever in my mind from a joke the director of admissions for my MFA program used to make when having to read through, some years, 1,100 application essays for fifteen available spots.

When I applied twenty-five years ago, you could apply to either the poetry or the fiction program. There was no such thing as creative nonfiction yet, let alone a category called food writing. This is now so quaint as to be absurd. Of course I chuckle at how antiquated it sounds, as if it was only Homer, Aeschylus, and Aristides on deck. For a very long while now, of course, people have been writing about food, food media, food history, anthropology of food, food policy, theory and methodology of gastronomy, food memoir, foodways, food marketing, and the social history of food. I found it exhilarating to read through the ninety essays, like going on a cross-country road trip through the vast and remarkable landscape of what constitutes American food writing. I marveled at the varied terrain, the many outlets and their attendant technologies,

and then at the influence of those many varied outlets and technologies on form, voice, craft, and style.

It turns out that the merits found in good writing back when there were only two categories to choose between—fiction and poetry—are the same no matter the expansion of these new possible routes by which to traverse the country, as it were. Good food writing is just good writing. It is as obvious when you come upon it as the field of sunflowers that goes on a full, impossible 330 acres as you drive.

Here is Sheila Marikar on chef Gaggan Anand, a pre-pandemic portrait that crystallizes exactly where we were, here in food land, just before the lights went out. And here is Foster Kamer on impossible-to-get reservations for the most sought restaurants in the city and the bizarre transaction of power it was to get them, in another perfect time capsule of who we'd been just moments before we were none of that anymore. How strange to be reading about getting the right table at the right resto on the right night at the right hour when we know what it is to be grateful to sit in a freezing wooden hut built into the gutter of a desolate street, huddling in our masks under an inadequate heat lamp.

And here is Priya Krishna and the exhilarating story of the Sikhs who had the systematic machinery already in place—volunteers, facilities, donations, food supplies—to feed thousands daily, who did not find themselves overwhelmed by the needy but quite the contrary could've easily provided much more. Who have always prepared free meals not only during the pandemic for the needy as well as for Black Lives Matter protesters—not just showing up as newly minted "pandemic heroes"—but as they always had, in accordance with an essential facet of the centuries-old practice of their faith: selfless service.

And here is Kaitlin Menza, at the other end of things, who simply wrote about what it was like to be a nervous person self-quarantined with her fine dining chef boyfriend, himself now restless, idle, and cooking at home for just the two of them. But like all the best writing, it has another story inside of it, which reveals what a complex and involved project it is to try and cut the engine on such a huge and gleaming vessel as a Michelin-starred restaurant chef. Impossible to still the propellers, to drain the hydraulics.

Here is Soleil Ho, with her precise carburetion of hot outrage and cool observation when the clear plastic bubbles began pop-

ping up in San Francisco, inside which determined, can't-stop-won't-stop restaurants served $200-per-person tasting menus to the uber-wealthy while their masked and gloved servers stood at risk, ready to serve, as COVID-19 deaths continued to soar. Beyond questions about our responsibilities to one another as humans, here is the quiet, gorgeous appeal of Liza Monroy, on how we get our milk from dairy cows, who asks, "What is human responsibility to other species?" so gently and so persuasively with not even a wisp of sarcastic rage that I haven't bought cow's milk in four months and counting.

While I was in grad school learning to write, I also learned how to play pool. A good friend taught me to play on the long, smooth, nine-foot regulation tables in the hushed and rarefied setting of the student union that had marble floors and polished brass railings. To bank and draw and sink capably on a nine-footer, it turns out, trains you mightily for the six-foot pool tables in dive bars downtown—where we would later go for beers—the kind with nicks in the felt, cigarette burns on the rails, and a rowdy crowd who thinks the louder the cracking of the opening break, the better the play.

Having spent the afternoons focusing on smart angle, soft spin, cluster management, and the quiet strategy of setting up your "leave"—the position on the table where you want the cue ball to end up after you sink your shot so you can then be nicely poised to sink your second, and so forth, keeping a long run in mind the whole time—by the time we'd put our quarters on the rail at the bar, signaling we'd like to be next to bid the challenger, we would end up running the table for the rest of the night. This had nothing to do with poetry or fiction, obviously, yet it helped me a lot back on campus.

Do I think food writing is the six-foot, dive bar pool table version of writing, where anybody can throw their name up on the chalkboard and play the game? Do I think food writing is easily underestimated, often even by its practitioners? The kind of category that prompts *authors* to want to see us as only capable of swapping recipes? I guess I think about food writing what probably everybody thinks: it's sloppy saloon pool only if we show up like it is.

Read the opulent, glistening nine-footer finesse of Ligaya Mishan's piece on gout and Amy Irvine's deft, assured, muscular break-and-run about eating meat and it's simply undeniable: they will be

running the table for the rest of the night. But I promised the curing of cancer, here, not just smooth careful play on the felt! Check out Jonathan Kauffman's piece about Beowulf Thorne, who published the humor zine *Diseased Pariah News* in the '90s and the first cooking column for people dying of wasting syndrome associated with AIDS. And tell me that that elegant writing with its precision, discipline, and rigor doesn't make you a little pride-drunk too. A little swelled in the head on his behalf. I don't mind yelling about it in the most immoderate fit of pride: "That is not just a squirt of Betadine and a slapped-on Band-Aid! That essay right there is brain surgery, people!"

<div align="right">GABRIELLE HAMILTON</div>

The Best American
Food Writing 2021

A New Orleans Chef Navigates Disaster

FROM *The New Yorker*

NEW ORLEANS, AS the old line goes, is a city of a thousand restaurants but only one menu. Its celebrated dishes—gumbo, jambalaya, catfish, crawfish étouffée, po'boy and muffuletta sandwiches, red beans and rice—are the products of a glorious culinary sfumato, blending the techniques and ingredients of Spanish and French colonizers, enslaved Africans and their free descendants, Italian immigrants, and Native Americans. The flavors are cayenne and black pepper, toasty roux, smoked meats, the slick deep-greenness of okra, the muscular brine wallop of a Gulf oyster. Perhaps more than anywhere else in the United States, New Orleans boasts its own rich regional culinary tradition, one that is integral to the city's sense of itself—and famously resistant to change. "For three hundred years, it's been kind of the same," Emeril Lagasse, one of the most influential ambassadors of New Orleans gastronomy, lamented in an interview in 2000. "There are restaurants in New Orleans that the menu hasn't changed in a hundred and twenty-five years, so how is one going to change or evolve the food?"

By the time the chef Nina Compton arrived in New Orleans, in 2015, the city's cuisine was no longer so rigidly set in amber. What loosened it was one of the most catastrophic disasters in modern American history: the federal levee failures that followed Hurricane Katrina, in August of 2005, killing an estimated 1,833 people, displacing 770,000 residents, and devastating entire neighborhoods. In the years after, as the city slowly recovered, an influx of outsid-

ers arrived, drawn by cheap rents and by the romance of rebuild-
ing. Among them was a new generation of chefs proudly cooking
the foods of their places of origin. Before the storm, restaurants
that cooked outside of the city's Creole vernacular rarely landed
on tourists' must-visit lists. Now New Orleans was earning attention
for new Middle Eastern and Latin American restaurants, farm-to-
table cafés, a flurry of serious pizza joints. Compton's first restau-
rant, Compère Lapin, opened in mid-2015, in a hotel in the city's
trendy Warehouse District, showcasing the food of the Caribbean,
and of her native St. Lucia in particular: seafood pepper pot, cow-
heel soup, jerk fish. Her dishes were threaded through with the
islands' smoke and spice and with the ambrosial sweetness of trop-
ical fruit, but they also borrowed freely from France and Italy, the
American South, and from the flavors of New Orleans itself.

New Orleans is often described as the northernmost city in the
Caribbean. As with the city's past, the layered history of the islands
—of European colonizers, enslaved Africans, indentured labor-
ers from South Asia and China—can be gleaned by studying the
dishes on its tables. Compton played up the culinary harmonies
between her home country and her adopted city, serving dishes
such as *accra*—Caribbean salt-fish fritters—alongside green beans
with rémoulade, a quintessential New Orleans sauce. The New Or-
leanian writer and food historian Lolis Eric Elie told me that he
sees Compère Lapin as an exultant argument for a more complete
understanding of the city's culinary history. "There's a knee-jerk
assumption that the goodness of New Orleans food stems from
its French influence, and that's largely wrong," Elie said. "To un-
derstand our cuisine, we need to look south, to the Caribbean
and Latin America, and we need to look east, to Africa." Even
the restaurant's name highlights the connection: the character of
Compère Lapin, a trickster rabbit, originates in African folklore
and is a centerpiece of both St. Lucian and Louisiana storytelling.
(Others might know him by his Anglophone name: Br'er Rabbit.)

In St. Lucia, Compton is political royalty: her late father, John
Compton, was the nation's first prime minister, and is considered
its founding father. But in the United States she made her name on
reality TV, as a standout competitor on the eleventh season of *Top
Chef.* New Orleanians might have been wary of a TV chef sweep-
ing in to open a restaurant. But Compton's deeply personal cook-
ing won the city over. Almost right away, Compère Lapin's dining

room was packed from breakfast to nightcap; its signature dish, curried goat over sweet-potato gnocchi, became so popular that Compton ran through her goat supplier's entire stock. In 2016, Brett Anderson, then the restaurant critic at the *Times-Picayune,* named Compère Lapin the restaurant of the year, calling Compton's cooking "a delicious case study in the art of belonging." In 2018, Compton opened Bywater American Bistro, which hewed more closely to New Orleans tradition, with dishes like hog's-head boudin and fried oysters alongside precision-engineered bistro fare. It, too, was a hit.

Being a famous chef in New Orleans is a responsibility, as much as anything; the city elevates its culinary titans into civic spokespeople and cultural custodians. In the five years since she arrived, Compton has become one of New Orleans's most recognizable faces. As a newcomer who earned the support of a community resistant to outsiders, and a Black woman who found her spotlight in a system that struggles to celebrate people of color, she embodies some of the good that's come out of the city's postdiluvian renewal. But not all of New Orleans recovered after Katrina: fifteen years later, parts of the Lower Ninth Ward, one of the city's poorest neighborhoods, remain ravaged, and many of the people who left never made it back. The city is still rebuilding, still mapping the path from before to after.

Now the novel coronavirus has upended New Orleans all over again. Four hundred thousand people live in New Orleans; last year, it saw twenty million visitors, who spill out onto courtyards and sidewalks, crowd onto raucous party porches, and turn the narrow streets of the French Quarter into dense rivers of revelry. This year, Mardi Gras was a harbinger: according to official counts, attendance at the revel, which spanned a week in late February, was down by about 20 percent compared with 2019. City officials attributed the dip to public anxiety about the virus, which had begun its spread through parts of the United States. It was around that time that Compton noticed that the reservation books at her restaurants were thinning: fewer new bookings, more cancellations and no-shows. A little more than a week later, on March 9, the first case of COVID-19 in Louisiana was detected, in Jefferson Parish, just outside New Orleans.

"I was trying to be eternally optimistic," Compton told me recently. March 15 was Bywater American Bistro's second anniver-

sary, and she and Larry Miller, her husband and business partner, had been planning a massive lunchtime crawfish boil for the occasion. The day before, the state recorded its first COVID-19-related death. She and Miller went through with the party, hoping that it would be a distraction. "Everybody was trying to act normal, but they all looked like they stole a pack of gum from the convenience store and somebody saw them do it—fear," Compton said. That evening, after the crowd had dwindled, Compton and Miller sat down in the bistro's dining room to have dinner with some friends. Compton, who is forty-one years old, is slender, with short, shaggy hair and a spray of cooking burns across her forearms. Halfway through the meal, the restaurant's general manager pulled her aside: the mayor had just imposed a curfew on the city's businesses—they would need to empty the dining room by nine o'clock that night—and, starting the next day, all restaurants would be required to shift to takeout only.

Little was known about COVID-19 at that point, besides its rapaciousness. Health and government officials were giving out conflicting messages about how the virus spread, how to prevent it, what its effects would be. That night, overwhelmed by the wave of rapidly changing information, Compton and Miller decided that the best thing to do was wait: they would close both restaurants and then figure out what their next steps ought to be. On Tuesday, March 17—the same day that New Orleans claimed the second-highest per-capita case rate in the country—they called a staff meeting and announced that Compère Lapin and Bywater American Bistro would be going dark indefinitely, and that the entire staff—some 120 employees—was being laid off.

In the span of just a few days, virtually all of New Orleans shut down; statewide, unemployment claims leaped in a single week from 1,700 to more than 30,000. After the closures, Compton had a conversation with a longtime New Orleans restaurateur. "He said, 'You know, Nina, during Katrina, it was up to our knees, but everybody wanted to reopen,'" Compton told me. The city's attitude in the face of the coronavirus seemed similarly resolute, she said. "Everybody's like, 'It may not be this month, but we're going to reopen.'" In the pandemic, though, the strategies for survival are different. Anderson, who covered the city's restaurants in the immediate aftermath of Katrina, and who is now a writer for the *New York Times*, told me, "Reopening a restaurant after Katrina was,

'You know what? I'm going to grill hamburgers. Watch me go find some soft-shell fucking crabs right now.'" In the pandemic, pushing defiantly ahead is dangerous. "We've got the calluses, we've got the know-how, we've got a playbook," Anderson said. "It turns out all those things aren't really that useful."

Compton was an infant when St. Lucia declared independence from Britain, on February 22, 1979, after centuries of colonial rule. That day, her father, already the island's leader, was sworn in as its first prime minister. John Compton, born on a tiny island in the Grenadines and educated in St. Lucia for secondary school, had studied law at the London School of Economics. Upon his return to the islands, he became involved in St. Lucia's anti-colonial movement. John was a charismatic speaker with a flair for dramatic gestures—early in his career, he'd made his name by drawing a gun on a white sugar-factory owner who had refused to recognize an employee union. By the time he came to govern the island, in 1964 (before independence, he held the titles of chief minister and premier), he was the face of the conservative establishment, which he headed until his death, in 2007. For almost all of Compton's upbringing, she was a first daughter of a young nation.

"I had the best childhood, I really did," Compton told me. Alongside his political career, John was a prosperous banana and coconut farmer, and the family's large house, called Moulin-a-Vent, after an old windmill on the property, was set on a hillside, with a sunset view over Rodney Bay. One of Compton's most indelible memories, she said, was of her father squeezing fresh juice each morning, for the family's breakfast. Another was afternoons spent at the beach, where her parents would slice mangoes picked from the family's trees, and Compton and her siblings would race into the ocean to dunk the sticky fruit in saltwater before eating it.

I was surprised by the pastoral, apolitical glow of Compton's childhood stories, given her father's reputation among St. Lucia's 180,000 citizens. Months after becoming prime minister, he had been voted out of office by a furious opposition; three years later, he staged a return, with the backing of Ronald Reagan and Margaret Thatcher. "Don't get me wrong," Compton said at one point. "It wasn't an island where every single person loved my father. We would be driving to school and hear people be, like, 'Down with Compton!'" She felt self-conscious of her privilege, and learned to

downplay her family name. The New Orleans chef Donald Link, a friend of Compton's, recalled a recent trip to St. Lucia where, at Compton's insistence, he spent an afternoon being shown around the island by her mother, Janice. "Everywhere we went, people were like, 'Hello, Lady Compton!'" he recalled. "I was, like, okay, she seems to be someone of stature on this island." Outside the central market in Castries, the island's capital, Link saw a statue of John, and texted a picture of it to Compton. "You didn't tell me everything about your life here," he wrote her.

The family had a maid who did much of the cooking, and it wasn't until Janice's mother—a white Englishwoman who had relocated to St. Lucia after falling in love with Compton's grandfather—moved in with the family, when Compton was eight or nine, that Compton started to develop an interest in food. "She especially loved cooking flying fish with parsley sauce, and I became her sous-chef," Compton told me. "I'd say, 'Yeah, Granny, what do you need? I'll peel the onions, I'll chop the carrots.'" At sixteen, while home from boarding school in the United Kingdom, Compton volunteered to take over the family's Christmas dinner. After the meal, Compton recalls feeling a great sense of rightness. "I was, like, 'You know what? If I can make them happy, I'm sure I can make other people happy.' And that was kind of my driving force," she said.

When Compton was eighteen, Janice arranged for her daughter's first professional kitchen job, a summer gig at a Sandals resort on the island. Compton loved the work so much that she stayed for a year, then spent another two at a Sandals in Jamaica. There, she worked under a chef who had graduated from the Culinary Institute of America, in New York's Hudson Valley, and who told her that it was one of the only culinary schools worth the money. In 2000, Compton enrolled, and after graduating she secured a coveted job at Daniel, one of Manhattan's most rarefied French restaurants.

At Daniel, she was exposed to a new kind of kitchen: hierarchical, male-dominated, cutthroat. "Yelling, screaming, demeaning —just high anxiety all the time," Compton said. As a Black, immigrant woman ("That's the trifecta," she said), she felt there was little space for her to advance. "There was a woman who worked appetizers, Leslie," she recalled. "I'll never forget her. She said, 'Nothing's going to change. Even though you're the best cook,

you'll never make it to the hot line'"—the center of a kitchen's action, where line cooks work to prove themselves crafting a restaurant's main courses, jockeying for promotions and mentorship. "And that's just how it was."

Disillusioned, Compton left Daniel after a year, for work in Miami, where she remained for more than a decade. She met Miller, who was then a restaurant consultant, when they were both working at Casa Casuarina, a luxury hotel in the Miami Beach mansion formerly owned by Gianni Versace, and they began dreaming about opening a place of their own. In 2013, when Compton was working as the chef de cuisine at the Miami outpost of the pasta restaurant Scarpetta, she received a call on the kitchen phone. It was a *Top Chef* producer, inviting her to be a contestant on the show's next season, which would film primarily in New Orleans. (Scott Conant, the former chef-owner of Scarpetta, had previously been a judge on the show, but he told me that the producers found Compton independently.) If Compton won, she would get a prize of $125,000. Even if she didn't win, the show would also allow her, on a national stage, to cook the St. Lucian food she loved. "I called my mom, and she said, 'Don't do it, it's too stressful for me,'" Compton said. "I told her, 'Mom, this could be good. Maybe I'll win the money. I can put Caribbean food on the map.'"

Bywater American Bistro—often called BABS by its regulars—is named for the Bywater neighborhood, which, with the adjacent Faubourg Marigny, sits to the "downtown" side of the French Quarter, atop a natural levee along the curve of the Mississippi. Before Katrina, the Bywater was a bohemian enclave of artists and working-class families; as in New Orleans at large, six in ten neighborhood residents were Black. After the storm, as the city worked to rebuild both its infrastructure and its population, the demographics of the Bywater inverted. Real estate prices soared, and —at least until the COVID-19 era—the streets buzzed with tourists, who cycled through the neighborhood's hundreds of short-term Airbnbs. Many of the area's old factories were converted into loft apartments; Bywater American Bistro occupies the ground floor of a converted rice mill, where residents' amenities include bike racks fabricated by an Estonian design collective and a lap pool set in an "Italian citrus grove."

In January, Compton and Miller moved from that building,

where they'd lived since opening Bywater American Bistro, to a house nearby, a white-painted shotgun with tidy gray trim. After closing her restaurants for the coronavirus lockdown, Compton spent two weeks at home, tending her new garden. After a time, she started taking daily walks to the restaurant. She and Miller had donated most of the perishables in the walk-in refrigerators to food banks, but, working with what remained in the pantry and freezers, she cooked meals for health-care workers: semolina gnocchi, grits with sausage gravy. Even in normal times, restaurants operate on knife-blade margins; after the sudden shutdowns, many could not afford their overhead costs. Compton is in a relatively lucky position: for both Compère Lapin and Bywater American Bistro, her rent is tied to revenue. Still, "once you hit the one-month mark, then six weeks, now eight weeks—the longer you stay closed, the harder it is to open," Compton said.

It was May 15, the day that New Orleans entered Phase 1 of its reopening, allowing restaurants to resume dine-in service at 25 percent capacity. But Compton and Miller were worried about moving too quickly. Orleans and Jefferson Parishes had just surpassed a combined 13,000 infections, nearly a third of the state-wide total. "We don't want to do it prematurely. We don't want it to blow up in our face," Compton said. In April, Bywater American Bistro had been approved for a Paycheck Protection Program loan, and Compton and Miller had rehired four of their former staff and spun up a takeout business, with weekly themes—a St. Lucian fish fry, a pig roast, a pasta feast. Now they settled on a tentative next step: at the beginning of June, Bywater American Bistro would reopen its dining room for just one table a night. It was part dress rehearsal, part low-key stunt. Mostly, Compton told me, it was about the pleasure of getting back to serving dinner. "The room, the music, somebody pouring wine for you, the lighting—that doesn't fit in a to-go box," she said. When online bookings for the first few tables went live, an onrush of aspiring diners caused the reservation page to crash.

Two weeks later, Compton sat on a green banquette in the center of the restaurant, a double-height space with raw brick walls, conducting a staff meeting before the first night of service. She was wearing her usual uniform, a striped canvas apron over a fitted T-shirt, plus a white disposable mask. Her handful of employees, also masked, sat spaced out at separate tables. A week before, the

police killing of George Floyd, a Black man in Minneapolis, had prompted mass protests across the country. In New Orleans, the marches had been notable for their peacefulness, but the night before police had fired tear gas at protesters attempting to cross a bridge. The city was on pins and needles—plus, a tropical storm was on the way. But Compton's voice—slightly raspy, with the lilt of a Caribbean accent—was focused and calm.

"We can't catch a break," she said, with a half laugh. "I think the best part of our day is going to be two people coming in, and we're just making them feel good."

The guests that night were locals, two friends who'd pounced on OpenTable the moment the reservation link went live. Compton served them duck breast on a puree of carrots and foie gras; tortellini filled with squash blossoms harvested from a friend's garden, draped in saffron cream; and paper-thin slices of a tuna loin that she'd been curing in salt and sugar for days, so that the ruby-red fish was dense and rich like bresaola, served with stewed okra and a sip of pot liquor. Rosie Jean Adams, the general manager, had seated the pair in a little section that juts out from the main dining room like a windowed panhandle, where the narrower space and lower ceiling could make being alone in the restaurant feel more like intimacy than isolation.

Compton called me later that night, alive with adrenaline. "It was amazing, just amazing," she said. Her plan was to increase the number of customers in the following weeks. "The restaurant is really open now," she said. "Now it's a fast track to July, when we open up for real, and things will hopefully start to go back to normal."

In recent years, Compton told me, she has noticed parallels between her professional trajectory and those of the handful of other Black chefs who've achieved national fame. "Everybody had the same narrative: 'When I started cooking, I wanted to work for the best chefs. When I worked in these kitchens, I was the only Black person,'" she said. Several, she added—Carla Hall, Kwame Onwuachi, Nyesha Arrington—used appearances on *Top Chef,* as she did, to build their names, and to set in motion extraordinary careers. Jessica B. Harris, a scholar of Black foodways, told me she doesn't think that pattern is a coincidence. Unlike restaurant investors, reality-show producers tend to prize diversity. Competing

on TV, Harris said, "has become, if you will, an opening—a way to raise consciousness about what you do for African American chefs who might otherwise have had even more difficulty being seen or being heard."

Before Compton flew to New Orleans to film *Top Chef,* she told her staff at Scarpetta that she would be taking a leave of absence to visit her family in St. Lucia—the show's nondisclosure agreement meant that almost nobody could know where she really was and what she was doing. (All communication with the outside world was prohibited during the six-week shoot; to maintain secrecy, Miller kept hold of Compton's phone, and responded to incoming messages as if he were her.) The show aired in the fall of 2013; from the first episode, in which Compton wowed the judges with curried-turtle meatballs, she distinguished herself with an amiable perfectionism. Week after week, other contestants were told to pack their knives and go, until only Compton and Nicholas Elmi, an anger-prone Philadelphia chef, remained. In the finale, filmed in Maui, Compton prepared a meal that foregrounded tropical flavors: golden slices of breadfruit with a foie-gras "butter," a jewel-like tartare of tuna and escolar under a snowdrift of tomato granita. Elmi underseasoned his tuna, undercooked his duck, and threw a tantrum loud enough for the judges, seated outside the kitchen, to hear. "I said I had to be perfect to beat you," he said to Compton bitterly, while the two waited to hear their fates—Compton, it seemed, was the obvious winner. After an unusually long period of deliberation, the chefs were brought before the judges. The dramatic music swelled. "Nick," Padma Lakshmi, the show's host, said. "You are Top Chef."

Being robbed of victory may have done more for Compton's career than winning ever could. The internet lit up with the injustice; Tom Colicchio, the judge who'd seemed most impressed by Elmi's showing, was pummeled on Twitter with accusations that he'd railroaded the other judges. Six years later, Compton told me, she still gets messages from outraged fans. After the season wrapped, she and Miller received pitches from investors and developers around the country: Los Angeles, Chicago, New York. In late 2014, they heard from the new owners of the Ambassador Hotel, in New Orleans, who were giving the place a face-lift and rechristening it the Old No. 77 Hotel. They wanted her to create a restaurant that could help put them on the map. Compton had

never been to the city before filming *Top Chef,* but she loved the thought of moving there. In many ways, she said, New Orleans reminded her of St. Lucia: "The buildings, the climate, the vegetation, the colorfulness of the people. The love of life, you know?"

Growing up in the Caribbean didn't fully prepare Compton for the pernicious racial dynamics of the United States, she told me. St. Lucia's population is less than 2 percent white; its citizens are overwhelmingly the descendants of enslaved Africans. "My sister and I were talking about this," Compton said. "She said, 'Nina, think about it. Growing up, you had so many people as prime ministers, as governors, as business owners who were Black, right?' Here, in America, we don't have that representation." After some time of living and working in the United States, her understanding of her racial identity changed, and the nature of her ambition changed with it: she wanted to succeed as a chef not only for the sake of personal fulfillment but as an act of defiance against a society rigged against Black achievement. "I can't make a huge splash, but I can make a ripple," Compton said. "And then, hopefully, that becomes a wave."

Still, in the early days of the George Floyd marches and rallies, perhaps the largest civil rights protests in American history, Compton found herself feeling skeptical. I asked if this had to do with her upbringing in a political family—her father, during his career, had often faced angry crowds. "I think protests do have a place, but sometimes the point doesn't really get across," she said. "It's very emotional, and I feel sometimes that processing the moment is better." She was especially uncomfortable with the outpouring of white allyship—including, she told me, an uptick in takeout orders at Bywater American Bistro, which she suspected were from people making an effort to support Black-owned businesses. She worried that support for the cause of racial equality would prove to be little more than a passing trend. "I've been on calls with so many people who run restaurants, or tech companies, or whatever else—they want to put out a statement. Stop right there. Look in the mirror. And also look at your payroll, look at your schedule. You need to do some housekeeping before you start saying 'Black Lives Matter.'"

In New Orleans, Black cooks who've come up within the city's restaurants have struggled to be seen—in *Creole Feast,* a cookbook and oral history from 1978, the civil rights activist and author

Rudy Lombard described them as working "in almost complete anonymity and frequently in a hostile environment." Black chefs have run the kitchens of some of the city's most revered establishments—Milton Prudence at Galatoire's, Lazone Randolph at Brennan's—but they've received none of the fanfare that was given to their restaurants' white owners, or to white chefs such as Paul Prudhomme, Lagasse, or (before his #MeToo downfall) John Besh. Since the inception of the James Beard Awards, the nation's most prestigious restaurant honors, in 1991, New Orleans establishments and chefs have won competitive awards twenty-six times. Only one of those has gone to a Black-owned restaurant or a Black chef: Compton, who in 2018 was declared the Best Chef of the South for her cooking at Compère Lapin. (The James Beard Foundation recently announced that, because of the coronavirus, it is suspending the 2020 and 2021 awards; according to the *Times*, concern over racial inequities in the awards process also played a role.) Lolis Eric Elie, the writer and historian, posited that Compton's status as an already accomplished cook, with an established public profile, helped insulate her from the forces that too often block the city's talented Black cooks from reaching the spotlight. "Had she been a line cook at fill-in-the-blank restaurant in New Orleans, would they have noticed her talent?" he said.

For more than a half century, the city's most famous Black chef was Leah Chase, the owner of the legendary restaurant Dooky Chase, in the Treme neighborhood. Chase, who died last year, at the age of ninety-six, was New Orleans's undisputed queen of Creole cooking, serving politicians, celebrities, and civil rights leaders fried chicken, shrimp Clemenceau, and, each Holy Thursday, her famous gumbo z'herbes. (She, too, has been recognized by the Beard Foundation, but only with honorary awards: Lifetime Achievement, Who's Who of Food & Beverage in America.) Chase's death left a hole in the New Orleans culinary pantheon; Elie, Harris, and Anderson all told me that they see Compton as an heir to Chase's legacy. Compton recalled that, shortly after Compère Lapin opened, Chase paid her a visit: "She said, 'Welcome to the city. We're so happy to have you.' And then she said to me, 'Listen, you have to make it.' I said, 'Miss Leah, I'm going to try,' and she said, 'No, you have to make it. We are counting on you.' She told me that you have to be the toughest person in the room. You can't

show signs of weakness, or give up. You have to keep pushing. Because, she said, 'Nina, if you make it, you're leading the way for other Black female chefs to make it in New Orleans.'"

Four days before Hurricane Katrina struck New Orleans, it blew through Miami, where Compton, who was single at the time, was living in a one-bedroom apartment in South Beach. In the middle of the night, fearful that the winds would blow her windows out, she grabbed her passport, a bottle of wine, and a bag of Doritos and locked herself in her apartment's interior bathroom. When she emerged, after eight nervous hours, the sun was shining, and the city, rattled but mostly whole, was already moving on. Compton has since experienced several hurricanes in New Orleans; on Thursday, the city was on tornado watch as Hurricane Laura, a category 4 storm, pummeled parts of the Gulf Coast. Still, when she decided to put down roots in the city, Compton resolved to listen to locals' Katrina stories whenever she found the chance. "There's a phrase we say back home, in St. Lucia: empty vessels make the most noise," she said. "I didn't want to be a person talking about New Orleans without really saying anything. It's an old city, and I'm new here. You have to come in on tippy-toe, be respectful, appreciate the nuances."

For survivors of Katrina, the current crisis is in many ways cruelly familiar: another foreseeable calamity ignored, another disaster-management hack job by the federal government, another era of lives and livelihoods on pause. As with Katrina, the city's Black residents have been hit hardest by both the virus and the economic devastation caused by the efforts to halt its spread. But everyone I spoke to said that the pandemic is likely to prove even worse than Katrina in the long run. By mid-August, the coronavirus had caused more than 4,500 deaths in the state, more than double the highest estimates of fatalities from the hurricane and its aftermath. Each day, on average, the virus claims twenty more Louisianan lives. "The thing with Katrina was it had an end point," L. Kasimu Harris, a New Orleans writer and photographer who chronicled the hurricane's aftermath, told me. "The storm happened on the twenty-ninth of August, the levees started breaking the same day, and weeks after that, pretty much, you could start rebuilding." With the coronavirus, by contrast, the disaster phase

is dragging on indefinitely. The pandemic has been six straight months of the levees breaking, and the water has not yet begun to recede.

Since June, New Orleans has been stuck in Phase 2 of reopening; a planned transition to Phase 3—which would allow more customers in restaurants and other businesses—has been postponed several times. A third of all New Orleans hospitality workers remain unemployed. Compton and Miller, so far, have been able to rehire only ten of their former staffers. Compère Lapin remains closed, and Bywater American Bistro, in accordance with Phase 2 rules, is filling only half of its eighty-five seats each night, plus an additional dozen at outdoor tables set up on the sidewalk.

"Last week, there was talk about going back to Phase 1," Compton said. "So you spend a whole day waiting for this press conference—like, what are they going to say today? It's a constant state of fear." In April, Compton had become involved with the Independent Restaurant Coalition, a national industry lobbying group formed in order to ensure that non-chain restaurants—and their collective millions of employees—were not overlooked in the government's coronavirus-relief legislation. She pointed me to the results of a survey that the group had conducted, in July, of more than 2,000 restaurants and bars, which showed that, on average, their owners were not confident that they would be able to remain operational through October. Compton told me, "We're not trying to turn a profit. We're just trying to stay afloat."

At five o'clock on a recent evening, a half hour before Bywater American Bistro was scheduled to open, Compton was surprised to notice customers already forming a socially distanced queue outside. She unlocked the doors early, and Miller, doing double duty as a host and a runner, directed parties to their tables. He handed each person a printer-paper menu, explaining, from behind a mask bearing the logo of the New Orleans Saints, that the sheets would be discarded after customers had handled them. The kitchen fired up—three cooks, down from the usual crew of seven, plus Compton and a dishwasher—and the room filled with the sounds of conversation and clinking tableware, and Mel Waiters crooning on the sound system: the rising hum of a restaurant coming halfway back to life.

The next day, around noon, after receiving a delivery of Gulf shrimp at the restaurant, Compton called me, over FaceTime,

as she strolled home along Crescent Park, a new, narrow strip of greenery that follows the line of the Mississippi. There were few other people out, but not because of COVID-19, she explained: this time of year, at the hottest time of day, there's almost nobody around. New Orleans is brutal in the summertime—the suffocating heat broken only by brief, torrential squalls of rain—but it's beautiful too. Heavy yellow sunlight wraps cars and buildings in its glimmer; the city's greenery, always lush, becomes a jungle. Compton said that some people in the neighborhood were running ersatz takeout restaurants out of their homes. "A lot of people are doing things like this, selling tacos or snowballs," she said. "Just trying to be creative and get some income." In an open-walled shed behind the Joint, a barbecue spot down the street, a hulking smoker purred, and Compton drew in a deep, happy breath.

As she rounded the corner, toward her home, she passed Vaughan's Lounge, a venerable jazz and blues dive. The bar, open since 1959, is a Bywater landmark, famous for its annual block party and, until a few years ago, for the Thursday-night residency of the trumpet great Kermit Ruffins. Compton paused by the door, where the owners had posted a sign urging patrons to wear masks: PROTECT YOURSELF AND OTHERS. "There have been times during all of this when I'm, like, What is the point? What is the incentive?" she had said to me, in one of our earlier conversations. There was so much to despair of: the people who refused to wear masks, the lack of care shown by the government, the relentlessness of racism, the feeling that, over all, things were lots of tunnel and very little light. "But I remind myself, 'Nina, it's not all about you,'" she had said. "It's about giving other people hope. The goal is to weather the storm."

RUBY TANDOH

How a Cheese Goes Extinct

FROM *The New Yorker*

THE LATE MARY HOLBROOK, a white-haired maestro in the British cheesemaking world, was known for her soft cheeses and her sharp temper. Once a week, she made the trip from Sleight Farm, her home in the southwest of England, to London to check on her wares as they ripened in the maturation rooms of an up-scale cheese shop. Holbrook's apprentices, hardened to her singular style of mentorship, knew to brace themselves for reprimands when she returned. Occasionally, though, Holbrook would come back with bags of treats—yogurt, mangoes, sweets—which she spilled across the kitchen table of her cold mid-nineteenth-century farmhouse on the crest of a hill, and they knew that the cheese must be tasting good, and that Mary's little world was in order.

Before turning to cheesemaking, in the 1970s, Holbrook had been an archaeologist. Some forty years into her second career, she still had a way of getting history to rise to the surface. Sleight Farm was littered with relics, pieces of rusting machinery scattered across the rolling fields. "If they broke," Julianna Sedli, who worked with Holbrook for a little over three and a half years, said, "they broke forever." In one shabby outbuilding, alongside vats of oil and parts of a tractor, craggy wheels of hard Old Ford cheese aged in the cool, damp shade. In a room along a little track, French influences converged with old English traditions of goat's- and sheep's-milk cheesemaking. There, Holbrook made Tymsboro, an ash-rubbed pyramid of soft cheese, with bright, peppery notes. Her semi-soft washed-rind Cardo cheese, meanwhile, borrowed from Portuguese tradition, using a vegetarian rennet made from thistle stamens.

As Holbrook's renown spread—as well as gaining acclaim for her cheeses, she made her name by supplying pork to some of London's most famous restaurants—aspiring cheesemakers made pilgrimages to the farm, keen to learn from the woman who had built a reputation as one of Britain's finest. Some journeyed down only for a week or two; others stayed for years. In 2004, Martin Gott and his partner Nicola Robinson moved to Sleight Farm from their jobs in Lancashire, in the northwest of England. They bought a flock of sheep and rented some grazing land and barn space from Holbrook, developing their own washed-rind sheep's cheese —St. James—in snatched moments when they weren't farming and cheesemaking for Holbrook. Their vision didn't always align with Holbrook's: Gott recalls that, much of the time, he was left to make his own mistakes, with his mentor only chiming in to express disappointment or dissent. But there were bright moments too. In the evening, they would leaf through cheese-industry catalogues, laughing about the incredible strangeness of being able to buy starter cultures—packages of concentrated bacteria designed to help the milk sour safely and with the right flavor—with futuristic names like Go17-B.

"I wouldn't say that Mary taught us a huge amount of practical cheesemaking," Gott said. "But she put us in a position where we could learn." If the work of an archaeologist is to let objects tell their own story, Mary carried this philosophy forward in her cheesemaking, too: smelling, tasting, observing, and touching the cheese as it was made and aged, letting it speak for itself.

Holbrook died in February of 2019, at the age of eighty, following a short illness. She left behind no children, and her cousin's daughter, Catherine Ochiltree, was unable to continue the difficult work of farming and cheesemaking in her absence. Ochiltree and her partner were traveling nearly 150 miles from their home in Kent to the farm on weekends, in addition to working full-time jobs. "We just didn't have that resilience," Ochiltree said. "We were running on a very skeleton staff. I took the decision that we needed to bow out, so we started to dry the goats off and started to sell the herd."

By July of that year, the farm ceased production, and Holbrook's cheeses—Old Ford, Cardo, Sleightlett, and Tymsboro—slipped out of the living tradition and into the pages of history. A cheese is just one small piece of the world—one lump of microbe-riddled milk

curds—but each is an endpoint of centuries of tradition. Some disappear for months or years; others never return. The cheesemonger and writer Ned Palmer told me that, when a cheese is lost, "Your grief reaches back into the past—into decades and centuries and millennia of culture. You feel all of that."

When you talk with cheese aficionados, it doesn't usually take long for the conversation to veer this way: away from curds, whey, and mold, and toward matters of life and death. With the zeal of nineteenth-century naturalists, they discuss great lineages and endangered species, painstakingly cataloguing those cheeses that are thriving and those that are lost to history. In his classic *The Great British Cheese Book*, from 1982, Major Patrick Rance—a monocled founding father of modern British cheese—intersperses his tales of surviving regional cheeses with obituaries for those that never made it so far, going as far as to describe their disappearance as extinction. Under "Extinct cheeses of the Midlands and East Anglia," Rance pays his respects to a lost Newmarket cheese, "a 40lb marigold-coloured cheese," pressed under cloth and rubbed with salt and cream, the recipe for which was unearthed in a 1774 housekeeping manual.

There are countless ways for a cheese to disappear. Some, like Holbrook's, die with their makers. Others fall out of favor because they're simply not good: one extinct Suffolk cheese, "stony-hard" because it was made only with skimmed milk, was so notoriously bad that, in 1825, the *Hampshire Chronicle* reported that one ship's cargo of grindstones was eaten by rats while the neighboring haul of Suffolk cheese escaped untouched. As Palmer has outlined in his book, *A Cheesemonger's History of the British Isles,* the fate of a cheese is often entangled with economic and political circumstances, as well as the failings of its makers. During the Second World War, much milk was redirected away from cheese production and toward drinking. The small amount of cheese that was permitted to be made was strictly regulated, with only a small roster of cheeses—mostly hard cow's-milk cheeses similar to Cheddar —approved for production. Soft and blue cheeses, which tended to contain higher moisture levels than those permitted in ration cheese, and which were less durable, didn't make the cut. Within two decades, the number of farmhouse cheesemakers had plummeted from over 1,000 to less than 200.

Even if a cheese can be rescued, the act of bringing it back to life can be fraught. In 2004, when the founder of the artisanal-cheese retailer Neal's Yard Dairy, Randolph Hodgson, and the cheesemaker Joe Schneider decided to make a raw-milk version of Stilton, the process was like trying to resurrect the dinosaurs using only a sketch of a Tyrannosaurus rex on the back of a napkin for reference. Although Stilton is celebrated as a jewel among British cheeses, a raw-milk version hadn't been made since the late 1980s, when a health scare led the final few creameries making it to switch to pasteurized milk. To find a path toward an authentic Stilton taste and texture—the way it had been made for more than 200 years—Schneider had to rely on the "taste memory" of people who had last eaten the cheese a decade earlier. "I felt like a blind man trying to navigate my way, while these guys shouted orders at me to move a little bit left or a little bit right," he said. He found images in old books of wheels of Stilton stacked high at market: these scraps of information gave him vital clues about the size, moisture, and structure of the traditional version. "You could never do that with a modern Stilton," Schneider said. "It would crush—it's too broken down and soft."

Matters were complicated further by the very PDO (Protected Designation of Origin) status that is supposed to protect traditional Stilton-making. With existing producers having switched to pasteurized-milk production in the 1990s, pasteurization became a protected trait for all Stilton cheeses, leaving Schneider and Hodgson's cheese—made by the same methods, in the same place, and with the same microbial cultures as Stilton had been for centuries—unable to use that name. Not deterred, however, they leapfrogged back through history and secured the name Stichelton—which is, according to Schneider, the Old English name for the town of Stilton—for his cheese. Because it wasn't Stilton, the cheese was more itself than ever.

These existential wranglings are familiar to Harry G. West, an anthropologist who has spent much of his academic life interrogating the way cheese is shaped by tradition, technology, and legislation. In Stichelton cheese, Schneider and Hodgson re-created the unpasteurized Stilton piece by piece, accounting for biological and environmental factors, in order to revive an old cheese in a new time. But West said that overly exacting approaches can be

beside the point. "I think the question isn't 'Is it the same?' but 'Is it connected?'" he said. "And I think those connections can be made in so many different ways."

For some cheesemakers, like Schneider, the quest to save a cheese will bear down on the minutiae of environmental terroir: the land, the biodiversity of the grazing pastures, and the microbial communities present in the raw milk. For others, continuity has a more human dimension, drawing a link between past and present through family lineage: the Lancashire cheese produced by the Kirkham family, for example, is widely considered to be the last remaining raw-milk farmhouse Lancashire in production. Regardless of titles and official designations, cheeses will always reflect the people who make them. (Gott, who remembers Holbrook's obsessive attention to detail—sourcing starter cultures from the Loire Valley, in France, and thistle stamens from Portugal—likes to say, "If you want to change a cheese, change the cheesemaker.") But the human factors also extend further afield, to the hands that will package the cheese, the money that will purchase it, the shelves it will fill, and the mouths it will feed. Stilton cheese is a case in point: as West points out, Stilton was named not after the place that it was first made, but the town where it was first marketed and sold. In fact, Stilton cannot legally be made in the town of Stilton, which sits outside of the geographical area specified in the cheese's PDO. What irony, that a cheese now defined by where it comes from was initially defined by where it went to—brought to life not in the farmhouse or the dairy but in the marketplace.

Such conversations have taken on particular resonance today, as the coronavirus reshapes the ways we shop, dine, and cook. The food writer Jenny Linford was among the first to document the challenges faced by cheesemakers when the pandemic struck, with some makers seeing restaurant and wholesale orders dry up virtually overnight, and others having to put production on hold for now—and maybe even forever. "We need to put our arms around our cheese world and understand how precious it is," Linford told me.

There have already been casualties of the crisis. Innes Cheese, based at Highfields Farm Dairy, in Staffordshire, has been a site of goat's-milk cheesemaking since 1987. Their signature cheese, Innes Log, with its grassy, sometimes nutty flavor and fudgelike

texture, was singled out by Neal's Yard Dairy as an alternative to Holbrook's Tymsboro, after she had died. Their Highfields cheese —crumbly, Caerphilly inspired—was billed as a successor to Holbrook's Old Ford. Before the pandemic hit, Joe Bennett and his partner, Amiee Lawn, the joint owners of Innes Cheese, found themselves on the brink of investing a lot of money in a new milking parlor and improved facilities at the farm. "We were talking to the bank, and literally the next day everything stopped," Bennett said.

When the lockdown started and restaurants—Innes Cheese's principal buyers—were shuttered, the dairy's plans were upended. "For three weeks, we had virtually no sales at all," Bennett said. "It just all stopped pretty much overnight." With one young child and a second on the way, Bennett and Lawn felt they had no choice but to stop cheesemaking and sell their herd of goats. On June 15, the pair drove down to London with the last of their cheeses. Soon, the last of them will have been sold and eaten, and a thread of tradition after thirty-three years in the goat-cheese business will be lost.

Last month, Bennett and Lawn's flock of 300 goats were driven over 150 miles north to a new home at Holker Farm, in Cumbria, where Gott and Robinson have lived and made cheese since their yearlong apprenticeship with Holbrook. They had been considering making their own goat's-milk cheese since Holbrook died, so when they got a call from Bennett to let them know that he and Lawn would be bowing out of the business, they took it as a sign. Within a week, the first Holker Farm kids were born. With the population of their farm having more than doubled, Gott and Robinson are busier than ever. The traditional dry stone walls that crisscross the farm have to be safeguarded. ("To the goats," Gott noted, "they're like climbing frames!") Fences and hedges need to be checked and checked again in order to goat-proof the paddocks. But there's excitement too. The goats are mostly British Saanen crossed with Golden Guernsey, which means that they yield smaller quantities of richer milk—perfect for making cheese.

Gott and Robinson have started by making a hard goat's-milk cheese. Like their Crookwheel sheep's-milk cheese, which they rushed into production after the start of lockdown, in March, this new offering will be a firm, reasonably dry cheese: less labor-inten-

sive to produce and durable enough to weather uncertain market conditions over the coming weeks and months. With Innes Cheese's goats, transplanted to the rolling Cumbrian countryside, and using cheesemaking techniques that they learned at Sleight Farm, in Somerset, Gott and Robinson are making something entirely new from old parts. They have called the cheese Holbrook.

Good Bread

FROM *The New Yorker*

IN LYON, AN ancient but benevolent law compels bakers to take one day off a week, and so most don't work Sundays. An exception was the one in the quartier where I lived with my family for five years, until 2013. On Sundays, the baker, Bob, worked without sleep. Late-night carousers started appearing at three in the morning to ask for a hot baguette, swaying on tiptoe at a high ventilation window by the oven room, a hand outstretched with a euro coin. By nine, a line extended down the street, and the shop, when you finally got inside, was loud from people and from music being played at high volume. Everyone shouted to be heard—the cacophonous hustle, oven doors banging, people waving and trying to get noticed, too-hot-to-touch baguettes arriving in baskets, money changing hands. Everyone left with an armful and with the same look, suspended between appetite and the prospect of an appetite satisfied. It was a lesson in the appeal of good bread—handmade, aromatically yeasty, with a just-out-of-the-oven texture of crunchy air. This was their breakfast. It completed the week. This was Sunday in Lyon.

For most of my adult life, I had secretly wanted to find myself in France: in a French kitchen, somehow holding my own, having been "French-trained" (the enduring magic of that phrase). I thought of Lyon, rather than Paris or Provence, because it was said to be the most Frenchly authentic and was known historically as the world's gastronomic capital. Daniel Boulud, the most successful serious French chef in the United States, was from there, as was Paul Bocuse, the most celebrated chef in the world. The

restaurateur Jean-Georges Vongerichten had trained in Bocuse's kitchen, as his sauce-maker. "Lyon is a wonderful city," he told me. "It is where it all started. You really should go."

Why not? My wife, Jessica Green, a wine educator and lecturer, lived for the next chance to pack her bags. (She also spoke fluent French, which I did not.) And our twin boys, George and Frederick, were three years old—possibly the perfect age to move to a new country. Our landing, though, was surprisingly rough. Lyon seemed unwelcoming, suspicious of outsiders, and indifferently itself. "Our town is not easy to love," a Lyonnais novelist had written in the '30s (the Fascist Henri Béraud, who was also not so easy to love). "It is an acquired taste. Almost a vice."

We got an apartment by the River Saône, situated auspiciously on the Quai Saint-Vincent. (Vincent was the patron saint of winemakers.) A gnarly first-century aqueduct column by a post office reminded us that the Romans had been here. In entryways, I found stone stairs rendered concave by boot traffic. Farther up the quai was a former monastery courtyard, overgrown but graceful. In our quartier, there were workshops, not shops: a bookbinder, a violin-repair person, a seamstress, a guitar-maker, a one-room pastry "factory." The next street over, Arabic was the principal language, and women, their heads covered, fetched water by bucket from an archaic faucet.

There was also—on the nearby Place Sathonay—a porn shop, park benches occupied by drunks, drug deals, graffiti on most surfaces, dog shit everywhere. At a playground, sparkly with bits of broken glass, we watched small children hitting one another. And yet the quartier, for all its in-your-face grittiness, also had energy and integrity and an abundance of small eateries. The food wasn't grand, but it was always honest, characterized by *bon rapport qualité-prix*—good quality for the price, an essential feature of the Lyonnais meal. Our apartment was opposite a mural called *La Fresque des Lyonnais,* two millennia of the city's famous citizens painted onto a six-story windowless wall. The same building housed Bob's boulangerie, where, friends told us, you could find the best bread in the city.

The boulangerie was where the boys discovered the word *goûter* (from *goût,* meaning "flavor," and probably the single most important word in the entire language). A *goûter* is an afternoon snack—eaten universally at 4 p.m., when children get out of school—and

an exception to two of the city's implicit rules about food: you do not eat standing up, and you never eat between meals. A *goûter* is devoured instantly. The boys discovered Bob's *pain au chocolat* and didn't understand why they should eat anything else.

They also discovered Bob's baguettes, which Frederick developed a practice of assaulting each morning before eating: breaking one open with his hands, sticking his nose inside, inhaling, and then smiling. On Wednesdays, when Bob was closed and we bought baguettes elsewhere, Frederick subjected them to his test and, without fail, found them inedible. (Bob was thrilled by Frederick's findings.) Bob's bread had aromatic complexity and was long in flavor in ways that we'd never known before. We were at his boulangerie every day. Some days, we went three times, which concerned him: "You've had enough bread today. Go home!"

We had been in Lyon a month when the evidence was inescapable: I couldn't find a restaurant to take me on. I had cooking experience, but it was mainly Italian, and Italian, I was discovering, didn't count. I was at home pacing (panicking, frankly), when I declared to Jessica, "I'm going to work for Bob. In fact, I'm going to walk over there now and present myself."

It was eight in the evening, but I was pretty sure he'd be there. Bob was known for his extreme hours, his light on in the back when the rest of the quartier was dark. And he *was* there, but he was heading home for a nap.

Bob knew why I was in Lyon. He also knew that I hadn't found a kitchen to work in. So, when I made my proposal, straight out —"Bob, I've decided, on reflection, that I should start with you, in your boulangerie"—he knew that he was my backup: that, in effect, I was lying.

"No," he said.

"No?" I pressed. "Bob, you make the best bread in the city. I want to learn why."

His gaze drifted above my head. He seemed to be imagining what it might be like for me to work there.

Bob was forty-four. He was jowly and wide of girth and, when unshaven, looked something like a genetic intermarriage of Fred Flintstone and Jackie Gleason. His hair was brownish and shaggy and usually matted with flour. There was flour in his beard and on his clogs, his sweater, and his trousers. (He wore an apron,

but it didn't help.) Bathing was not a priority. He slept when he could, and seemed to live by an internal clock set to an alarm that was always going off—yeast, dough-making, the unforgiving speed of a hot oven. He knew that his bread was exceptionally good, but he did not see himself as a genius. In a city of food fanatics, he was just a baker. He was, in fact, just Bob. And he wasn't even that. His real name was Yves. (No one knew why he went by Bob. I once asked him, and he was vague: "Somebody, a long time ago . . .")

"Yes," he said slowly: *Oui-i-i-i.* He actually seemed to be getting excited. I could see excitement in his fingers. They were drumming a counter. "Come. Work here. You will be welcome."

"I will see you tomorrow." I thanked him. We shook hands. I made to leave.

"You live across the street, right? You can stop by anytime. If you can't sleep, come over. At three in the morning, I'll be here."

I thought, *If I can't sleep at three in the morning, I don't go for walks.* But I understood the message. Bob was making himself available. I'll be your friend, he was saying.

At three on a weekday morning, when I set out for my first training, the city was lonely. The river was cold-making to look at and thick like motor oil when a barge appeared (suddenly, unexpectedly) a few feet away. From Thursday to Sunday, Lyon was all-night drinking, loud music, car burnings, vandalism, vomiting. Now there were no vehicles, no people, not a light on in any apartment.

Bob was clearly waiting for me. He ripped open a fifty-kilo sack of flour, lifted it without a sign of strain, and emptied it into a large steel basin. He grabbed a milk carton with the top cut off and told me to follow him to a sink—a startling sight, filled with coffee paraphernalia, grounds everywhere, a sandwich floating in something black, a wet roll of toilet paper. He negotiated the carton to a position under the faucet and ran it hot.

"You arrive at the correct temperature by a formula involving two other factors," Bob explained. "One is the temperature of the air. This morning, it is cold—it is probably two degrees. The other is the flour—"

"How do you know that?"

"It's the temperature of the air."

"Of course."

"These two factors added together, plus the water, should equal 54 degrees Celsius." So if the air was 2 degrees, and the flour was 2 degrees, the water would have to be 50.

"Hot," I said.

"Exactly."

The water from the tap was steaming. Bob filled the carton.

I asked, "Bob, you don't use a thermometer?"

"No."

"Do you own a thermometer?"

"No." He considered. "You know, I might."

Bob poured the water into the basin and started an apparatus attached at the top, a kneader. It appeared to have originally operated by turning a crank, and at some point had been upgraded with a washing-machine motor. Two hooks, looking like prosthetic hands, scooped up the dough very slowly. "It is no faster than if you did this with your own hands," he said.

"Then we take some of last night's dough." *La vieille pâte.* It was brown and cakey, wrapped in plastic film. He pinched a bit between his thumb and forefinger and tossed it into the basin. He took a second pinch, scrutinized it, thought better of the quantity, and tossed in half. This, in effect, was his "starter," yeasts still alive from last night that would be woken up in the new batch. It wasn't the only source. I knew enough about yeasts to know that, here, they were everywhere. You could peel them off the walls. You could scrape all you needed from underneath Bob's fingernails.

I looked around. On every available surface, there was an unwashed coffee mug. Fabric *couches,* used for shaping baguettes, were draped across wooden poles, like beach towels still damp from last summer. A light bulb dangled from the ceiling. There were the flickering blue lights of the ovens. The darkness put you on your guard. You could trip here and die.

He stopped the kneader and tore off a piece of dough. It was thin and elastic. "You can see through it," he said, laughing as he stretched it across my face like a mask.

Tonight's dough would be ready the next afternoon. The morning's baguettes would be made, therefore, from last night's.

"Let's get breakfast," Bob said.

An off-track-betting bar opened at six. The coffee was filthy, the bread was stale, and the clientele might be flatteringly described as "rough" (phlegmatic one-lunged hackers knocking back sunrise

brandies, while studying the racing odds), but, for Bob, they represented companionship. He was at ease among them. He introduced me as the guy he was training to make bread, his way.

Bob had not set out to be a baker. In his twenties, he worked in a law library in Paris, a job that he loved. His father had been a baker. His older brother Philippe was a great one, who had already opened three bakeries, as well as doing stints at ski resorts in the winter and in the Caribbean during the spring.

It was Jacques, another brother, who discovered, by accident, the boulangerie on the Saône. He had come upon a space for rent, situated in front of a footbridge, but it was filthy and filled with trash. He investigated: two floors, thick stone walls, a worn stone staircase, and, in the back, an old wood-burning oven. He wiped off the soot. It said 1802. He became excited—the river, the history (*La Fresque des Lyonnais* was then being painted on the back wall)—and summoned his father, Philippe, and Bob. "My father looked at the property from the outside and said, 'Yes, this is a good boulangerie,'" Bob told me. "'Bread has been made here for a long time.'" The family bought the boulangerie, for what was then about eleven thousand dollars, and got it ready. (It was probably—I couldn't keep myself from thinking—the last time the floors were cleaned.)

Bob returned to Paris, and a sign went up: PHILIPPE RICHARD ARTISAN BOULANGER. But it seems unlikely that Philippe intended to remain. He had a family and a business in Nantes, eight hours away. He called Bob: Quit your job, he said, and come run the boulangerie with me. In effect, he was beginning Bob's training (what in French is called a *formation*), helping him find his calling. "Without Philippe," Bob said, "I would be nothing." After a time—six months? A year? Bob couldn't remember—Philippe announced that he needed to return to Nantes. He'd be back, he said. It had been fifteen years. Bob hadn't changed the sign. "I will never take it down," he said.

From our balcony, with a mountain breeze coming off the Saône, the smells of the boulangerie were inescapable. When you live here, you have no choice: Bob's bread enters your living space. The boulangerie was the village equivalent of a campfire. It held the restaurants together. It united chefs and diners. It made the quartier a gastronomic destination.

Once, I asked Bob for his secret: "Is it the yeasts? Are they what make your bread so good?"

"*Oui*," he said very, very slowly, meaning, "Well, no."

I pondered. "Is it the leavening?" Bob always insisted that a slow first rise—called *le pointage*—was essential to good bread. Factory bread-makers use high-speed mixers to whip a dough into readiness in minutes. Bob's took all night.

"*Oui-i-i-i.*"

"The final resting?" Bread gets its deeper flavor in its last stages, people say.

"*Oui-i-i-i.* But no. These are the ABCs. Mainly, they are what you do *not* do to make bad bread. There is a lot of bad bread in France. Good bread comes from good flour. It's the flour."

"The flour?"

"*Oui*," he said, definitively.

I thought, *Flour is flour is flour.* "The flour?"

"*Oui.* The flour."

Bob bought a lot of flours, but a farm in the Auvergne provided his favorite. The Auvergne, west of Lyon, is rarely mentioned without an epithet invoking its otherness. It is *sauvage*—wild—with cliffs and forests and boar. Its mountains were formed by volcanoes, like so many chimneys. In the boulangerie, there was a picture of a goat on a steep hill. It was kept by a farmer friend, who grew the wheat that was milled locally into a flour that Bob used to make his bread. The picture was the only information that Bob's customers required. Who needs a label when you have a goat?

For Bob, farms were the "heart of Frenchness." His grandfather had been a farmer. Every one of the friends he would eventually introduce me to were also the grandchildren of farmers. They felt connected to the rhythm of plows and seasons, and were beneficiaries of a knowledge that had been in their families for generations. When Bob described it, he used the word *transmettre,* with its sense of "to hand over"—something passed between eras.

George and Frederick, enrolled in a neighborhood school, were learning their new language, hesitantly at first and then with sudden fluency. Jessica, with a mimic's gift for languages, spoke with authority and ease.

Was my French improving? No.

Did my French even exist? *Meh.*

I had a bad episode with *four*—the word in French for "oven" (pronounced as if someone has just hit you hard on the back). It sounds the same if the ovens referred to are in the plural (*fours*). And *fours* were, of course, what Bob baked his bread in, the blue-lit, glass-door contraptions on the ground floor.

One afternoon, there were two people in the back of the bou-langerie: Denis, Bob's sole full-time employee, and me. Denis—thirty, with cropped blond hair and dressed in white, like a proper baker—was upstairs. I was below, making dough. When I bounded up to retrieve a sack of flour, Denis asked: The bread—was it still in the oven (*au four*)? At least, I think that this was what he said. He repeated the question, and this time it was more like "Don't tell me that the fucking bread is still in the oven?" What I heard was strong emotion and "*four.*"

Four, I said to myself. *Four.* I know that word.

"*Four?*" I said, aloud this time, which was provoking, probably because it wasn't "yes" or "no."

"*Au four? C'est au four? Le pain!*"

Denis bolted down the stairs in what seemed to me like histri-onic distress. I heard an oven door being slammed open and a bread tray yanked out on its rollers.

"*Oh, putain!*"

For me, the door was the prompt. Of course. *Four!* It's "oven"!

The bread was ruined. (*Putain* means "whore." *Pute* is also "whore," but "*putain!*" is what you say when you've burned a full tray of baguettes.)

One evening, Bob announced, "Tomorrow, we do deliveries. It is time to meet the real Lyon."

Bob delivered bread via an ancient dinky Citroën that he hadn't washed—ever. On the passenger seat were plastic sandwich wrap-pers, a half-eaten quiche, a nearly empty family-size bottle of Co-ca-Cola, and editions of the local paper, *Le Progrès,* that lay open at such specific spots as to suggest that this is what Bob did while driving: he caught up on the news. He pushed it all to the floor and invited me to sit. Inside was a fine white cloud, as though the air had reached a point of molecular flour saturation and none of it would quite settle. The car explained why Bob so seldom bathed. Really, what would be the point? (In the wintertime, Bob had the appearance of an old mattress.)

Bob drove fast, he talked fast, he parked badly. The first stop was L'Harmonie des Vins, on the Presqu'île, a wine bar with food ("But good food," Bob said). Two owners were in the back, busy preparing for the lunch service but delighted by the sight of their bread guy, even though he came by every day at exactly this time. I was introduced, Bob's new student, quick-quick, bag drop, kisses, out. Next: La Quintessence, a new restaurant ("Really good food," Bob said, pumping his fist), husband and wife, one prep cook, frantic, but spontaneous smiles, the introduction, the bag drop, kisses, out. We crossed the Rhône, rolled up onto a sidewalk, and rushed out, Bob with one sack of bread, me with another, trying to keep up: Les Oliviers ("Exceptional food"—a double pump—"Michelin-listed but not pretentious"), young chef, tough-guy shoulders, an affectionate face, bag drop, high-fives, out.

One eating establishment after another: in, then out. Many seemed less like businesses than like improvisations that resulted, somehow, in dinner. Chez Albert, created on a dare by friends. Le Saint-Vincent, with a kitchen no larger than a coat closet. In the seventh arrondissement—industrial, two-up-two-down housing, gray stucco fronts—we arrived at Le Fleurie, a bistro named after a Beaujolais *cru*, as accessible as the wine. "I love this place," Bob said: a daily chalkboard menu on the sidewalk, twelve euros for a three-course meal (lake fish with shellfish sauce, filet of pork with pepper sauce), polemically T-shirt-and-jeans informal, the food uncompromisingly seasonal (i.e., if it's winter, you eat roots). Bob walked straight to the back, a sack on his shoulder, the familiar routine. Then, the day's last delivery completed, he asked after Olivier, the chef, and was directed to the bar.

Olivier Paget, Bob's age, was born in Beaujolais, father a plumber, grandfather a vigneron, cooking since age sixteen; normal chef stuff, including stints making fancy food with *grands chefs*, like Georges Blanc, with whom Boulud had trained. But Paget, his training complete, situated himself in a remote working-class district, made good food at a fair price, and filled every seat, every lunch and dinner: tight.

"*This,*" Bob said, "is my idea of a restaurant."

As Paget poured glasses of Beaujolais, Bob confessed to liking the idea of *grande cuisine*—cooking of the highest order. He still hoped that one day he would experience it properly. "I tried once" —a meal at Paul Bocuse's three-star Auberge, with Jacqueline, his

wife. No one could have arrived with higher expectations. Few could have been more disappointed.

It wasn't the food, which Bob doesn't remember. "We were condescended to," he said. Waiters sneered at them for not knowing which glass was for which wine, and served them with manifest reluctance. (Jacqueline is Cuban and Black. That evening, there was one other Black person at the restaurant: the footman, dressed up in a costume reminiscent of Southern plantation livery.) The bill was more than Bob earned in a month. It had been a mugging.

Bob knocked back his Beaujolais, and Paget poured him another, and, as I watched the easy intimacy between them, I believed that I was starting to understand what I had been seeing all morning: a fraternity, recognized by a coat of arms visible only to other members.

Through Bob, I learned about the city's eating societies, a proliferation of them: one for the *bouchon* owners; another for the *bouchon* eaters. One for the true bistros, and another for the modern ones. There was the Gueules de Lyon, which, by the designation of its members, included the city's eight coolest, philosophically unfussy, kick-ass restaurants. At least three societies were committed to hosting a real *mâchon*. (This is the all-day Lyonnais "breakfast" practice, featuring every edible morsel of a pig, limitless-seeming quantities of Beaujolais, and loud, sloppy parades of singing men who, by then, are trying to remember how to get home. I feared it.) And there were serious grownup societies, like Les Toques Blanches, whose members were the grandest of the region's *grands chefs*.

When I crossed the city, I met people I knew through Bob. I was starting to feel at home.

And then I quit.

I stepped into the boulangerie to tell him.

"Bonjour, Bill."

"Bonjour, Bob. Bob, I have decided to go to cooking school."

I could have hit him in the nose with my fist. He took a step back, as if he had lost his balance. "Oh," he whispered.

What had I done? I tried to explain, how I needed to learn kitchen skills first.

"Of course."

And that I would be back soon. If he would have me. That there was so much more to learn.

The air seemed to be leaving him. His shoulders sloped. He was just a baker, his posture said. He was Bob. Just Bob.

"You're going to L'Institut Paul Bocuse," he said—the most prestigious school in France. It was a statement, not a question.

"I am."

He whistled.

"But I will be back."

He didn't believe me.

We stood like that. He seemed to be thinking.

"At L'Institut Bocuse, you will learn *la grande cuisine*," he said forthrightly, with energy.

"I don't know."

"Of course you will." He seemed excited. "For the first time in my life, I will eat a grand meal and enjoy it. You will make me something from the repertoire of *la grande cuisine*. It will be like Bocuse but without all the Bocuse."

"Of course I will," I said.

He smiled.

I tried working for Bob on Saturdays, but it was too much. Then, after L'Institut, I found work in a restaurant kitchen. ("Good food there," Bob said, "but bad bread.") Bob continued to be in our life. He made a bread, combining American and French flours, that expressed our friendship. We called it a Lafayette.

More than a year later, we asked if we could take him out to dinner. It was an indirect apology. I hadn't cooked for him yet.

He picked the day: a Tuesday—i.e., not a school night. (Bob closed on Wednesdays, like the schools, so he could be with his young daughter.) He had both bathed and shaved, a radical sight. He had also determined the itinerary, which began with his friends at L'Harmonie des Vins, because they had just taken delivery of *the* new Saint-Péray, a small-production white wine made by Alain Voge. Bob taught us that, where we lived, a wine sometimes has a release date, like a play's opening night.

Bob talked and talked and talked. He knew plenty about us. He wanted us to know about him. He talked about his father, a farmer's son ("My grandfather, my great-grandfather, my great-great-grandfather, all of them, for generations, were *paysans*"), who became the renowned town baker, a patriarch whom his many children sought advice from before making major decisions, and who,

for no reason that anyone understood, no longer spoke to Bob's mother. ("It was strange. He spoke to the rest of us.")

About his mother, eighty-five, who pretended not to be distressed that her husband of fifty-nine years and the father of her seven children no longer spoke to her.

About his wife, Jacqueline, who was a single mother when he met her, on a vacation to Cuba, and who agreed to marry him only if the proposal was blessed by her priest, a disciple of Santería, the Caribbean religion.

About returning to Cuba to attend a ceremony, people dancing and chanting, until the priest stopped the proceedings: "He held my face between his hands, and looked into my eyes, and declared, 'Your family traded in the flesh of our ancestors. You cannot marry Jacqueline. Leave my sight.'"

About his returning to France, heartbroken, and being told by his mother that there was merit in the priest's declaration, that there had been a terrible rupture in the family, because one branch traded in slaves and the other found the practice unacceptable. About how Bob returned to Havana and explained his history to the priest, who then blessed his marriage.

About his six siblings (by then we were at Les Oliviers, Bob talking faster and faster to say it all): Marc, an archivist in Paris; Jacques, between Paris and Lyon, doing this and that; a couple of sisters; another brother; and *then* Philippe, dear Philippe, four years older than Bob, and the one he talked to the least because he thought about him the most. "Philippe," Bob said, "is my greatest friend. He is half of my soul."

When Bob was growing up, every member of the family worked in his father's boulangerie at Christmas and Easter. Bob had emerged with a refrain: Everyone deserves good bread. It was like a calling or a social imperative. A *boulanger* can be counted on by the people he feeds.

Once, I asked Bob, "Which of your breads makes you the proudest?"

No hesitation. "My baguette."

"Really? The French eat ten billion baguettes a year. Yours are so different?"

"No. But mine, sometimes, are what a baguette should be."

Bob took one and brought it up to the side of my head and snapped it. The crack was thunderous.

The word *baguette* means "stick," or "baton," the kind that an orchestra conductor keeps time with, and wasn't used to describe bread until the Second World War, probably—and I say "probably" because there is invariably debate. (There is even more about how to define a baguette: Should it weigh two hundred and fifty grams? Two seventy-five? Do you care?) Tellingly, the word appears nowhere in my 1938 *Larousse Gastronomique,* a thousand-page codex of French cuisine. Until *baguette* became standard, there were plenty of other big-stick bakery words, like *ficelle* (string), and *flûte* (flute), and *bâtard* (the fat one, the bastard). It doesn't matter: it is not the name that is French but the shape. A long bread has a higher proportion of crust to crumb than a round one. The shape means: crunch.

When I made baguettes, I was astonished at both the labor and the unforgiving economy—you pull off a small piece of dough and weigh it on an old metal scale, roll it out, grab one of the *couches* from a pole to let it rest, let it rise again, slash it, bake it, and then collect ninety centimes for your efforts. The slash is effected by a light slice with an angled razor blade, *une scarification,* done so weightlessly that you don't crush the loaf. But I had trouble with the slash—I couldn't do it without exerting pressure, just as I couldn't roll out the dough without squishing it. Bob had a touch that seemed to be lighter than air; he left no fingerprints.

The result was irresistible. Once, when we were having lunch at Le Fleurie, Bob directed my attention to a woman on the far side of the room: well dressed, gray hair in a bun, eating by herself. She was removing a sliced baguette from the basket and meticulously putting it, piece by piece, into her purse, where there appeared to be a napkin to fold it into. She closed her purse and put her hand up for a waiter's attention: *"Plus de pain, s'il vous plaît."* More bread, please.

I popped into the boulangerie late one morning. Bob was in the back. No one else was there. I waited several minutes before he walked out.

"I was on the phone with my mother. My brother Philippe. He had an aneurysm this morning. He is dead."

Il est mort.

Bob was pale, flat eyes, no affect, able to relay the news but seemingly unable to understand what he was saying. "He is fifty. He *was* fifty. An aneurysm. This morning."

Bob left to attend the funeral. When he returned, he was ponderous, in manner and movement. One morning, he didn't show up at the boulangerie. Another time, I watched him standing by a streetlight, seeming to stare at nothing. The light changed, then changed back. He didn't cross. His thoughts were like a black tide moving back and forth inside his head. I feared for him.

"I have to change my life," he told Jessica. "I must make Lucas a partner." Lucas was the first baker Bob employed who had his lightness of touch. "I have to share the workload."

He seemed to have instantly gained weight. He wasn't sleeping. The nights, he said, were the hardest: "That's when I think of him. I have never been closer to a human being, those nights, making bread."

One Saturday night, as Bob mourned, a kid threw a rock at the back-room window, shattering it. On Saturday nights, everyone comes into Lyon. It is noisy and drunken, and stuff happens. On this particular Saturday, Bob was in the back, thinking of his brother. The broken window was an affront. Bob, apparently, gave chase down the Quai Saint-Vincent.

Is it possible that Bob thought he could catch the vandal? By what impulsive leap of the imagination did he regard himself as a sprinter?

The quai there was badly lit, the curb stacked with boards left over from a construction project. Bob tripped and fell and broke his leg. He had to pull himself back onto the sidewalk to avoid being run over. Bob, whose work means standing on his feet, had to give up the boulangerie for an inconceivably long time.

Roberto Bonomo, the quartier's Italian chef, was in touch with Bob and provided updates. After a month, he was still supine, Roberto told us, but the break seemed to be healing. Bob had attempted walking with crutches.

I began preparing a dinner for his return, a *grande cuisine* dish that I had been practicing, *tourte de canard* (duck pie). Bob needed some love and affection. He would, I was sure, really like a piece of pie.

The boulangerie continued—Lucas's bread was flawless—with

one persistent problem: the flour kept running out. Lucas didn't know how often Bob ordered it. In most bakeries, you buy flour in bulk; it is always there, you don't think about it. But Bob got his flour from small farmers who valued its freshness. It was, in effect, milled to order. He might get some at the beginning of the week. On Friday, he would ask for more. Or on Wednesday. The deliveries would be stacked by the staircase: forty big, dusty sacks, fifty. Lucas, suddenly without flour, had to close until the next delivery.

One Sunday, Roberto threw a party, only his regulars, his best food, the best wine. Bob promised to come, Roberto said: "He'll be on crutches, but he'll be there." When we turned up, Bob hadn't arrived yet. Babysitter issues, Roberto said.

Bob died while we were drinking wine and eating bruschetta. A clot developed in the leg, came loose, rushed up an artery, and lodged in his lungs. He knew at once that he was in fatal trouble. Jacqueline called an ambulance. He was unconscious before it arrived.

I learned this in the morning. I rushed down to the boulangerie. I didn't know what else to do. I opened the door, and the bell jingled, and Ailene, one of Bob's helpers, came out from the back, because it was the routine to come out at the sound of the bell. She saw me and stopped, lower lip trembling, holding herself still. I thought, *If she carries on as though nothing has changed, if Lucas makes the bread at 3 a.m. and she sells it, can we all pretend that Bob is still at home recuperating?*

The bell jingled, and one of the quartier's restaurant people appeared, a waiter. He was bald, quiet, thin, one of the five people who ran Chez Albert, a purple-painted place, decorated with chicken images, that served good, unradical food. The waiter was bearing a large bread sack that needed filling. He handed it to Ailene and said he'd pick it up later.

"*Bisous à Bob.*" Kisses to Bob.

"Bob is dead." *Bob est mort.* The waiter stood, unmoving, taking in the simple, declarative piece of news. *Bob est mort.* He didn't ask Ailene to repeat herself. He didn't ask how or when or where. The questions would have been an evasion, an effort to fill this sudden void with noise.

"*Putain de merde,*" he said finally. A nonsense phrase. Two bad words in one, as though it were the worst thing you could say. Or it was just what you say when you don't have the words.

When you live on a river, you are never not thinking about it. You see it on waking, hear it in nighttime barges that slice through it, feel it in the dampness of the air. It's never the same—rising, rushing, sinking, slow in fog, thick in the summer—and is also always the same. Bob used to throw his unsold baguettes into it. Only now does it occur to me that, with bread that he had made single-handedly, he couldn't do the obvious and put it out with the trash. He seemed to need to replicate the making of it in its unmaking, tossing the baguettes, one by one, as if returning them to nature for the birds and the fish.

Bob had held the quartier together, a community of like-minded food fanatics, and when he died we briefly considered returning to the United States. We didn't, we couldn't, until finally, after five years in Lyon, we went back for many reasons, including the fact that our children, who could read and write in French, were having trouble speaking English.

I returned the following year on my own, to visit Lac du Bourget, the largest lake in France, a piece of unfinished business. I spent the night at La Source, a farmhouse turned into a restaurant with rooms, which was run by a husband-and-wife team, members of the Maîtres Restaurateurs, a chefs' collective committed to making as much as possible from scratch: butter churned by hand, fresh ice cream daily.

At breakfast, I scooped up butter on the tip of my knife and tasted it. It was fatty and beautifully bovine. The bread was curious. It had been sliced from a rectangular loaf and, to my prejudiced eye, looked store-bought and industrial. I had a bite. It wasn't store-bought. *Wow,* I thought. *This is good bread.*

The flour, the owner told me, was from Le Bourget-du-Lac, on the other side of the lake. The name of the miller was Philippe Degrange. I wrote it down. It didn't seem right. A grange is where you store your grains. Degrange? It would be akin to buying milk from a guy named Dairy.

I drove to the town and got a coffee. At the bar, I Googled "Degrange"—and there he was. Minoterie Degrange. What was a *minoterie*? I looked it up. "Flour mill." It appeared to be within walking distance. I set off.

After half an hour, my doubts returned. The addresses were erratic, and the street—flower beds, trimmed hedges, garages for

the family car—was unequivocally suburban. Was there really an operation here, milling only local grains? But then, just when I decided to turn back, voilà! In the shade of tall trees, half obscured by thick foliage, was a small letter-slot mailbox, no street number but a name, Minoterie Degrange.

The trees and a high metal gate, covered with graffiti, hid whatever was behind. Next to the mail slot was a speaker box. I pressed a button.

"Oui?" the speaker box said, a woman's voice.

"Bonjour," I told the box. "I have eaten a bread made from your flour, and I would like to meet the owner, Monsieur Degrange?"

Nothing.

"But it's lunchtime," the box said finally.

"Of course. I'm sorry. I'll wait."

Another protracted silence. Then the gate opened and revealed an industrial yard, completely out of keeping with its neighbors. A man emerged, round and robust, with a factory foreman's forthrightness, wiping his mouth with a napkin. He looked at me hard.

"Monsieur Degrange?" I confirmed. "Please excuse me. I ate a slice of bread that was made, I believe, with your flour, and it reminds me of the bread that my friend Bob used to make."

He pointed to a car: "Get in."

I got in.

"It's all about the flour," he said. "I'll take you to Boulangerie Vincent."

The boulangerie, a few miles down the road, was also a bar and a pub and a restaurant with tablecloths. The door opened directly onto the *four* and a cooling rack built against a wall. The top rows were for *boules* ("balls," the ancient way of bread baking), about thirty of them. On the bottom were *couronnes,* massive, each fashioned into a ring like a crown. A woman, carefully dressed, affluent in manner, was negotiating with the bread guy.

"*Mais, Pierre, s'il vous plaît.* Just one *boule,* please. I have guests tonight."

"I am very sorry, madame, but every loaf has a name attached to it. You know that. If you haven't reserved, I can't give you one."

"He does two ferments," Degrange whispered, "and starts at seven in the evening. The bread needs ten hours. Or twelve. Sometimes fourteen."

Inside, men were gathered around a bar—electricians, cable

people, metalworkers, painters, *mecs*. The room roared with con-
viviality. Degrange ordered us *diots*, a Savoyard sausage, and a glass
of wine, a local Mondeuse. Through the door to a kitchen, I saw
hundreds of *diots*, drying in the air, looped by a string. They were
cooked in a deep sauté pan with onions, red wine, and two bay
leaves, and served in a roll made with Degrange's flour.

It had the flavors that I had tasted at breakfast. I asked for an-
other roll, broke it open, and stuck my nose into *la mie*, the crumb
—Frederick's routine. It smelled of yeast and oven-caramelized
aromas, and of something else, an evocative fruitiness. I closed my
eyes. Bob.

"You recognize it," Degrange said. "It comes from wheat that
grew in good soil."

"Where do you get it?"

"Small farms. Nothing more than forty hectares."

Small farms, he explained, are often the only ones in France
with soil that hasn't been ruined.

"Where are they?"

"Here in Savoie. And the Rhône Valley. They grow an old wheat,
a quality wheat. And the Auvergne. I love the wheat from the Au-
vergne. Everyone does. The volcanic soil, the iron-rich dirt. You
can taste it in the bread."

We drank another glass of Mondeuse. Degrange proposed that
we go back: "I want to show you the factory."

A Degrange has been milling flour here, or on a site closer to
the river, since 1704. Until modern times, the operation was pow-
ered by water; on a wall was an old photo of Degrange's father and
grandfather, seated before a mill paddle wheel three times their
height. There are no mill paddles today. The process is whirringly
hidden in pipes and generators and computer screens—except
for the source material, freshly picked wheat that is tipped out
from hydraulically raised trailers. I followed Degrange up ladder-
like stairs to the third floor, where he opened the cap of a pipe
and retrieved a cupful of a bright-golden grain.

"Taste."

It seemed to dissolve in my mouth, creamy and sweet and long
in flavor. "What is it?"

"Wheat germ."

I wanted to take some home. "You'll have to refrigerate it," he

said. "It is like flour but more extreme. It has fat, which spoils rapidly."

He described conventional flour production—the sprawling farms in the French breadbasket or the American Midwest, their accelerated-growth tricks, their soils so manipulated that they could have been created in a chemistry lab. "The bread that you make from it has the right texture. But it doesn't have the taste, the *goût*." He asked an assistant to bring him a baguette, then tore off a piece, smelled it, and looked at it approvingly.

"In the country, we don't change as fast as people in the city," Degrange said. "For us, the meal is still important. We don't 'snack,'" he said, using the English word. "What I learned from my father and grandfather is what they learned from their fathers and grandfathers. There is a handing off between generations." The word he used was *transmettre. Le goût et les valeurs sont transmis.* Flavor and value: those are the qualities that are transmitted. Only in France would "flavor" and "value" have the same moral weight.

Degrange gave me a ten-kilo bag of his flour. A gift. I said good-bye, an affectionate embrace, feeling an unexpected closeness to this man I had reached by intercom only a few hours ago, and who instantly knew what I was talking about: *goût.*

I was flying home in the morning and reserved a *boule* at the Boulangerie Vincent. I contemplated the prospect of arriving in New York bearing bread for my children which had been made near the Lac du Bourget earlier that very day. On the way to the airport, I stopped to pick it up. It was dawn, and there were no lights on inside, just the red glow from the oven. My *boule* was hot and irresistibly fragrant.

In New York, I cut a few thick slices and put out some butter. "I think you'll like this," I said.

Frederick took a slice and sniffed it and then slammed it into his face, inhaling deeply: "It's like Bob's."

George ate a slice, then asked for another and spread butter on it.

When the loaf was done, I made more from the ten-kilo bag. It was good—not as good as the *boule* from the Boulangerie Vincent, but still good. It had fruit and complexity and a feeling of nutritiousness. A month later, it was gone, and I stopped making bread.

PRIYA KRISHNA

How to Feed Crowds in a Protest or Pandemic? The Sikhs Know

FROM *The New York Times*

INSIDE A LOW, brick-red building in Queens Village, a group of about thirty cooks has made and served more than 145,000 free meals in just ten weeks. They arrive at 4 a.m. three days a week to methodically assemble vast quantities of basmati rice, dal, beans, and vibrantly flavored sabzis for New York City hospital workers, people in poverty, and anyone else in search of a hot meal.

This isn't a soup kitchen or a food bank. It's a gurdwara, the place of worship for Sikhs, members of the fifth-largest organized religion in the world, with about twenty-five million adherents. Providing for people in need is built into their faith.

An essential part of Sikhism is *langar,* the practice of preparing and serving a free meal to promote the Sikh tenet of *seva,* or self-less service. Anyone, Sikh or not, can visit a gurdwara and partake in langar, with the biggest ones—like the Golden Temple in Amritsar, India—serving more than 100,000 people every day.

Since the coronavirus pandemic has halted religious gatherings in most of the country, including langar, gurdwaras like the Sikh Center of New York, in Queens Village, are mobilizing their large-scale cooking resources to meet the skyrocketing need for food aid outside their places of worship.

Some are feeding the protesters marching in outrage over the killings of George Floyd and other Black Americans by the police. Last week, a dozen or so volunteers from the Queens center served 500 portions of matar paneer, rice, and rajma, a creamy, comforting dish of red beans stewed with tomatoes, and 1,000 bottles of

water and cans of soda to demonstrators in Sunnyside. They also offered dessert: kheer, a sweetened rice pudding.

"Where we see peaceful protest, we are going," said Himmat Singh, a coordinator at the World Sikh Parliament, an advocacy group providing volunteers for the Queens Village efforts. "We are looking for justice. We support this."

Since the pandemic began, soup kitchens have had difficulty keeping up with demand. Shuttered schools and even fine dining restaurants are using their kitchens to prepare and serve hot meals. But few other places are as well positioned to handle the sheer scale of assistance required right now as the gurdwaras. Most have large, well-equipped kitchens, a steady stream of volunteers, and no shortage of ingredients, thanks to regular donations from community members.

During the last annual Sikh Day Parade in New York, in April 2019, the Queens Village kitchen—which has a walk-in cooler, multiple freezers, 50-liter stockpots, and a huge grill that can cook dozens of rotis at once—produced 15,000 meals in a single day.

The Sikhs' biggest challenge isn't keeping up with demand. It's letting people know that they're here—without making a big show of it or proselytizing, which is forbidden.

Founded in the fifteenth century in Punjab, India, by the spiritual leader Guru Nanak, Sikhism has an estimated 500,000 followers in the United States and 280 gurdwaras, according to the Sikh Coalition, a civil rights organization in New York City. One of the most visibly distinctive features of the Sikh practice is the turban—a symbol of the religion's belief in equality—though not everyone chooses to wear one.

Sikhs in America have often been prey to bigotry, hate crimes, and Islamophobia, particularly since 9/11. A few volunteers said in interviews that before going out to distribute meals, they worried that they might hear ignorant comments. But Santokh Dillon, the president of the Guru Nanak Mission Society of Atlanta, said the people he serves are often more puzzled than prejudiced. Most have never even heard of Sikhism, he said.

When some find out that the meals are free, "They look at us and say, 'You are kidding, right?'"

At least eighty gurdwaras in the United States are now providing food assistance. For many, the transition has been quick and seamless.

This is not just because the infrastructure is already there, said Satjeet Kaur, the executive director of the Sikh Coalition. "The call to action and the responsibility" for helping others is deeply entrenched in the Sikh way of life. Sikhs are expected to donate at least 10 percent of their time or income toward community service.

It took the Gurdwara Sahib of Fremont, California, just a few days after suspending religious services in March to set up a meal and grocery delivery program, and a drive-through meal pickup system outside the gurdwara.

Cooks wear gloves and masks, and the kitchen is big enough for workers to stand more than six feet from one another. As at most gurdwaras, the menu changes regularly, but is typically Indian and always vegetarian. (Meat is not permitted in gurdwaras.)

While these Sikh volunteers, known as *sevadars,* are experts in mass-meal preparation, they aren't as accustomed to spreading the word. The Fremont kitchen has produced 15,000 to 20,000 meals a day on holidays like New Year's Eve, said Dr. Pritpal Singh, a member of the gurdwara. But now, the gurdwara is serving just 100 to 150 people each day.

Dr. Singh said he hoped that more people in need would come pick up food. "We could do hundreds of thousands of meals if given the task," he said.

But with the demonstrations unfolding around the country, Sikhs aren't waiting for people to come to them any longer. On Tuesday, volunteers from the Gurdwara Sahib attended a protest in Fremont and handed out several hundred bottles of water as a show of solidarity.

On a recent Friday, Gurjiv Kaur and Kiren Singh asked the volunteers at their gurdwara, the Khalsa Care Foundation, in the Pacoima neighborhood of Los Angeles, to prepare meals in the community kitchen that they could take to the protest. The next morning, they and others picked up about 700 containers of pasta with a garlic- and onion-laden tomato sauce and 500 bottles of water from the gurdwara, and set up a tent in Pan Pacific Park. Soon, protesters started arriving at the tent with other donations, like medical supplies, snacks, and hand sanitizer.

"It is our duty to stand up with others to fight for justice," said Ms. Kaur, a graduating senior at the University of California, Irvine. "Langar at its core is a revolution—against inequality and the

caste system," the antiquated hereditary class structure in South Asia, which Sikhism has always rejected.

In Norwich, Connecticut, volunteers from five gurdwaras handed out a few hundred bottles of water to protesters last Tuesday, and on Friday, distributed as many containers of rajma, or kidney beans, and rice on a Main Street sidewalk, a block from City Hall.

Swaranjit Singh Khalsa, a volunteer and a member of the Norwich Board of Education, noted that historically, many Sikhs in India have been killed by the police while fighting for their civil rights.

At many gurdwaras in the United States, most of those who show up for langar meals are Sikhs. Now that they are catering to a broader population, menus have changed to suit different tastes. In the Seattle area, volunteers at the Gurudwara Sacha Marag Sahib are making pasta and tacos in addition to rice and dal.

At the Hacienda de Guru Ram Das in Española, New Mexico, meals have included enchiladas and burritos. Still, Harimandir Khalsa, a volunteer, said the community kitchen is operating at less than 10 percent of its capacity.

"I think it is about convenience," Mr. Khalsa said, as the gurdwara isn't centrally located. "If we had a food truck parked in front of Walmart that said, FREE FOOD, we could get more takers. But for people to get in their cars and drive over to this place—people aren't that desperate yet."

Location is also an issue for the Guru Ramdas Gurdwara Sahib in Vancouver, Washington, as the neighborhood doesn't have much foot traffic, said Mohan Grewal, the gurdwara secretary. So every other Sunday, volunteers pack up 300 to 400 meals made in the gurdwara and drive them to the Living Hope Church, a Christian congregation six miles away, in a more urban part of the city.

One of the biggest challenges for gurdwaras is that many hospitals, shelters, and other charitable organizations they'd like to help don't take cooked food because of hygienic concerns, or accept it only if it meets certain health codes. Many Sikhs have started collecting and distributing pantry items in addition to making meals.

Still, some gurdwaras are bustling. In Riverside, California, a hub for the Sikh population, volunteers from the United Sikh Mission, an American nonprofit aid group, and the Khalsa School Riverside, a children's program, serve 3,000 to 5,000 meals every day

at the Riverside Gurdwara. People line up in the drive-through as early as 9:30 a.m., even though it doesn't open until 11:30.

The process is highly systematized. The cooking team shows up at 5:30 a.m. to prepare meals based on previous days' numbers, as well as requests from senior centers, hospitals, and nursing homes; another team packs the meals into microwave-safe boxes; and the third distributes them at the drive-through and other locations. The gurdwara shares information about the free meals through regular posts on large Facebook groups for local residents.

"We didn't just sit there and say we are going to cook and wait for people to come," said Gurpreet Singh, a volunteer for the United Sikh Mission.

Since the protests, Mr. Singh and others have been reaching out to Black organizations, like churches, offering to drop off meals or groceries. They expect to see an increase in people showing up for meals, as thousands have been attending protests in the area.

Groups like United Sikhs, an international nonprofit, are helping to get the word out. They have stepped up efforts to identify areas of need, connect gurdwaras with organizations seeking assistance, provide best practices for food preparation during the pandemic, and mobilize Sikhs to help feed protesters.

While the pandemic continues, a few gurdwaras aren't using their kitchens. Tejkiran Singh, a spokesman for the Singh Sabha of Michigan, west of Detroit, said the gurdwara committee decided it was too risky to start a meal distribution service, especially since Michigan has become a hot spot for the coronavirus.

When the Sikh Society of Central Florida, in Oviedo, reopens on June 14, services will be limited to fewer people, and food will be handed out in to-go containers as they leave.

But Amit Pal Singh and Charanjit Singh, the chairman and the treasurer of the Sikh Society of Central Florida, also want to continue the drive-through and delivery services they developed during the pandemic.

"The concept of langar is to serve the needy," Mr. Pal Singh said. Before the pandemic, he said, most people participating in langar were local Sikhs coming more for social and religious reasons than out of need. The drive-through and deliveries will allow them to put meals into the hands of people who struggle to afford to eat.

That will mean a lot of extra food for volunteers to prepare, in a city where the Sikh population is still small. But none of that seemed to worry Mr. Pal Singh.

"We would love to be in that situation," he said, his optimism vibrating through the phone. "We will handle it."

The Fed-Up Chef

FROM *The New York Times Magazine*

THE MEAL COST $400 and came with rules. No. 1: No using cell-phones, except to document the dinner and the chefs preparing it. "Please do the Instagram, the Facebook, the Twitter; give me the fame, I need the fame," said Gaggan Anand, whose restaurant bore the same name. Clad in black, with a booming voice that suited his hulking figure, he stalked between a vast kitchen island and an L-shaped table for fourteen. "Those of you with good cameras, if you can take a photo of me scratching my ass, you get a bottle of Champagne."

Rule No. 2: "If this is on your 'Things to Do in Bangkok' list, you're in the wrong restaurant." Anand wore his hair in a messy bun; he sounded like a principal scolding a group of wayward adolescents. "If you are here to judge me, you are in the super-wrong restaurant, because we are [expletive] judging you." He went on: "This is not a, what do you call it?"—his fingers curled into air quotes—"'fine dining experience.'"

More rules preceded each dish. (There would be twenty-five.) No smoke breaks. "I'm not antismoking," he said, "but my nose is very particular, and your smoke will change my nose." Limits on trips to the bathroom. "The first hour is all belted in," he said. "After that, we will not give toilet breaks"—the meal would last the usual five hours—"but if you have to, just go quickly and come back. Think of this as a nonsmoking flight with no Wi-Fi, no network, and it's an Indian airline, so nothing works and it's very turbulent. You might be crashing soon, so you'd better enjoy."

Anand says it was around this point in his customary spiel that

one evening last fall, a woman got up and walked out. But on the night I visited the restaurant last December, there were only nods of assent and ripples of nervous laughter.

Anand, the most famous Indian chef in the world, delights in subversion. "Lick it up," one of his staple dishes, looks like spray paint but tastes like India, a schmear of pulverized herbs and spices that, indeed, he demands you lick directly off the plate. Scallop "curry" comes ice-cold, sans gravy, with puffs of curry-infused ice cream. "Asteroid," a charcoal-dusted morsel of sea bass with a molten core of roe, is his version of the fish cutlets he saw a woman frying in a charcoal-fired wok, on the street in the rain, the last time he visited India. Even his menu is outré: for years, it has been composed of only emoji, no text.

Last August, after receiving two Michelin stars and landing the fourth spot on the 2019 World's 50 Best Restaurants list, Anand did something remarkable: fed up with being micromanaged by his financial backers, he left the restaurant that made him famous, called Gaggan, and started over with the new one, Gaggan Anand. (His financiers had the rights to his first name but not the last.) "I've never seen anything like it," says David Gelb, the creator of the Netflix documentary series *Chef's Table*. "Traditionally, when you have a star chef, as investors, you support them." Gelb's show, in 2016, is what turned Anand from relative obscurity—an Indian chef in the middle of Thailand—into an emblem of defiance and a food-world antihero.

More twists followed. In February, Anand, who is forty-two, divorced his wife of seven years. (They have a four-year-old daughter.) March brought the coronavirus and subsequent lockdown. Then on June 1, Anand reopened his restaurant with a new protocol for sanitization and social distancing; by mid-July, owing to Thailand's relative success in responding to the pandemic, he was able to take down the plexiglass shields between seats. These days, he helms the chef's table six nights a week, unmasked. "I ask the guests' permission," he told me in September, "but they're also not wearing masks, so."

Around the world, Anand's peers have responded to the pandemic's privations by dabbling in lower-cost, higher-volume spinoffs to make up for lost revenue. In Copenhagen, for example, René Redzepi transformed Noma, which formerly charged close to $400 for a tasting menu of gastronomic curiosities like edible

soil, into a wine-and-burger bar. (The cheeseburger goes for about $18.) While Anand experimented with cheaper offerings, seeing others push comfort food intensified his commitment to haute cuisine. "I would love to open a fried-chicken restaurant or some stupid [expletive] like that and kind of survive," he says, "but I don't want to give up fine dining."

He fired no one. He hired ten new employees. "I'm still able to pay my staff," he says. "We are not sinking, yet."

Reality looms. Michelin devotees with money to burn and airline miles to accrue made up a significant portion of Anand's customer base. Before the pandemic, 80 percent of his business came from international tourists; now, because Thailand requires foreigners to quarantine for fourteen days, almost all of his customers are locals, and he has changed his business model accordingly, slashing prices by 40 percent, adding a $50 lunch, and subtracting ninety minutes from the chef's-table experience ("locally, they have less patience"). "That brought in people who thought we were unapproachable," Anand says. But this month, he raised prices "because it's not sustainable." (Lunch now costs $100.) Fine dining the world over faces the same problem. International travel is severely limited, as William Drew, a director of World's 50 Best Restaurants, points out—and it "will be for the foreseeable future."

On that evening last December, Anand served crumbles of cumin and tamarind that looked like Pop Rocks. He made each guest at the chef's table use a middle finger to eat a savory miniature doughnut; he described a dish of pork vindaloo as "a little Portuguese, a little Indian, and none of either." "If you tell me to make a chicken curry and naan, I will tell you to get the [expletive] out of here," he said. He poked; he prodded. In order to get a reservation at the chef's table, you had to have filled out a questionnaire that included prompts like "Tell us about an embarrassing moment in your life" and pick one of five songs you'd sing with abandon if asked to do so (among the options: "I Want It That Way" by the Backstreet Boys and "Chop Suey!" by System of a Down). "You're a gastroenterologist?" Anand asked one diner. "Can you tell me why my sous-chef farts so much?" On one wall, hot-pink tubes of neon spelled out Anand's axiom: BE A REBEL.

Toward the end of hour four, it was time to sing. The group consensus: "I Want It That Way." Anand gave everyone the side-eye

but obliged. A minute in, he switched to "Chop Suey!," turned up the volume, and started playing air guitar.

If you are an Indian who lives outside of India, you get used to people casually disparaging your food: "too smelly," "too spicy," "too heavy." Compliments are generally reserved for chicken tikka masala, a dish believed by some to have been invented by a Bangladeshi chef in Glasgow sometime in the '70s. You get used to seeing your food in chafing trays and foam containers. You get used to eating one thing at home and something completely different at a restaurant, which probably charges $9.99 for its lunch buffet ($12.99 on Saturdays and Sundays), because what kind of person —Indians included—would deign to pay much more than that for Indian food?

At least, that was how it was for me, a first-generation Indian American growing up in New Jersey in the '90s. According to Khushbu Shah, the restaurant editor of Food & Wine, in the last decade, Indian restaurant food has undergone a renaissance, thanks largely to the Indian diaspora and the internet, which enabled the access to new sources of inspiration. At Sydney's Don't Tell Aunty, Jessi Singh serves sea urchin biryani, a marriage of coastal Australia and his native Punjab; at Los Angeles's Badmaash, the brothers Nakul and Arjun Mahendro offer chicken tikka poutine, a nod to their Toronto hometown, where their dad, Pawan, ran an Indian restaurant of his own.

Chefs in India have also evolved. In 2008, Manish Mehrotra persuaded the head of the hospitality firm for which he worked to let him do a tasting menu at a new space in New Delhi. "At least two guests a night would read the menu and walk out, saying, 'We don't understand, and you don't have butter chicken on the menu,'" Mehrotra told me in 2015. Last year, World's 50 Best named Mehrotra's Indian Accent the best restaurant in India. Indian Accent also has an outpost in New York, where a $125, ten-course tasting menu might include blue cheese–stuffed naan.

Anand, however, does more than mash-up Indian standards and Western ingredients. He creates dishes that defy easy categorization, like his mango-infused pâté of foie gras dressed with Japanese oak leaves. "You don't see Indian food the way that he does it," Shah says. "You talk to any wealthy South Asian in that hemisphere

of the world, it becomes a priority to get to his restaurant. Gaggan is one of the few that made it in the fine dining world. There are really not that many."

Anand grew up in poverty outside Kolkata. "That scene in *Slumdog Millionaire* where the guy would [expletive] on top and it would fall on the next guy's head? That's why I have dandruff," he says. He watched his mother prepare simple dishes, like fish fry and chicken masala (without the cream found in chicken tikka masala). "My mom could have taken a cart and made money," he says, "but women in India back then were not supposed to work, or she didn't have the confidence to do it."

He went to hotel-management school—culinary institutes are relatively new in India—and from there to jobs in hotel kitchens. He married, started a catering company that quickly flopped, and spent a year delivering food on a bicycle, making twenty-five cents an hour, before his brother finagled a job for him in 2003, running the cafeteria of a telecom company's office in Kolkata. "I learned how to use $1 to make a meal that will satisfy a person," Anand says.

In 2009, he spent two months at Ferran Adrià's Alícia Foundation in Spain. By this point, Anand had divorced his first wife and moved to Bangkok to do some consulting for an Indian restaurant there. That job led to his first fan, Rajesh Kewalramani, whom Anand says encouraged him to open his own place and offered to help finance it. Gaggan opened in 2010.

His stint in Spain inspired him to reimagine the humble food of his roots. He learned how to manipulate liquid nitrogen and carbon dioxide, how sodium alginate and calcium chloride could turn olive juice into an opalescent olive sphere. "If Ferran could do that with an olive," Anand says, "I figured I could change yogurt." What the olive is to Spain, yogurt is to India: emblematic, iconic, a thing not to be messed with. The dish Anand came up with is now a mainstay on his menu: the "yogurt explosion," a seemingly normal dollop of yogurt on a spoon that explodes in your mouth, a flavor bomb of cumin and dried mango powder contained by a layer of diaphanously thin gelatin.

Anand characterizes his food not as Indian but as "Gaggan Anand." "If you're from India," he says, "you will feel either disgraced, like, 'Why are you touching my cuisine?' or you will say,

'Wow, you really changed my food forever.'" Just as Mehrotra does, he thinks Indian cuisine has an image problem. "Indians have let their food be defined by what the world wants from them: chicken tikka masala because of the British, Goan fish curry because of the Portuguese," Anand says. "As a chef, it's a disgrace that I sit with Japanese, French, and Italian chefs, and they talk about fine dining, and I'm like a donkey, just sitting there. They will always value a French dish more than an Indian dish. They don't care what techniques you use. I get so angry."

After seeing Anand's *Chef's Table* episode in 2016, I went to dine at Gaggan, which occupied a nineteenth-century townhouse about four miles from his new restaurant, a modern building draped with greenery. Sitting in the main dining room, I could not see Anand holding court at the chef's table, but I could hear him (until he turned up a Foo Fighters song). At the end of the night, I saw him by the door and asked for a selfie; he obliged. I had come expecting the best Indian meal of my life, and it was moving to see the food of my ethnicity executed with such finesse. But more than the food, Anand himself left me in awe, an Indian chef with swagger, chutzpah, and enough star power to warrant an 8,000-mile journey.

While the pandemic precludes this sort of pilgrimage, it has strengthened the pull of chef-performers like Anand, who, on Instagram, toggles between stylized photos of his greatest hits and unvarnished videos that show him making, say, a burger from refrigerator odds and ends. He has figured out how to be at once relatable and bucket list-y. "People still have a huge appetite, perhaps even more of an appetite, for special experiences," says Drew, from World's 50 Best. "It may take a while before they travel the distances that they may have in the past. They may be more discerning. But I don't think they're going to stop eating."

For a certain type of gourmet, getting a reservation at a place like Gaggan Anand will always justify the cost of a trip. Last year, Truong Mai, an investment banker I met at Gaggan Anand, traveled from his home in Maryland to Michelin-starred restaurants in Hong Kong, Singapore, San Sebastián, New York, Belgium, Paris, the Netherlands, and, of course, Bangkok. He's eaten at Anand restaurants twenty times. "My first truly world-class meal was Gaggan in 2012," Mai told me. "That's why I hold him so dear."

*

The second time I met Anand, in Los Angeles in May 2019, he had soured on Gaggan. For two years, he had been talking publicly about his plans to close it in 2020 and open a new one in Japan. (This plan has since been abandoned.) He felt he had to churn out the same dishes over and over again, to appease the Yelpers, selfie seekers, and critics. "At my new restaurant," he said, "there will be a sign: WE DON'T MAKE FOOD FOR TIRES." He said he had no respect for Michelin and its rankings. "They will always send a French or a Brit to my restaurant who might have spent time in India but would not know India like an Indian would, and they will never give me a fair judgment." Because of the Eurocentric palates of the reviewers, he said, "it's impossible for me to convince them how good I am." He claimed he no longer wanted the fame. "If this is what being a celebrity means," he said, "I want [expletive] none of it. I'm tired."

He was in town to headline the Los Angeles Food Bowl, a monthlong festival. Five hundred people came to the Wiltern Theater to hear him speak. On Memorial Day, he took over an outdoor bar in the arts district and posted an invitation on his Instagram account: "whole world welcome." He and his staff had prepared enough pulled pork vindaloo and papri chaat nachos to feed 600 people, but two hours into the six-hour event, most of their supplies were gone. Anand emerged from the kitchen to address a line that wrapped around two blocks. "I [expletive] love you all for waiting!" he hollered. His fans hollered back, angling for selfies. He seemed to love it. It was hard to believe that he didn't want this anymore.

Then came the rupture last July, when Kewalramani and his two financial partners apparently tried to oust him from Gaggan while he was vacationing in Austria. Once Vladimir Kojic, Anand's head sommelier, informed him of the investors' plans—"They called a town-hall meeting, like they're Google," Kojic told me—Anand gave his staff of seventy-one an ultimatum: walk with me, and we start over, or stick with the suits. All but five went with Anand, effectively shuttering the restaurant. Anand says his investors objected to his practice of hiring top talent from abroad, which required costly work visas. "I'm from Serbia," Kojic says. "We have chefs from Chile, Brazil, the United States. Why did they come to

Thailand? It's not for the money. It's for Gaggan." Anand's former partners did not respond to my repeated requests for comment.

"It's not an easy thing to do, to leave your partners," says Massimo Bottura, Anand's friend and the chef of Osteria Francescana (three Michelin stars). But Bottura says he probably would have done the same thing. "My chefs are like my brothers and sisters. The team is more important than anything."

The past seven months have given Anand an opportunity to immerse himself in a local market he took for granted. "We ignored our immediate 50 kilometers for a decade because we were in the fame run," he says. "Our reservations were full; we didn't give a [expletive]. We are now more connected to the community, to foodies who may not have been able to afford us. I'm looking for more Thai products and more local farmers."

But he refuses to steer away from fine dining, no matter how unsettled the environment. Last December, he offered to drive me to the airport. He showed up an hour late. Though Bangkok thrummed with traffic, he ignored Waze. "It's a calculated risk," he said, adding that if that bet proved wrong, I'd see his "dark side." I made my flight.

LIGAYA MISHAN

Once the Disease of Gluttonous Aristocrats, Gout Is Now Tormenting the Masses

FROM *T: The New York Times Style Magazine*

IT HAS COME for genius and aristocrat, conqueror and king. Like a succubus, it descends at night, first as a fevered dream, then pain in darkness, the body turned rude animal, reduced to its lowest, humblest extremity: the foot, red and swollen, throbbing like a heart. You are left to hobble, if that; the flutter of a bedsheet over the distended foot is anguish enough, let alone the full weight of the body bearing down. To take a step is to see the abyss. Often the pain is concentrated in the big toe, ridiculous, stubby and chubby, Napoleonic, *the fat piggie sent to market*. So acute is the sensitivity of this bloated hallux—"so exquisite and lively," in the words of the seventeenth-century English physician Thomas Sydenham, chronicling his bouts with the disease—that the faintest footfall of a sympathetic visitor is a gunshot straight to the nerve. The American poet and novelist Jim Harrison, writing in 1991, likened his throes to those of "a wolf with the steel teeth of a trap buried in its paw." It will not help, at such a moment, to recall that Alexander the Great, Charlemagne, Leonardo da Vinci, Isaac Newton, and Henry James reportedly suffered thus, and that you have joined, in your abasement, the noblest ranks.

The disease can be chronic (the pain goes away but may return at will) and excruciating (if not fatal), yet say its name—gout—and people snicker. It has a whiff of the powdered wig, of a time when the powerful could continue to rule the world even half incapac-

itated, with one grotesquely tumescent foot lolling atop a dainty cushioned stool, like some priapic cartoon. The phallic symbolism is inevitable, especially since the condition predominantly afflicts men—the eighteenth-century British Queen Anne, shown groaning from a gout-inflamed leg in Yorgos Lanthimos's 2018 film, *The Favourite,* was a notable historical exception—and in keeping with the belief that attacks were triggered by wanton appetite, whether in bed or at table. In fact, genetics are most often the culprit and sex has nothing to do with it, although diet can play a part: If, in breaking down food for digestion, the body produces more uric acid than the kidneys can filter out, the excess may form microscopic, dagger-shaped crystals that stiffen in the joints and trigger inflammation. The foods most likely to contribute to these inner stalagmites are high in the chemical compound purine, among them venison and foie gras, pheasant and scallops, goose and caviar. In short, a grandee's banquet.

As the British and American historians Roy Porter and George Sebastian Rousseau write in *Gout: The Patrician Malady* (1998), the disease, cast by some as "a quasi-deity born of the union of Bacchus and Venus," appeared to reach epidemic proportions in eighteenth-century England as more people attained affluence. A 1703 treaty with Portugal flooded the market with imported wines, which were stabilized for the voyage across the sea with extra alcohol, often aged in leaded vessels—just enough lead to inhibit kidney function, if not bring down an empire. A critic of the upper classes might have found gleeful rough justice in the gouty punishment of a prosperous glutton, while the victim took solace in the pain as a mark of high status. The rich are always easier to mock than overthrow.

We might dismiss gout as a specter from a fable, which it was: in the works of the seventeenth-century French poet Jean de La Fontaine, Gout latches onto a poor man and then, appalled by her host's ceaseless labor, retreats to a life of idleness in a mansion. Surely it's a relic of a less enlightened, more hierarchical age, which we can laugh at from the safe distance of the present day. But the American cultural critic Susan Sontag warned us in the 1970s against illness as metaphor. And there is no safety: The disease has not been banished to the past, nor is it any longer the exclusive insignia of rich white men (if it ever really was). From the 1960s to the 1990s, the number of sufferers more than doubled in

the United States, and that's continued to rise. If some cases seem to confirm the notion that food is to blame—the actor Jared Leto was diagnosed with gout after gaining sixty-seven pounds for the 2007 film *Chapter 27*—note that vegans, too, have been stricken. According to data collected by the National Health and Nutrition Examination Survey (NHANES), as of 2016, around 9.2 million American adults, 5.9 million men and 3.3 million women, were living with the disease, making up 3.9 percent of the adult population, and another 32.5 million (14.6 percent) exhibited hyperuricemia, elevated levels of uric acid, putting them at risk.

No one knows exactly what's behind the numbers. The rich keep getting richer, but there's been no corresponding spike in sales of historically gouty luxury foods like veal and foie gras; if anything, their appeal has waned with increasing concerns about the ethics of producing them. Red meat consumption in the United States has significantly decreased since the nineteenth century, recent fad high-protein diets notwithstanding, and Americans (or at least those with the privilege and resources to do so) have become more self-conscious about how and what they eat, both spawning and spurred on by a multitrillion-dollar wellness industry. Some scientists point to the dramatic rise in rates of obesity—from 13.4 percent of adults in 1980 to 42.4 percent in 2017–18, again per the NHANES—since excess weight depresses kidney efficiency, and to the likely not unrelated introduction, in 1967, of high-fructose corn syrup, which can cause the body to produce higher levels of uric acid, and its wholesale embrace in the early 1980s by the American food industry and then the world. Once gout was confined largely to Western civilization (with some outliers, like the Mongol ruler Kublai Khan); now its ravages are global.

The Greek physician Hippocrates in the fifth century BC knew the disease as *podagra*, from the roots for "foot" (*pous*) and "catching" or "seizing" (*agra*). Its modern name comes from the Latin *gutta,* a drop of fluid, a term first recorded in the thirteenth century by an English monk, suggesting that the body's phlegm had overflowed and flooded the joint—not so far-off from the actual surfeit of uric acid. For early doctors, the question was: Is the condition endogenous or exogenous; does it come from within or without? A satirical print from 1799 by the British caricaturist James Gillray suggests both, showing a fire-snorting demon with its fangs sunk

into an engorged foot. The rest of the body is unseen, irrelevant, without agency or personality. But as the British art critic Tom Lubbock noted in 2005, it's not clear if the creature has sprung onto or emerged from the foot: "Tormentor and tormented are one," he wrote.

The idea that the disease might be self-inflicted was a way to exert control over what was, once an attack started, uncontrollable, and to give the pain meaning, as a path to edification and redemption, since for centuries, sacrifice of earthly pleasures was the only relief. Premodern medical treatments—apart from colchicine, a plant extract applied by the Byzantine physician Alexander of Tralles in the sixth century and still used today—were largely ineffective: leeches, diuretic purges, poultices of fermented ox dung, ointments of boiled dog, glugs of treacle, and, in one 1518 prescription, a roasted goose stuffed with "chopped kittens, lard, incense wax and flour of rye. This must all be eaten, and the drippings applied to the painful joints." In Sydenham's 1683 treatise on the disease, for the sudden onset of violent symptoms he recommended laudanum—a tincture of opium and alcohol—to take the edge off the pain; his own blend was steeped with saffron, cinnamon, and cloves. Formulas like this helped spawn a market in patent medicines, sold out of suitcases by bamboozlers promising miracle cures. The British historian Richard Barnett has even traced a line from another Sydenham gout treatment, distilled alcohol laced with the likes of horseradish and wormwood—that is, bitters—to contemporary cocktail culture.

If gout is but a historical footnote (forgive the pun), it has nevertheless occasionally caused a tiny flutter in world events, because its victims have so often been men of power. In 1552, Charles V, Holy Roman Emperor, had to delay his siege on French-held Metz while he grappled with the disease, giving the enemy ample time to fortify the city. His armies repulsed, he slunk back to the Low Countries and, a few years later, gave up the throne. The British statesman William Pitt, first Earl of Chatham, was a fervent champion and defender of the young American colonies in the late eighteenth century, but when gout confined him at home, less sympathetic members of Parliament took advantage of his absence to rally support for the Stamp Act of 1765, imposing the first direct tax on the colonists, and then the infamous Townshend Acts, which taxed tea, among other goods. Revolution followed.

More recently, after Paul Manafort, the American political consultant and former campaign chairman for President Trump, was convicted in 2018 for financial fraud, he was rolled into court in a wheelchair for a sentencing hearing, his right foot in bandages without a shoe, felled by what his lawyers described as "severe gout." Some observers suspected that this was just a ploy for leniency; Manafort ended up getting less than four years instead of the recommended nineteen to twenty-four (three and a half years were added later for separate charges, though he was released this past May to serve the remainder of his sentence at home, because of concerns about the coronavirus). But others saw the disease's sudden public manifestation as an emblem of our indulgent epoch. Katy Schneider, writing in *The Cut,* pointed out Manafort's fondness for fine clothes—like the $15,000 ostrich-leather jacket entered into evidence during the trial, one in a series of wardrobe purchases totaling nearly $1.4 million over six years—as part of a pattern of overconsumption. Of course he got gout.

It's tempting to see gout as an avenging angel, come to condemn greed and put the lie to dreams of dominion without consequences; to strip the rich of their glamour, in this age when we worship and despise them in equal measure. Imagine Bobby Axelrod, the brazen, Metallica-shirted finance god of the Showtime drama *Billions,* losing his cool over a wayward foot, limping instead of prowling through his glass penthouse. Writing of the romantic aura of tuberculosis in the nineteenth century, Sontag argues that, metaphorically, gout was TB's antithesis: The gout-ridden were guilty of consuming too much, while those dying of TB were themselves consumed, eaten away from the inside (thus the disease's popular name, consumption). Wasting away from TB was taken as a sign of elegant, otherworldly interiority, with poets considered suspect if they weighed a hundred pounds or more, and so "it became rude to eat heartily," Sontag writes, reinforcing a strange hierarchy in which the tubercular's hollow cheeks and haunted mien prevailed as the desired look for women, while great men "grew fat, founded industrial empires, wrote hundreds of novels, made wars, and plundered continents." As incidences of gout have increased, so has economic inequality: according to the Pew Research Center, in the decade since the start of the Great Recession in 2007, the

wealthiest Americans, those in the top quintile, gained 13 percent in median net worth, while the rest lost at least 20 percent.

But this is coincidence, not correlation. For all its historical freight, gout cannot be explained as an indictment of a lifestyle or an era. It's likely that in those centuries when the disease was hailed as the wages of fortune (and thus a perverse sort of honor), the anguish of the gout-ridden poor was simply ignored or credited to less distinguished causes. Misdiagnosis can still be a problem today: The Brooklyn-based composer Mark Phillips, now thirty-nine, experienced his first attack at thirty and suffered without treatment for half a decade because the doctors he saw couldn't believe that gout would present in someone so young and lean. Friends likewise scoffed, while his agonies mounted; at one point he thought, *I don't want to live for another fifty years with this pain.* What now holds his symptoms at bay is a daily dose of allopurinol, a drug developed in 1963 by the American biochemists Gertrude Elion and George Hitchings (who went on to win the Nobel Prize in Physiology or Medicine). For decades it has been the gold standard, even as the proliferation of cases has spurred the growth of a therapeutics industry projected to reach $10 billion by 2026.

The disease remains mysterious in its onset. Beyond genetic factors, high-fructose corn syrup poses a greater danger than a lobe of foie gras, cutting across class lines. Brewer's yeast is high in purines, so indulging in something as populist as beer is another risk. Even an ascetic approach may not save you. Beans—a staple throughout lockdown during the coronavirus pandemic—have been known to elevate uric acid (although plant-based purines pose a lesser risk than animal-based ones, and the effect is probably outweighed by their health benefits). For those predisposed to the condition, what might be the cost of these past months as we all hunker down, forgo the perils of a questionably ventilated gym, and eat and drink our sorrows away?

Still, it's hard to resist a metaphor. It imposes order on the arbitrary, purpose where we might succumb to futility. If gout is just a matter of birth or chance, what then? One victim, who asked to be nameless, was perplexed by his fate, given his fairly temperate habits, until he read that hyperuricemia had been found in a small number of patients (less than 2 percent) in clinical trials of Viagra, approved for erectile dysfunction in 1998 but also used off-book as

a recreational drug for sexual enhancement. No proof of causality exists, but the possibility, however tenuous, gave him a strange sense of relief. He could view his affliction as "karmic retribution," he said, for leading what he called an "opulent" life. "It wasn't opulent in the sense of eating rack of lamb and drinking thirty beers a night, like a king," he said. "But this is my price to pay."

Like a fugitive from another century, he accepts gout as his punishment, and through the crucible of suffering is refined. It's the smallest of consolations. But far worse to believe that there is no moral to the story—that pain is just pain, and we have no answers.

This Is the Dumbest Foodie Battle of Our Time

FROM *Slate*

BAD NEWS FROM the foodie frontlines: the apparently endless war over recipe headnotes—those introductory riffs of varying length that often appear before the "ingredients" list, chatty versions of which are a hallmark of online cooking blogs—has flared up again.

On Saturday, reporter Kathryn Watson broke a precious, too-short peace: "I hate recipes on the internet," she volleyed. "I do not care about your cute little story and pictures. Just tell me the ingredients and how I'm supposed to turn them into deliciousness." The ensuing skirmish has roiled all week.

If you just got shivers of déjà vu, it's because we had this exact fight *last* February, when historian Kevin Kruse tweeted, to great virality: "Hey, cooking websites! I don't really need a thousand words about how you discovered the recipe or the feelings it evoked for you. Ingredients, steps, total time for prep and cooking. That's it. I'm trying to feed my family. No need to curate the experience for me." Chelsea Peretti made the same jab in November 2018, just three months after Rekha Shankar satirized the personal headnote in *The New Yorker*'s humor column.

By this point, it's clear that the disagreement over the value of headnotes is an internet Forever War. But why is this the case? What is it about a few (or many!) paragraphs of anecdote and context from a recipe's author before her (free!) recipe that foments such intense division and durable, viral rage?

For one thing, food bloggers face the same problem all writers

for the web do: context collapse. We don't write for publications
that will be read only by our subscribers, our subscribers' house-
guests, or, possibly, people waiting for a train who got hooked by
a snappy coverline and shelled out for a newsstand copy. (Ah, the
good old days!) The advantage of this situation is reach; the disad-
vantage is also reach.

The blog-style recipe headnote is trying to forge connection
with a dedicated audience—a basic function of writing, and es-
pecially of writing in the internet era. The goal, or at least part
of the goal, is to build a kind of community *around* food, rather
than simply a database of ways to make it. But the tone and con-
tent appropriate for this audience-building leaves recipe bloggers
open for ungenerous reading and sniping from fly-by browsers. As
researchers Elzbieta Lepkowska-White and Emily Kortright found
in a 2018 study of successful female food bloggers, the ones that
succeed establish "emotional attachment," along with "trust, cred-
ibility, and professionalism," with readers. But those posts that do
such a good job connecting with longtime fans will also reach give-
me-my-casserole searchers. People who followed along with *Pinch
of Yum*'s Lindsay's super-sad, and super-personal, birth story posts
in 2017 will be reading her recipe for Instant Pot Pot Roast right
alongside those who just want the facts, ma'am.

Of course, food bloggers also want to survive as small, click-de-
pendent businesses in a crowded marketplace—how presumptu-
ous!—and headnoting has become part of the game. After last
year's dustup, Chloe Bryan pointed out on *Mashable* that food
bloggers are trying to convince Google's algorithm that they have
"authority" and should be returned near the top of the search re-
sults when we type in "vegetarian meatballs," apparently without
a moment to spare. Bloggers may add more content to the top of
the recipe—tips, advice, or step-by-step pictures and videos (one
of my own pet peeves)—to demonstrate to the Machine that theirs
is a site that offers value. The headnote is also a place to insert key-
words that potential readers might use to find recipes.

Bloggers know many people are annoyed about their headnotes
and are annoyed right back. Julie Wampler, of the *Table for Two*
blog, let fly in an epic May 2018 post: "The State of Blogging: It's
No Longer Fun." "I get so many comments about, 'I don't care
about your life, just give me the recipe,'" Wampler wrote. "Dude,

that's bad. I don't even think it's an attention span thing. I think it's a lazy thing." A commenter replied, proving my point about context collapse quite neatly: "I'm one of those horrid people who Just Wants a Recipe . . . I'm not a short attention span operant conditioned 'millennial': I'm someone for whom the internet is primarily an information resource, because the offline things I do don't leave all sorts of *disposable time* for wandering the aisles of the internet." But a blog post with a recipe in it is always going to be a hybrid, offering information along with the option of con-nection. Yes, some of that charming/distracting story is there for SEO, but it's also just the nature of the genre.

Some of the staying power of headnote hate has to be attributed to misogyny—even though some notable headnote critics have been women. Deb Perelman of *Smitten Kitchen*—a classic, and ex-tremely successful, "here's my story, now here's the recipe" food blog—replied to last year's flurry of complaints in a thread: "It's mostly women telling these stories. Congratulations, you've found a new, not particularly original, way to say 'shut up and cook.' (I just don't see the same pushback when male chefs write about their wild days or basically anything. Do you?)"

The replies to any of these viral anti-headnote tweets are hon-estly the best argument for Perelman's theory. Reporter Olivia Nuzzi replied to Kathryn Watson: "Gotta tell you about my divorce and my sorority sisters first sorry." Every joke, with few exceptions, about the kind of headnote people just *despise* centers around a woman's boring domestic life: a woman saying annoying things about her "hubs" and children, telling a dumb story about her dog, or rhapsodizing clumsily about her sponsors' products. *God, Mom! Just let us eat our muffins in peace!*

Is there any hope for moving our culture beyond this impasse? Well, if you just can't with some lady's chitchat, and your scroll wheel is broken, there's the Recipe Filter extension for Firefox, or Paprika Recipe Manager, with its handy SAVE RECIPE button, or a quick control-F for "Ingredients."

Or better still, we could engage in a little critical thinking about genre and venue. Kevin Kruse, for his part, apologized last year in a statement to *Food52*'s Emma Laperruque, saying that he had learned a lot about the issue since his tweet went viral. For any given web annoyance, there are reasons. Headnotes build audi-

ence, allow for expression, and connect food to life. There are better ones and worse ones, but there are better and worse tweets too. As hacky and boring as a given "meditation on my lemon tree" headnote may be, complaining about it online is—in the blessed year of 2020—even hackier. For the love of cooking, let's call a truce.

SOLEIL HO

SF Restaurant's $200-Per-Person Dome Is America's Problems in a Plastic Nutshell

FROM *The San Francisco Chronicle*

WE KNEW THIS was coming: I knew it, you knew it, anyone who didn't get a federal stimulus check knew it. In lieu of aggressive public policies that would actually take care of the people who make up this country during a massive global pandemic, we now have plastic dome-covered tables and quirky improvised patios being erected outside of restaurants—solutions that beleaguered restaurateurs have slapped together to prevent their businesses and employees' livelihoods from being completely wrecked as we enter the seventh month of this thing.

The domes in question are at fine dining restaurant Hashiri, which is offering $200-per-person seatings inside the structures to offer "safety and peace" in Mint Plaza, an area near Fifth and Mission Streets where many people, both unhoused and housed, often congregate. The striking image immediately ignited debate among readers, garnering dozens of responses when I solicited thoughts on social media. The domes look a bit difficult to keep clean, some said; others decried the cartoonish way the domes dramatized the city's wealth inequality, while expressing empathy for a restaurant industry pushed to such desperate measures.

I think what really gets people going about the dome is that it's a perfect symbol of the complete inadequacy of our social safety net: in a queer reversal, the dome is a shield against, not for, those who need sheltering the most.

Its shape and transparency are both a visual echo and rebuttal to the multicolored rows of dome-shape tents that line the streets of downtown San Francisco: An unhoused person's tent is erected in a desire for opaqueness and privacy, a space of one's own, whereas the fine dining dome invites the onlooker's gaze as a bombastic spectacle. The unhoused people who walk the streets of the nearby Tenderloin, who sleep and eat and gather their worldly items in the alcoves of buildings and under awnings, already live in a state of absolute visibility; for the housed, being seen eating on the street or in a park is a premium experience, especially now.

Reader Maura Chen, an architectural designer and urbanist, likened the domes to a restaurant pop-up that took place in Toronto last year, where diners ate dinner in heated glass domes under an expressway where multiple homeless encampments had been evicted and demolished during a citywide crackdown on such encampments. The cost breakdown for the event, which will of course be coming to San Francisco in 2021, is $199.99 to reserve a dome and $109.99 per person to eat.

Like the glass domes in Toronto, Hashiri's setup entirely centers on the comfort of the consumer, Chen wrote to me. "This disgustingly ostentatious version is so unapologetic about its protection of the customer and prioritizing of the consumer's life over the folks preparing food or caring for those consumers." Each one has to be completely sanitized between seatings, and staff must flit between the tables and the restaurant kitchen during service.

Food truck owner Victor Guzman, of La Santa Torta, said the dome is disrespectful toward those who need the community's help. "We should care for one another, not dispose of the less fortunate ones," he said. "This makes us sad!"

Several others mused that, if they have to go through all this trouble to eat out and feel protected from the virus, then takeout seemed like a less troublesome option. If culinary variety and a night of no dishes are what you're after, takeout works fine.

When I think about what I miss about restaurants, it's not the act of being served that I miss: It's the element of surprise that greets me whenever I'm out, whether that's in some new dish or seeing a familiar face emerge from the kitchen or learning that the food runner and I were at the same concert the night before. It's in the interactions that lingering begets. To have masked restaurant workers put themselves into harm's way just to change out my

silverware feels like the wrong answer to that yearning that I think many feel for the old way of life.

But right now, it's the only answer that some restaurateurs can think of. Hashiri tried takeout, the manager told the *Chronicle,* but it hasn't been working. Plenty of other restaurants are in a similar position. The Paycheck Protection Program loan money, said to be earmarked for American small businesses, is all gone, and some will have to start paying those loans back as early as October. Restaurants that have been fortunate enough to receive those loans must start making enough money to pay them back, and that often means expanding their services beyond takeout and delivery.

Those who can't, close. Since the start of shelter-in-place, dozens of well-known restaurants have already permanently shut their doors, and an innumerable amount of food workers have been left adrift, without affordable health insurance during a global health crisis. It feels like a mass culling.

Accepting the optics of domes and other such structures is the bind that restaurants are finding themselves in right now. The pricey domes—each costs more than $1,000—are a gamble. They, along with the improvised patios, are an investment that might not even pay off if, say, the Department of Public Health decides to clamp down on outdoor dining again.

"I have mixed feelings on these domes," wrote reader Jenny Kim. "I feel for the entire restaurant industry during this pandemic. I understand they are trying to find creative solutions in order to survive. But these domes also seem symbolic of all the inequities in our city."

That's why, even though the visual drama of the dome is so easy to grasp and the villains in this scenario seem fairly clear, it's important to step back and consider why such measures are being taken.

We're talking about domes because our nation's pandemic response didn't take advantage of the lessons learned by other nations; because our health-care system isn't accessible to people at all income levels; because there is no stimulus for the undocumented immigrants who feed the country; because restaurant staff and owners are forced to police diners' mask wearing themselves to protect everyone around them from harm; and because both restaurateurs and working-class people who cannot do their jobs

remotely have had to choose between their health and their live-lihoods.

We're talking about domes because this country doesn't take care of us.

"Can we hotbox them?" Instagram user @oldmaninthebay wrote to me of the domes. "Like I honestly would if it were allowed." Sometimes you have to laugh to keep from crying.

MACKENZIE CHUNG FEGAN

All Brandon Jew Wants Is for Chinese Restaurants to Know Their Worth

FROM *Resy*

WHEN A CHINESE auntie pays you a compliment—perhaps lauding your intelligence or admiring your rosy cheeks—there are a few acceptable responses, none of which is "Thank you." *Méi yǒu,* meaning "not have," is a straight-up negation. *Nǎlǐ, nǎlǐ* literally means "where, where," as if the intended target of the praise must be lurking behind you. Another modest reply, one particularly useful if someone compliments something you have cooked, is *māmǎhūhū,* which means "so-so."

Mamahuhu is also the name of Brandon Jew's latest restaurant, which he opened in collaboration with Ben Moore and Anmao Sun earlier this year, serving American Chinese food made with sustainably sourced ingredients. As opposed to his more upscale flagship restaurant Mister Jiu's, which is in the heart of Chinatown, Mamahuhu is located in the Richmond, a residential neighborhood with a large Chinese population. Jew lives there now, in the same house that Jew's father grew up in. While a branding expert would probably advise against naming your restaurant "Just Okay," Mamahuhu is a tribute to the Chinese ethic of humility. Please, try my food. It probably isn't very good. If it is, I just got lucky.

My mother and her siblings also grew up in the Richmond, and my grandfather lived nearby in the Avenues until he passed away three years ago. He was the Henry of Henry's Hunan, one of the first regional Chinese restaurants in San Francisco to find popu-

larity among non-Chinese audiences. The original location, a non-descript hole-in-the-wall on Kearny Street in Chinatown, departed from the Cantonese-influenced dishes familiar to Americans. Instead, my grandparents served up the rustic, spicy food they remembered from home, dishes studded with chiles, house-smoked pork, and fermented black beans. In 1976, *The New Yorker* called it "the best Chinese restaurant in the world." I wasn't born yet, but my grandfather probably replied, "Nǎlǐ, nǎlǐ?"

In 2016, Mister Jiu's opened four blocks away from the original Henry's Hunan location, long since closed, and two blocks from the one on Sacramento Street, currently shuttered due to COVID-19. Jew took over the 10,000-square-foot space formerly occupied by the banquet hall Four Seas, a grand, table-clothed affair with swagged drapery and golden lotus chandeliers. As acclaim for Jew's cooking grew, garnering him a Michelin star and a spot on *Bon Appétit*'s Hot 10 list, I insisted my mom and I go next time I returned home from New York. She was dismissive. Twenty-two dollars for dumplings? Over a hundred for Peking duck? Those were white-people prices.

"I encounter that too, even from my own family," Jew commiserates, sitting under the skylight at the Moongate Lounge, one floor above Mister Jiu's. Chairs are overturned on tables. Sectional sofas are askew. Mister Jiu's and Moongate Lounge haven't served customers indoors in more than four months. He wears a Gallic striped T-shirt and a black face mask. Culinary tweezers—a kitchen tool as foreign to my grandfather as a zoodler—poke out of his apron pocket.

Jew also encountered skepticism from his family about his intended career path. "A chef was the last thing my family wanted me to be," he says, echoing the experience of all Asian non-doctors and non-engineers in America. "My grandma was like, 'Absolutely not. I did not come to this country so you could be a cook.' It took a lot of convincing." Jew goes on to explain that, actually, his work as a chef is intellectually rigorous, encompassing research and the history of Chinese cuisine and advocacy. I gently point out that he doesn't have to make the case to *me* about why being a chef is a worthy career. "Yeah," he chuckles, "that's probably my family speaking."

*

As for convincing my own mother, I launched a lobbying campaign to bring her around to Mister Jiu's. Why, I asked her, did she value Eurocentric cuisine above her own? As someone comfortable paying $10 for spaghetti and meatballs at a red-sauce joint or $50 for bucatini with shaved truffles at a high-end restaurant, why did she think that Chinese food had to be a bargain? I argued that by ghettoizing the foodways of a particular culture—whether Chinese, Mexican, or Ethiopian—she was making a statement about which cultures are valuable and which are not.

"The prices are driven by two things—the ingredients that we're using, and the labor that goes into creating the dishes and keeping them consistent," Jew explains. He rejects the notion that the labor and skill required for classical European cookery are somehow more complex than Chinese cuisine. "In my professional career, I learned how to cook French and Italian food before I learned how to cook Chinese," says Jew. "If you're poaching chicken for a French galantine? You're trying to cook it really gently so that jelly forms under the skin, and the meat stays perfect. When I learned how to poach a chicken Chinese-style, I was like, 'This is the same thing!'"

As for the ingredients, Jew's approach can be attributed to his time at Zuni Café, Quince, and Bar Agricole, bastions of California cuisine driven by seasonality and local produce. But it can also be traced back to his grandmother. "My mom's mom lived in Chinatown, she shopped in Chinatown, she went to church in Chinatown," says Jew. "She ate like food was medicine, and would go to crazy extents to get exactly what she wanted. Going to the market, touching and examining the ingredients—that's how I was taught professionally, but it's also just how Chinese grandmas do it."

Many of those ingredients used at Jew's restaurants come from local farms run by his peers—first- and second-generation Asian Americans interested in connecting to their roots through food. One of his suppliers, Radical Family Farms in Sebastopol, is run by Leslie Wiser, a queer mixed Taiwanese-Chinese-German American who farms Asian heritage vegetables like celtuce and Chinese mustard greens. "There is this expectation that Chinese vegetables should be extremely cheap," says Wiser, "and that's coming from within our own communities, from the aunties. Our customers are not the OG immigrants. They're like me—the children of immi-

grants who are interested in heritage cooking and cultural recla-
mation."

For Wiser, farming is a way to fight back against the process of
assimilation—she had never tasted a bitter melon before she grew
one last year—while deepening her relationship to her own cul-
ture. Cooking plays a similar role for Jew. "The more I learn about
Chinese cuisine," he says, "the more I'm fascinated by the depth
of its history, the techniques and observations that have passed
from generation to generation. Chinese culinary traditions have
the same worth as any other culture's cuisine, and when I cook,
I remember the people who came before me. I want to celebrate
this food, and give it its due worth."

My mom and I did eventually go to Mister Jiu's, and although
there was still some low-key griping about portion size, she ended
up having a great time. She loved her fancy cocktail and artfully
plated dessert—not something on offer at her favorite neighbor-
hood spot on Clement. She gushed over the quail stuffed with
sticky rice and lap cheong. She even fist-bumped the waiter. We
were seated next to three white men in their fifties who, overhear-
ing us talk about the family business, politely interjected. They
had a standing Thursday night dinner at Henry's Hunan, but this
week, they decided to check out Mister Jiu's instead. They seemed
to have no qualms about spending $25 a person on a Chinese
meal one week and $100 the next.

There's a scene in *The Joy Luck Club*—not that everything relates
back to *The Joy Luck Club,* but it kind of does—where An-mei's
mother grabs the strand of pearls given to her daughter by a du-
plicitous rival in an attempt to win An-mei's favor. She smashes
the pearls, exposing them as cheap fakes, and warns, "Know your
worth."

What Jew is doing in the kitchen is dynamic, inspired, and reso-
lutely delicious. But it's not revolutionary. Applying time-honored
techniques and sourcing high-quality ingredients is something
Chinese chefs have been doing for millennia. What is revolution-
ary is that Jew demands his due. He charges $16 for a vegetable
stir fry because those vegetables were organically grown by an
Asian American farmer, and cooked by someone who knows how
to handle a flaming hot wok. That deserves respect.

Asserting our worth, taking up space, insisting that our cuisine

is as valuable as cuisine from Western Europe—these are battles of Jew's, Wiser's, and my generation. Our immigrant parents and grandparents, already steeped in a culture that prizes humility, learned not to draw attention, or ask for too much, in order to survive. Don't own your excellence; insist the food you cooked is just mǎmǎhūhū and maybe they'll let you stay. But the next time someone pays me a compliment, I'll answer, "Thank you."

Close to the Bone

FROM *Orion*

AUTUMN'S FIRST COOL night seeps through the sky's scrim like ink on fine paper. Orion's belt straps the eastern horizon to a winsome San Juan Range. The animals are moving. Across our mesa, through stands of scrub oak and piñon. From timbered, meadowed high country to red, chalked desert below.

It's archery season in southwestern Colorado, and just beyond our fence line, H has taken a buck with a recurve bow. The animal hangs gutted and upside down in the shed while our three-year-old daughter toddles in circles on the tarp beneath it. The feet of her pink fleece onesie are soaked in fresh blood; the air is cast iron, sharp with the sanguine scent. Ruby's hungry. But there's work to do—skin and quarter, scrub bone saws and knives. Dinner's a long way from being on the table.

I go to the house to get a snack for her, and when I return to the shed, she's dragged a barstool onto the tarp and is standing on it, palming the swaying buck for balance, her eyes trained on the trunk, the piece of exposed flesh dangling above her. Before I can protest, she grabs the nearest side of the rib cage and ascends the bones like ladder rungs—climbing until she's eye level with the bit of meat. She swings out, snaps once at blank air. Swings and snaps again. This time her teeth make contact, tearing away the prize as her slick feet shoot out from under her, as gravity pulls her off the animal, the stool. I lunge to catch her in my arms. Cradled, Ruby looks up at me, her hazel eyes now shining the deepest green.

Her mouth: gnashes, swallows, grins.

*

Five years after this feral moment, my daughter declares herself vegetarian. I respect her choice; it's based on sentience and suffering. When she's thirteen, a mealtime turns tense when a neighbor's lamb simmers in the stew I've just made; that I've cooked my daughter a veggie version doesn't assuage. I try to reason with her. We're meant to eat meat! The animal was raised locally, sustainably, humanely! She says those reasons pale in the face of droughts, fires, floods. Mass extinctions and forced migrations.

As she stomps off to her room, I wonder, *Isn't this the age where we should be at loggerheads over curfews, boys, and clothes?*

Ruby is fourteen when the romance of summer withers. Charred and beetle-infested trees scrape at a dim sky, skeletal and smoking. Deer drag themselves across open valleys, tongues out and lolled. Cows barge through barbed-wire fencing and trail it like a bride's veil in their quest to find something edible. But they live, at least. They scavenge what wildfires don't devour.

Here in the American Southwest, the now-naked ground reveals hundreds of ancient spear points, arrowheads, and hand tools once buried in bunch grass and pasture. Quartz, jasper, and obsidian wink like SOS mirrors, an alphabet of artifacts spelling out a story of survival. The fine, fluted edges, impossibly sharp ends. The patience it required to knap such thick, rough stones down to near ephemera.

Pierce. Skin. Scrape. Every sharp edge honed for the hides of animals.

Three weeks after Ruby's fifteenth birthday—for which we grilled portobellos and lit candles on a rainbow unicorn cake to commemorate her coming out as queer—I'm riding a scrappy, one-eyed horse that has carried me through the Altai Mountains of western Mongolia. Our group of riders and the two camels who carry our gear descend from the mountains by way of a wide, dry valley full of coarse sand and jumbled stones made smooth by a now-gone river. Spread across the flats are half a dozen *gers,* or felt-wrapped yurts, whose inhabitants own the herds we dodge en route—sheep, goats, camels, yaks, and horses, all of them feasting on the unimaginable—spiny cacti or brittle, leafless bushes. Weaving my way through the animals, I wonder where they watered; our horses haven't had a lick of moisture since they ate snow the

day before. But the horses don't seem bothered. They trot right
through the foraging creatures with soft liquid eyes. Or eye, in the
case of my mount.

We halt our horses near the ger of the single ranger who patrols
the mountains here. I pat my horse's neck and stand in the stirrups,
swing my right leg over to meet my left for the dismount. Before
my boots hit the ground, what sounds like a toddler mid-tantrum
blares from behind. I turn to see a goat—small, ruddy, and pro-
testing—gripped at the horns by a young herdsman. He straddles
the goat, steering the horns like handles on a tricycle toward our
camp, where he hands off the goat to an older man as if handing
off a dance partner on the ballroom floor. The older man stoops,
cradles the goat's neck with one arm, and brings it in close. The
goat bleats softly in the man's ear. The man inhales, and his dry,
leathered face turns unguent. When he pulls his knife from its
sheath and draws it across the animal's throat, he could be a cellist
in an orchestra, drawing his bow across the receptive instrument
whose curves he knows like a lover, like his own heart.

A few of the riders in my group turn away, but I've crept in close
for a better look. The man pulls the half-severed head back from
the neck as the creature's knees go to ground. Blood spills. Papery
stalks of grass bend under the deluge—the first moisture they've
had in months. Visible in the rush of red is the gaping rubbery
end of the goat's windpipe, the clean cross section of a spinal cord
encased in small, stacked bones.

Before our ancestors socked away the extra protein and fat that
eating meat provided, their bodies burned through a dispropor-
tionate amount of energy to harvest and digest a largely plant-
based diet. We likely began to eat meat—at least larger game—by
scavenging from carcasses killed and eaten by hyenas and African
wild dogs. (We know this from the tapeworms in our intestines,
derived from those that once lived inside these two predators.)

The sloppy seconds, along with the parasites that came along
with them, turned out to be critical to the perpetuation of our
species. The extra calories powered and grew our predecessors'
brains like no other food source could. Like rich cream in a
bucket of milk, early humans rose to the top of the food chain.
They grew more inventive, more creative. They honed tools from

stone, painted art in caves—images of animals so masterful that Picasso declared we've since failed to achieve any better.

Our bellies and minds may have filled up on flesh, but we hungered still. For hunting grounds, firewood, a steady supply of water. When we'd secured the basics, we lusted after shells, turquoise, other tribes' wives. Over time, every luxury came to feel like a necessity—a thing we'd kill for, feast on, even if it were the last of its kind.

That appetite has yet to be sated.

I thought I was prepared. For long days in the saddle, harsh steppe winds, the hit-and-miss of water. In Colorado we cross high mountain passes, wind through deep river valleys, brave flash floods and bullying storms, just to get haircuts and medicine. I thought I knew what it meant to inhabit and move through such big, bony country, but I could not have prepared for the absence of fence line and roads. There are no gates to open, no cattle guards to tiptoe over. No signs that read NO TRESPASS. I've never seen land so undivided, so unaccounted for.

The day our plane descends from what the Mongolians call the Eternal Blue Sky, when my friends and I get our first glimpse of the Altai—its sprawl of steppe lands as rugged and remote as a fading dream—we are looking out at all of Europe, the Middle East, Asia. My mind nearly atomizes, trying to take it all in. From the heart of this range, we can meander any one of hundreds of valleys and end up in Russia, China, Kazakhstan. What hunger Genghis Khan must have had, to see the world and want the whole of it.

The landing gear drops and, with it, my heart. The landscape is gargantuan, but it is also gaunt—every square inch bald and barren, its fate far worse than lands at home. I knew better, that thanks to climate chaos, Mongolia is in swifter decline than most countries, but I had romanticized anyway, as white Westerners tend to with far-off places. I arrive at the Altai imagining a land virtually unchanged since the last ice age, teeming with limitless grasslands, countless spools of rivers, and a wondrous, wild bestiary. In my mind, the only thing missing is the mammoth.

But greenhouse gases were already gathering overhead when, in 1991, the Soviet Union dissolved. With it went programs that had buoyed Mongolian nomads whenever their herds were thinned by

a lethal *dzud*—a winter so brutal it kills the hardiest of animals. We're talking about beasts who forage through several feet of snow in forty below Fahrenheit and enter springtime not looking much worse for the wear. The time between two such winters has shortened. In the most recent dzud of 2018–19, nearly a million herd animals were lost in a country of just three million people. The nomads had a choice: either migrate to the edges of the nation's only metropolis, where they'd find themselves unemployable and burning rubber tires to stay warm, or stay in the outback and run larger herds to make up for the losses. The latter, for many, appealed —in part because the world's appetite for cashmere sweaters and scarves has turned voracious. Now, thanks to weather and wool, overgrazing has left Mongolia looking like carrion picked clean.

This, as the blood-red mercury rises. By as much as 4.5 degrees Fahrenheit over the past forty years—more than double the global average.

Two and a half million years ago, the earth warmed and dried. Withered flowers yielded no fruit, thirst-laden plants and trees bore few nuts and seeds. This is when animal bones are first found in or near human shelters, with marks made by human teeth.

How it must have been. To kneel in the dirt before a day-old hyena kill, with one eye and ear cocked behind you in case the pack came back for more. The hide peeled back to reveal a warm, wet mass of pink flesh, gamy and slightly fetid. Our senses would have burst like fireworks—the fear, revulsion, greed, pleasure—as we buried our faces, probed with mouth and tongue. The whole thing, like the first time a woman opens her legs to you, like a delta in a desert, or a canyon grotto, the damp places where animals go to quench their thirst. Now you are the animal, and you are going down. You are feasting and you are alive and this place where death and hunger merge feels dangerous and taboo.

You'll see then how we were created to consume. To ingest animals who once possessed a brain, who coursed with blood, who sang passions in the echoing chambers of the heart. It was a symphonic, if not sacred, commingling. A first communion. After that gorging: your face—flushed and looking at other human faces that looked back at you in the same way—predatory and streaked in scarlet.

We would never be the same again.

*

The man lays the nearly headless goat down on the bloody, dung-dappled ground and slices the belly open. Entrails are pulled, hurled at the tight circle of herd dogs. Another man arrives with a steel pail filled with small rocks straight off the fire, white with heat, which he procures with tongs and stuffs into the goat's body. Together they thread a large crude needle with a long strand of dried sinew—the same stuff that was tacked on my horse for reins and bridle. A third man delivers a small blowtorch, with which they scorch the fur. Bare, blackened, and stinking, the goat's carcass cooks from the inside out. Stomachs mewing like pitiful newborn felines, we wait.

It's not long before the goat is hoisted onto our folding table, the stitches are pulled, rocks removed from the cavity. Our host, the park ranger who's just installed nearly a hundred trail cameras in hopes of catching Russian and Chinese poachers, invites us and the herdsmen, his sons, to help ourselves. Sleeves are rolled up, and many dirty, sweaty hands plunge into the steaming goat. We come up with hot hunks of meat that go straight from our fingers to our mouths. There's the dim passing thought of hand sanitizer, but we're long past hygiene. Our faces glisten with grease and gratitude. We bow to our host; we know that these times are treacherous to his herds, his livelihood. To kill an animal is no small thing.

Indeed, it never was.

Here are some things I've learned.

Ninety-nine percent of US-farmed animals live in crowded, inhumane conditions on factory farms. Forty-eight percent of Americans admit they rarely or never seek information about where their food is grown or how it is produced. And for all the science we have, all our fluency for describing the physical world, more than a third of the American public believes that food, even when it comes from *living matter,* does not contain genes.

National surveys in Australia show that 40 percent of their fourth through sixth graders don't know that hamburger comes from cows. A full third of Australian young adults age sixteen to twenty-three don't know that bacon comes from pigs.

A hundred-year-old family-owned butcher shop in an English farming community is forced, through hate mail and calls for boycotts, to remove hanging pigs, pheasants, and rabbits from its store

window because it looks, as one Brit put it, "like a scene from a horror movie." Still, annual consumption of meat in England continues to exceed human weight levels.

I have learned that "avoidance coping" is the term for choosing behaviors that allow us to escape distressing thoughts and feelings. These behaviors incite the precise cognitive dissonance that drives eating disorders—the binge, purge, starvation. In other words, if I think about food—having it or not having it, how much weight is gained or lost—I don't have to think about my other problems. I can forget that only 2 percent of Americans live on family farms now, or that the way we contain animals is paving the way to the next pandemic.

Avoidance coping breeds anxiety like *E. coli* in a feedlot. The more I avoid thinking about something unpleasant, the more neurotic-compulsive-obsessive-hysterical I become. The more I avoid my complicity in the suffering of animals I eat, the more I absorb the violence done to them.

On our way to the ranger's ger for the goat dinner, we stop on a high mountain pass with the smallest patch of snow, and the horses and pack camels sip at the melting edges. It's their first water since morning, and we've covered a lot of ground. The herdsmen accompanying us—one of whom rode with a hand holding out a cell phone playing traditional Mongolian music—are anxious to tell us about Donald Trump Jr.'s recent killing of an endangered argali sheep here. They volley the details: The camouflage of darkness. The night scope. The lack of permit (although he obtained one later). The refusal to let locals field dress and quarter the animal for its meat—instead, the son of the sitting American president transports the animal whole on something like a giant metal baking sheet so he can harvest its horns and fur and discard the rest. The Mongolian nomads I meet are not prone to great expressions of emotion, but their voices and faces are tender with the telling.

We move out, the horses' hard, unshod hooves clocking hard scree as we descend into a narrow, snaking valley. The horses pick up the pace—they know they're headed home. The steep angle of the slope is irrelevant to such sure-footed beasts, but my horse stumbles in the scariest of places. This is because he moves with his head half-cocked, his one eye doing the job of two. One of the herdsmen explains that, as a foal, he'd gotten stuck in a bog,

where ravens pecked his right eyeball clean out of the socket. I decide I'll call him Bird's-eye.

When we stop for lunch, Bird's-eye finally—after days of turning away—lets me near his face. I peer into the wizened depression where his eye once lived. Wriggling through the goop and grit in there is a tiny worm. Feeling queasy and murderous, I pinch the little parasite between my fingers. It's sometimes unpleasant to be this up close and personal with animals. But it sure as hell beats the alternative, the loathsome creature who feeds indiscriminately, who depletes its host and in doing so endangers the whole species, the whole landscape, the whole system.

In 2017, just before the worst-ever dzud hit Mongolia, American public health and environmental watchdogs demand that the company Impossible Foods remove its meatless burgers from the grills of fast-food chains such as Burger King, and from upscale restaurants like New York's Momofuku Nishi, and every eatery in between. The concern: the company has not yet proved that an ingredient called soy leghemoglobin (SLH)—which is produced in the company's laboratories by way of a genetically modified yeast and gives the patty its bloody, fleshy qualities—is safe to eat.

In response, Impossible Foods commissions a study in which rats are fed SLH. According to GMO Science—a consortium of independent physicians, biochemists, and plant geneticists—over the course of the study, the rats experience decreased body weight gain despite increase in food consumption; decreased immature red blood cell count; decreased blood-clotting ability; decreased blood levels of alkaline phosphatase, indicating malnutrition and/or celiac disease; and decreased blood glucose and chloride, indicating kidney problems; as well as increased blood albumin, indicating acute infection or damage to tissues; increased potassium values, indicating kidney disease; and increased blood globulin values (common in inflammatory disease and cancer).

Despite the ominous results, the FDA capitulates, and the burgers keep right on broiling.

When Ruby is five, we bring home eighteen chicks, all black Australorps—known for being good layers and good meat birds. They are also cold-hardy and easy to free-range—these birds can really forage. At night we keep them safe in an old camp trailer with the

interior cabinets serving as nesting boxes. From day one, I remind my daughter not to get too attached, that when the chickens are big enough, I will butcher a dozen to be frozen for dinners—one a month for a year.

When the chickens are half-grown, a raccoon gets its teeth and claws into one of them before the dogs chase it off. The chicken's esophagus and spine are visible in her badly torn neck, but her eyes are piercing with resolve for living. I cannot bring myself to put her out of her misery. Instead I Google "chicken first aid" and find that chicken owners everywhere swear by superglue. I squeeze a tube onto the hen's long, torn flap of feathered neck skin and press it back in place. The chicken survives.

And when it comes time to butcher, Ruby stands by her. "Don't kill that one, Mom," she says. "I'm naming her Miracle."

Miracle escapes two more predators and lives to be ten years old, outlasted only by Cinnamon, another of Ruby's favorites. Cinnamon once holds her feet still so that Ruby can paint the nails bright red in exchange for some watermelon. She lets Ruby outfit her in a doll dress and wheel her around the property in a child-size grocery cart, her feet dangling through the cart's gridded bottom. Eventually, I tell Ruby that the hen has likely had enough, that she should remove the dress and return her to the flock. No sooner are we back in the house when Cinnamon runs across the yard, wings out and squawking. She takes a flying leap onto the porch and lands squarely in the parked grocery cart, ready for more.

That was the day I begin to wonder, *Do we diminish animals by eating them or by doting on them?*

And, *Must this be a black-and-white question?*

I step back from the group feeding off the goat to watch the Mongolian sky pull down the sun. Everything now gauzy in twilight. In all directions, hooved animals darken the nearest ridges, kicking up dust as they descend. Each herd, with its unique ratio of yak to sheep, goats, horses, and camels, is urged down into the valley by dogs under heel, a horse and rider. The animals bleat, bawl, blow. Brown dust swirls as they break into the valley like wave sets. Each one rolls toward a different dwelling, where it gathers itself tightly around the felt of a ger, an extra layer of living, breathing warmth

for the family inside. A source of milk, cheese, wool, leather. And the yak dung: the only source of fuel for fires.

The meat is gone. The group breaks into song. So, I think, as cheap vodka comes around again, it's not about eating meat or not. Mongolians—like so many other poor, Indigenous people living in increasingly harsh conditions around the globe—will never be able to grow tofu or arugula. For them, it's about living small so the animals can live large. It's about living so close you see the goop, the grit, the worm. About not looking away when life drains out. Being on your knees in that moment, a supplicant to life ending the way you were on the day the same animal was born.

Another ger, this one in an even hotter, drier part of the Altai. We are welcomed by a Kazakh eagle hunter and his family. We beg him not to slaughter a sheep in our honor, but he won't be dissuaded. Soon we are seated on the floor of the ger around a long squat table on which meat is piled high. The sheep's head peeks out of one mound; our host retrieves it and ceremoniously removes the brain, eyes, and cheeks. He offers them to the youngest, prettiest woman in our group. She smiles graciously, but as soon as the man turns to another guest, her face falls and her eyes brim with hunger and tears. The food part of this trip has been hard for her; like my daughter, she does not believe in eating animals.

The man turns to the other end of the table and offers us a platter of horse meat stuffed inside the animal's own intestines. I have eaten every kind of meat on this trip—have eaten meat almost exclusively—and I have never in my life felt so good, so clean, lean, and clearheaded. But here, I balk. To me, eating a horse would be like eating my dog—like eating my best friend or my kid.

Our host notices and explains that every year, his family culls the weakest, oldest member of their horse herd, the one likely to suffer most in the coming winter. To kill such an animal is an act of compassion, he says. To eat it is to ingest the fierce, passionate, and sacred nature of the horse. For the average Mongolian pastoralist, to not eat the horse is to weaken one's constitution, one's very soul.

I take a bite. It's good. Damn good.

As dinner rolls into more vodka and our host strumming his horsehead fiddle, my heart and tongue remain steadfastly at odds.

Not just because of the horse meat, but all the meat I've eaten —meat raised on a drought-stricken land where carbon dioxide emissions caused by raising animals for consumption promise only more drought.

As I stumble out of the yurt, past our host's tethered and hooded eagle, through the warm and blowing herd animals that have gathered for the night, I feel nuances drifting in like clouds before the bright light of a full moon on the black, blank night canvas —truth coming in shades of silver, slate, smoke. Here in Mongolia, as well as at home, I'd rather eat an old horse from nearby than an avocado or mango trucked halfway across the world, or the last wild-caught fish in the sea—frozen, then flown, then frozen again on its way to my landlocked home state of Colorado. This, just as I burn jet fuel to fly across the world before I spend six months working at home in my thrift store pajamas at a computer that runs on sunshine to convey why there is no one-stop shopping for how we humans, in our myriad communities, cultures, and geographies, respond to the climate crisis.

Just below the west rim of our Colorado mesa is a tiny, ramshackle town that's seen better days—days dusted yellow by uranium and smattered by trailers and boarded-up buildings for sale. Patagonia-clad travelers in tricked-out camper vans blow through here, en route from their winter range in Colorado ski towns to their spring and autumn range in Utah's slickrock and back again. Sometimes they stop to eat at a little family diner called Blondie's, a place owned by Seventh-day Adventists that, every day but Saturday, serves America's favorite fast food.

Blondie's also serves the Impossible Burger. On a gray Sunday afternoon in early spring, Ruby and I drive there to meet three friends for lunch. There are hugs all around. Two of the friends are women who traveled through Mongolia with me, one of whom has her husband in tow. We order at the grease-splattered counter: Ruby gets a black bean burger, the rest of us order all-beef ones. Then I add an Impossible Burger to the order.

We cozy up in a red, vinyl booth, and when the food comes, I divide the Impossible Burger five ways. The largest portion I give to Ruby, who, as the sole vegetarian, will no doubt be the easiest sell. She bends over and sniffs. Grimaces. "It's too much like meat," she

says. Just one bite, I say, bribing her with a milkshake. The rest of us agree to eat our portions at the same time as her.

Judgment is suspended as we bite, chew. My mouthful barely makes it down the gullet. Ruby spits hers out.

"If the zombie apocalypse happened and I had to choose between an Impossible Burger and real meat," she considers, "I'd choose real meat." She shoves her plate away. "But only if it came from a small local farm. And was well taken care of." With typical teen girl melodrama, she tosses her head and adds, "Otherwise, I'd just starve."

My two travel companions, Paula and Dawn, have taken a second bite.

Paula: "It's not toothsome. It just doesn't pass as *food*."

Dawn: "Poor fake burger. It never saw the outdoors."

Sajun, Paula's husband, pulls back the bun and pokes at the meat. The couple owns and operates Laid Back Ranch, a small, all-natural, grass-fed cattle operation not far from where we are eating. Their animals never eat grain or alfalfa. They roam widely, graze freely. They forage beneath snow all winter long.

I tell them what I know about the Impossible Burger. Everyone shoves their plate away.

Sajun: "I'm all for science and saving the planet, but this thing skirts the whole issue of small-scale, proper farming practices that can give back to the soil. That kind of dirt can hold a lot of carbon, and it's chock-full of beneficial microbes that are central to the whole ecosystem." He glances at Ruby, winks. He's known her since she was a toddler. "Sorry, Rubes. But that's what the vegetarians and vegans miss in their argument."

Ruby shrugs. "I'm not a fanatic, you know."

Minus Ruby, we dive into our beef burgers, which—despite this diner being surrounded by family-owned cattle-ranching operations—come from cows fed on GMO grain in a feedlot before being trucked dozens, if not hundreds, of miles to a mechanized slaughterhouse, and then processed and loaded on refrigerated semitrucks and delivered to supermarket distribution centers and then again to large-chain grocery stores and then home to someone's freezer.

Along with the factory-farmed burger, the black bean burger and Impossible Burger are delivered on the same truck.

*

Spring flirts with the mesa. My daughter will be driving soon, and may perhaps know her first kiss. Mountain bluebirds, the first of the migratory birds to return, twitter on fence lines that parallel the road. The irrigation ditches are suggestive; in a month's time, tiny green shoots along their banks will mature into crisp stalks of asparagus. Eagles—balds and goldens—spar with ravens above pastures gelatinous with the afterbirth of lambs and calves. In the timber, herds of elk pass through, silent as ghosts as they head to higher ground.

On a bad year fraught with drought and fire, living here is still a privilege. But right now, in this orgy of arrivals, this interspecies intimacy, it's an indulgence. One that must not be squandered.

This spring is the first one in which a zoonotic illness—that is, an infectious disease transmitted from animals to humans—has us cleaving close to home indefinitely. The sky is far less cluttered with contrails, the market barely stocked with food. Ruby, who embarks on a campaign to educate her classmates on the plight of the pangolin, the world's most trafficked animal and one of the potential transmitters of COVID-19 to humans, believes animals are exacting their revenge.

While the novel coronavirus is terrifying, it is also a brilliant example of the payback that happens when we begin to commodify a living thing—when we catch it, pack it, sell it as a product. As though it were never a creature.

Sometimes animals appear in the liminal, as if emerging from a dream. Everything but night itself is white and swirling, when a dark shape materializes in the middle of an iced road. It's too late, too slick, to stop—when the animal turns to kiss the headlights of an oncoming car. Everything slow and muted in the storm, the animal levitating now and passing through glass, an apparition. It nestles neatly into the laps of the passengers, whose mouths are open and cavernous. H pulls the truck off the road, and the hazards blink as he runs to the other vehicle, mounts the hood, and reaches through. He pulls the animal off the people who are now the ghostly ones—white-faced and wailing.

I am not in the dream. I am home with Ruby, with the practicalities of feeding goats and closing in roosting chickens. H calls from

within the dream, to say he's bringing home the deer he's just pulled from the car. I ask if the animal died instantly. That matters —in an animal that has suffered, adrenaline and stress hormones taint the meat. He says I should suit up, sharpen the knives, he's bringing home perfectly good venison.

We lay out the deer in the mudroom, wounded side up. When I run my hands through her wet fur, my fingers feel the dream shimmer, then ossify. I can feel the imprint of the car's front grille. Her body now reads like Braille.

The flesh is pulverized. I skip slicing steaks and roasts and instead chop the meat into chunks. For the rest of winter, into the next one, I cook packets of roadkill stew in the Dutch oven, and we partake of an animal born to this rough country, who knew danger and hunger, weather and wildness, in all the ways we've forgotten.

Through her body, I remember.

Cecilia Chiang

FROM *The New York Times Magazine*

To FOURTEEN-YEAR-OLD CECILIA Chiang, a bicycle meant freedom. Freedom from being enclosed in a rickshaw, pulled by a servant who was an extension of her mother's watchful eye. Freedom to ride fast, legs pumping, hair flying in the wind. With the resourcefulness that would allow her to reinvent herself repeatedly over the next century, Chiang managed to learn how to ride in secret before asking her parents for a bicycle of her own. After all, they had very specific ideas about what was proper for the kind of well-bred girls born to fifty-two-room palaces in Beijing that once housed Ming dynasty officials. Impressed, her softhearted father agreed, and her mother reluctantly allowed it. China was modernizing, but a wife still followed her husband's lead.

Until that moment, Chiang's days as the seventh of twelve children had centered largely on her prosperous, opera-loving family. Her early life unfolded with an ordered ease. Everything had its season. Swallows and peonies heralded spring, a time for filled spring pancakes, fresh spring onions, and lavish spring feasts where the adults drank wine and extemporized verses of poetry. The hot days of summer brought crisp, fragrant melons cooled in well water and refreshing pickles made of tiny cucumbers and tinier ears of corn. With fall came sweet crabs, steamed and served with dark rice vinegar and ginger, eaten in the preferred Chinese method: with great abandon. Chiang was rarely allowed in the kitchen, but the finely honed palate that would later be revered was already undergoing training.

In 1937, invading Japanese troops took over Beijing and com-

mandeered most of the city's food supplies. Residents survived on rice husks unless they had a family member like Chiang, who at around eighteen began to ride her red Schwinn into the countryside searching for black-market provisions. It was an untenable existence. By 1943, with resources dwindling, Chiang and a sister set out for Chongqing, over 1,000 miles to the south. Disguised as peasants, in plain cotton coats that hid their fur-lined undergarments, they boarded a train loaded with bags that included formal dresses and silk stockings. Within weeks, the train service stopped abruptly, their luggage was stolen by Japanese soldiers, and the young women found themselves walking or hitching rides on ox carts, sleeping in barns, and once, memorably, voluntarily tied to ropes and dragged across a wide mud pit—it was the only way to avoid a lengthy detour—until they stumbled, dirty and lice-ridden, into the first border town that marked Free China.

Soon after, in the rough, bustling city of Chongqing, Nationalist Party banners proclaiming THE FINAL VICTORY IS OURS! hung everywhere, *mapo* tofu burbled in street-vendor stalls, and the beautiful sisters soon befriended General Chiang Kai-shek's two sons and nephew. It was a heady, optimistic time. On the advice of a fortune-teller, Chiang discouraged the affections of dishy son No. 2 and the good-natured cousin and instead married her former-professor-turned-businessman. Soon after, her husband was offered a job in Shanghai, a city whose cosmopolitan promise had always enthralled Chiang. The newlyweds enjoyed a decadent few years in the supper clubs and jazz lounges, but fortunes turn quickly in war, and by 1949 they were lucky to book tickets on the last plane out of the city, three weeks before it fell to the Communists.

By 1961, Chiang was in San Francisco. She spent the previous decade in Tokyo, and although she ran a successful restaurant there with friends, living among her country's former occupiers must have rankled. America was, in all ways, a new world. Most Chinese restaurants at the time were Cantonese, with simple chopsuey menus tailored to supposed Western tastes, but Chiang was determined to present her version of China, with distinct regional preparations from Sichuan, Shanghai, and Beijing. And somehow, it worked. Initially, the Mandarin was a small restaurant on Polk Street where Chiang served the San Francisco columnist Herb Caen his first pot sticker. Soon she moved the business to Ghirar-

delli Square, with a million-dollar budget and strict instructions to her designer that there be "no gold, no red, no dragons, no lanterns." The 300-seat Mandarin felt more like an old temple, decorated with antiquities that Chiang carefully bought at auction. The restaurant was her attempt to re-create the world of her childhood, a world that was ripped out of time by conflict and war. In its specificity, it spoke to a new generation of California chefs like Alice Waters, who also cared deeply about food that was local and seasonal.

For most of her early years in America, Chiang was unable to contact her parents. China was closed to the world, its people mired in the emotional and economic destruction of the Cultural Revolution. But then, in 1975, two things happened. First, she opened the Beverly Hills outpost of the Mandarin, which quickly became a celebrity favorite. Paul Newman had a house account; John Lennon and Yoko Ono stopped by every time they were in town. Second, after years of thwarted attempts, Chiang got a visa to China with a little help from a frequent diner—Henry Kissinger.

The homeland she returned to was unrecognizable. So was her father. Forced out of the family house, he subsisted in a single dark room, ninety-seven and toothless. Worse, Chiang found that her mother had died of starvation five years earlier. Over a bottle of cognac that she managed to bring in, Chiang and her father traded stories of the thirty years they spent apart, of the other unknown losses. Chiang told him that his third-eldest son joined the Nationalist Air Force and died in a plane crash two decades before. Her father described the fate of her third-eldest sister, who took her own life after her daughter denounced her to the Communist authorities, a common event in those turbulent days. And then, right before her visa expired—maybe satisfied by finally seeing his daughter again—he died too.

The China that gave Chiang's family their wealth and privilege was hardly a just or equitable one; if it was, the Communists could never have risen to power. But Chiang spent half her life trying to preserve what she saw as its best parts—a deep appreciation of beauty, a desire to live deliberately and in harmony with the seasons, a love of feasting and family. As much as she treasured her youth, if that world hadn't been lost, her life would have been much more circumscribed, focused on home and children. Instead, she helped shape America's understanding of Chinese cui-

sine, and until her death at 100, she was dining out nightly, staying up late with a whole new generation of young chefs.

At Chiang's fiftieth-birthday party, her children surprised her with a brand-new red Schwinn. They knew how much she had loved that bicycle, what it meant to her. But Chiang didn't really need the bicycle anymore—she had freedom, and with it she made a world that was wholly her own.

BRITT H. YOUNG

Incubated Futures

FROM *n+1*

KENTUCKY FRIED CHICKEN wants to move into Addis Ababa. Among the last of African countries to be colonized by fast food, Ethiopia just received their first multinational fast-food chain in 2018, when two Pizza Huts opened in Addis. More international chains want to open in the capital, though their efforts are stymied by Ethiopia's fervor for self-branded counterfeits: Addis is home to a few unauthorized In-N-Out Burgers, at least one false Burger King, and a Subway that serves more stews than sandwiches. The logo for Kentaki Krunchy Fried Chicken, or KKFC, looks almost identical to its American inspiration. Its owner, Tseday Asrat, is a serial entrepreneur known for nearly reproducing Starbucks's green sigil logo at every location of Kaldi's, a coffee chain he also owns in Addis. Asrat claims to have received KFC branding licensing from KFC Saudi Arabia, but KFC corporate disagrees.

Despite a growing chicken availability, chicken simply isn't very popular in Ethiopia. Historically, local chickens have been too small and slow growing to be raised specifically for meat, and they are eaten only after they've fulfilled their life's mission as layers. As a result, chicken is widely treated as a delicacy, an anomaly among African countries. The bird is eaten for special occasions, like Ethiopian New Year and Christmas, while beef and goat are consumed far more casually. Doro wat, largely considered the national dish, is stewed for several hours to render old, egg-laying hens tender and moist with piles of shallots, berbere, and tomato paste. By day's end, the meat is stained through with red oil, while the *niter keb-beh*—spiced butter—lends the dish a creamy quality. A few eggs

hard-boiled in the red braise finish it off, resulting in a smooth, heat-speckled sauce that slow-burns its way down, a spicy funeral pyre for an old hen at the end of her life.

And yet, chicken eateries like Kentaki are suddenly opening across Addis. Another spot called Chicken Hut now sells barbeque chicken pieces in the high-rise malls popping up in the capital. The experience of eating there is very American: I went up and ordered, they gave me a big, ugly buzzer, and it rattled obnoxiously when the order was ready. The paper placemats on Chicken Hut's food court trays feature a cartoon cow imploring you to EAT MOORE CHICKEN, copying the iconic Chick-Fil-A tagline. But unlike Chick-Fil-A's self-interested heifer, the Ethiopian cow isn't just hoping to save its own skin. Instead, it's calling to the new Ethiopian denizens of the mall—tweens in black jeans and sneakers —and urging them to be modern. *Do what your parents would never do: order a Chicken Nugget Meal.*

With the influx of fast food–style eateries, casual chicken consumption appears to be growing more common in the capital. Fried chicken, chicken sandwiches, and stir-fried chicken are considered the food of foreigners but also of a modern Ethiopia —I've ordered chicken katsu at the country's only Japanese restaurant. Even outside of the restaurants, chicken seems to be having a small moment in the East African country. The protagonist of the country's first 3D mobile game, *Kukulu,* is a brave chicken trying to escape a prototypical Ethiopian village. A TV advertisement for an Ethiopian beer depicted football fans cheering on a single chicken to predict the winner of the 2018 World Cup.

This emergent chicken fever clashes, though, with traditional Ethiopian culture. Ethiopian Orthodox Christians, who make up about 40 percent of the population, are forbidden from eating chicken at all for approximately half of the year. Normal Orthodox fasting, for which one eats an effectively vegan diet, occurs two days out of every week, and then for longer sustained periods at various points. And while all meats are forbidden on fasting days, red meat is still far preferred over chicken. Another 36 percent of the population is Muslim and will only eat poultry if it is halal. In this atmosphere, how could an American fried chicken chain stay in business, let alone expand?

But international fast-food chains aren't even the main force driving chicken consumption: the heart of chicken's growing pres-

ence is the Ethiopian government. In 2011, the Ethiopian government's Climate Resilient Green Economy Initiative included a plan to ramp up chicken production and consumption dramatically in the coming decade, increasing the share of poultry in meat consumption by up to 30 percent by 2030. They have been aided by NGOs that have flocked to support a new wave of chicken-based interventions, designed to promote capitalist social relations, self-reliance, and climate change adaptation.

Ethiopia's native chickens are small and gangly. They grow slower, have less meat on them, produce fewer eggs, and die more easily compared to the mass production broiler varieties. Those high-production foreign breeds, however, require expensive input and mechanized environments to survive, while local breeds can survive with less mediation in their indigenous surroundings. For the international development community, this was a classic opportunity for intervention.

Attempts to jump-start economic development by improving the genetic quality of livestock have been a focus of development institutions for over fifty years. The difference now is the mobilization around "resilience," a development buzzword and organizing principle, in this case referencing an animal's ability to survive in harsh and uncertain climatic conditions. Economic development and climate adaptation can be tackled by introducing a "more resilient" chicken—or so says the International Livestock Research Institute (ILRI), a research organization that runs the African Chicken Genetic Gains program (ACGG) in Ethiopia, Nigeria, and Tanzania. According to the ILRI, problems with nutrition, with development, and with poverty in Ethiopia can all be tackled with a resilient chicken.

So, what is a resilient chicken? In Ethiopia, it's a chicken that can survive drought, grow faster, and grow larger without becoming more resource intensive. Resilience or resiliency, then, is the capacity of an individual chicken to fiercely withstand anything nature throws at it. Michael Watts, professor of geography and development studies at Berkeley, has argued that this new organizing ideology of resilience isn't dramatically different from previous development keywords like sustainability. Resilience redirects political imagination and governmental power toward biosecurity management while encouraging political subjects to be self-reliant.

By the logic of the development machine, a farmer with a resilient bird then becomes resilient too: she doesn't need resources from the state—she only needs herself and this bird to get through climate catastrophe. In this new era of climate adaptation development, the desired outcome is to discipline a neoliberal subjectivity comprised of subsistence farmers who internalize the state's neglect of them. Previously commonsense anti-poverty interventions, such as improving access to markets for subsistence farmers, are fading as rising global temperatures and increasingly extreme weather patterns threaten agricultural practices around the world. Twentieth-century attempts to improve the genetic stock of chickens across the continent may have produced healthier birds, but not birds especially designed to withstand drought (or certainly not on paper) and so-called "unimproved" indigenous breeds have remained the most ubiquitous. In the last two decades or so, though, international development institutions and NGOs have refocused on resilience strategies—including income diversification, access to some insurance, and improved livestock breeds—as ways to mitigate the disastrous and yet unknown effects of climate change.

The ACGG is running a few experiments on the growth and health of foreign breeds, testing their ecological appropriateness —an essential component of resiliency. They have taken South African and French breeds and placed them in what they believe are very common Ethiopian conditions: small farm properties with not a lot of free space, perhaps with some trash scattered nearby, and an intermingling of cattle, dogs, and sleepy house cats. Most indigenous breeds of chicken are completely free-scavenging, but not all foreign breeds are. The yard might have a stray soda can tab. Will the foreign chicken eat it, choke, and die—or not?

Curious about how resilience was assessed in the field and what it meant for a foreign breed to be doing well on the outskirts of Addis Ababa, I followed along with the ACGG researchers on an hour-long drive from the eastern end of the web of Addis to a western peri-urban space where people keep livestock in thatched, garage-like structures and weave cotton along the river. We snaked through the home of one farmer participating in the study, into their enclosed backyard where zebra-striped South African chicken breeds bolted about. They appeared to be thriving. But did that mean they were resilient?

*

I first came to Ethiopia to study the human impact of large-scale land expropriations for foreign agribusinesses. I had volunteered for an NGO in Oakland that had published reports about the federal government expropriating large tracts of land and giving it to foreign investors. In one egregious example, the federal government granted an Indian floriculture company 300,000 hectares of land in Gambela, destroying local livelihoods. When I arrived in Ethiopia, a young, excited bureaucrat at the Ethiopian Agricultural Investment Land Administration Agency told me they had halted their program in response to bad press coverage and NGO reports of human rights abuses, like those put out by the organization I'd worked with in Oakland. After further poking around, I was told in not-too-subtle terms that I shouldn't be looking into these land deals at all. My hand was forced, and I had to drop the project.

I wasn't sure where my research would turn until one afternoon my taxi stopped at one of the few traffic lights in the city, at Meskel Square, a massive plaza facing sweeping stadium steps. Behind the steps was a billboard advertising Ethiopian Airlines' new fleet that produced up to 15 percent fewer carbon emissions. In a country with negligible carbon output compared to those in the global North, and with so few Ethiopian citizens flying the national airline anyway, what was the intended audience for this ad? Who were the Ethiopians engaged in this discourse?

British friends of mine recommended I set up in the local co-working space, which was also the office of blueMoon, a sustainable agribusiness incubator in Addis. Although a chic standing bar-only café stood at the first floor of the glass mid-rise, traditional coffee is made on coals in the middle of the office floor, fanned occasionally to keep the pot boiling. In every other respect, the office sports the hallmarks of international startup culture: brightly colored sectional furniture and wall decals that say DISRUPT. The founder of blueMoon, Eleni Zaude Gabre-Madhin, received her PhD in applied economics at Stanford, and she adopted much of the ethos of Silicon Valley. At blueMoon, techie dogma transfers via reality TV versions of American entrepreneurship: the next generation of Ethiopian change-makers begins each day at the incubator with a mandatory episode of *Shark Tank*.

Everyone there is amped. When I interviewed the incubator fellows, they said: *I want to be Mark Cuban. I want to be Elon Musk. I'm going to have the Facebook of agriculture.* I'm still not really sure what that means.

Tadesse Alemu of Guaro Farms, a resident startup at blueMoon, hopes to sell vegetables and fruits grown on a rooftop garden in Addis to health-conscious elites. "My life is all hustling," he told me. He hopes to create an eco- and health-conscious lifestyle among his high-end clientele by bringing hydroponics to Ethiopia. When I asked him about his inspiration, he cited Ethiopia's climate vulnerability, as well as the growing severity of droughts in the North. While their business plan does nothing to address farming in such drought-prone regions, the pitch received funding based on its relationship to climate adaptation and sustainability.

For Bethelhem Dejene of Zafree Papers, making recycled paper products in Addis Ababa is all about "making Ethiopians care about the environment." She told me she sees value where no one sees it—in waste. In Ethiopia, the profitability of recycling is still promising. But if it turns out it's not, one of the largest landfills in Africa, Qoshee, recently constructed the continent's first waste-to-energy plants on the other side of town.

For weeks in the spring of 2018, every single showing of Marvel's *Black Panther* sold out at the one international theater in Addis. In its Afrofuturist imagining, the fictional country of Wakanda is the only African country that evaded European colonization. It's also the most technologically advanced society on Earth, its natural resources harnessed for its own use rather than expropriated by colonizers.

Many young, cosmopolitan Ethiopians see Ethiopia as the real-life Wakanda. In today's modern mythology, Ethiopia's victory over the Italian army at 1896's Battle of Adwa has been inflated to the point of obscuring the country's eventual fall to Italian occupation, however brief, under Mussolini. For Safia Aidid, writing in *Africa Is a Country,* the "ghosts of Adwa" are the ethnicities and distinct kingdoms that were pillaged and conquered under the empire's expansion, and the ongoing erasure of their histories to service Ethiopian nationalism. This myth of the nation as "never colonized" is a powerful image for Ethiopians trying to tell a new

—and a strongly nationalistic—story of Ethiopia, one that rejects the images of starving children and international stereotypes of Ethiopians as passive recipients of foreign aid.

In Ethiopia, the future is not conceived as a long-anticipated struggle toward triumph but instead, as the anthropologist Dan Mains writes in *Under Construction,* as a return to the glory of Abyssinia, the empire that formally ended in 1974 with the overthrow of Emperor Haile Selassie and was a time of redemption for those Ethiopians who identified with the regime. The future is a renaissance. The Grand Ethiopian Renaissance Dam, the filling of which has embroiled the country in significant tensions with Egypt, holds so much of these promises.

Biruk Yosef, the program manager at blueMoon, reiterated the Wakanda-esque narrative: "Ethiopia was never colonized" so the natural resources have yet to be "harnessed." In the Ethiopian tech sector, the country's potential is latent in its untapped resources and uncolonized spirit. And yet the techie capitalist ambition is another form of colonization itself.

Facing Marx's famous simplification of the transformation of capital, Aimé Cesáire proposed the equation: "colonization = 'thingification.'" Startup epistemology is the corollary to colonialism's commodification, whether it proceeds via reification or abstraction. Forests become pins on Google Maps—acreage to be included in carbon calculi; Indigenous agricultural practices are codified and scaled up for their climate adaptability; the Ethiopian coffee ceremony becomes a packaged experience for the ecotourist; chickens are genetically improved and mass-produced.

In the United States, the elite of the technology sector are largely notorious libertarians with deep-seated doubt about the ability of the public sector to provide services. Google cofounder Larry Page once claimed he'd like to leave his fortune to Elon Musk as an investment in humanity's future on this planet. In Ethiopia, startup culture isn't simply predicated on a war with a perceived inefficient state—it's conceived as pushing back against neocolonialism. After decades of being colonized by aid, young entrepreneurs see themselves as cultivating their own concept of "development." They argue they are making Ethiopian solutions for Ethiopian people.

At the end of November 2019, Jack Dorsey, Twitter's CEO, visited blueMoon and other tech incubators in Addis Ababa. "Africa

will define the future (especially the bitcoin one!)," he tweeted. A countermovement is brewing among middle-class and cosmopolitan Africans who think the established development institutions have done nothing for them, that "development" as it is known is coordinated by neocolonists who, at best, don't understand and, at worst, have insidious motives. Inspired by entrepreneur capitalism of the West, they believe growth and wealth can only be created through market-based solutions, with charismatic entrepreneurs at the helm. In Ethiopia in particular, the desire to realize techno-optimist hopes is shaded with nationalist dreams of the country becoming a pan-Africanist leader—for tech, for development, and for environmentalism—on the continent.

These are the Ethiopians that billboard spoke to.

At the ACGG's poultry research facility in Addis, there's a rectangular barnlike structure with segregated enclosures of various test breeds of chicken: one gated room for the South African breed, Potchefstroom Koekoek; the French selection from the company Sasso; and a strain named "DZ-White" collected from local farmers. A refrigerator-sized incubator filled with special eggs from Belgium sits in the corner of a spare concrete room.

In 2016, ACGG partnered with the Belgian artist Koen Vanmechelen, who had been crossbreeding chicken varieties for about twenty years—as art. By continuously crossbreeding endemic chicken breeds from around the world, he hopes to create "a Cosmopolitan Chicken carrying the genes of all the planet's chicken breeds." His Cosmopolitan Chicken Project in Ethiopia—entitled *Incubated Worlds* and referred to as an "installation" on his website —brings his latest generation of bird together with ACGG-selected local breeds to synthesize a new bird that is both Ethiopian and international.

It is, of course, impossible for a bird to acquire "all" of the genes; it has a set number, like all other living creatures. While you could, perhaps, genetically engineer more genes into your chicken, they couldn't all be expressed at the same time. If they did, you would not have a chicken—at best, you'd have some kind of chicken puddle. Vanmechelen has to know this; it's just the way the project gets presented, its ideological dressings, that makes it sound like a diversity buffet.

Once mature, the Cosmopolitan Chicken will be crossbred with

one of the local breeds, probably the Horo, supposedly making the ideal blend of global and local, cosmopolitan and Ethiopian. The local breed has ecological suitability and a long history of living in Ethiopia. Blended with the worldly resilience of the Cosmopolitan Chicken—a truly capitalist, cultured chicken—it will become the best chicken for Ethiopia. Likewise, the Cosmopolitan Chicken bred with the local Nigerian chicken will be the best chicken for Nigeria. Of course, this also benefits Vanmechelen: Every time he convinces a country to accept this crossbreeding endeavor, he adds another chicken to his gene-pool art show. It's also the ideal development project, scratching every ideological itch with tie-ins to diversity initiatives, climate change adaptation, local empowerment, and ecological resilience.

The ACGG project leader, Dr. Tadelle Dessie, hopes that Ethiopia can substitute a portion of cattle production with industrialized chicken production to help the country achieve the federal government's Climate Resilient Green Economy plan, which seeks to modernize and diversify the agricultural sector while reducing carbon output. Despite his continual insistence that Ethiopia needs to do its part to mitigate climate change, the country is responsible for a negligible share of the world's carbon output. Yet, the Ethiopian government hopes to increase chicken's share of national meat consumption to 30 percent with the explicit ostensible intention of lowering overall carbon emissions, a goal that will require a 500 percent increase in national poultry production. This might seem like a way to reduce carbon output, but only if it offsets beef production—and it simply won't.

Others, like Olivier Hanotte, a scientific advisor at ILRI, are more concerned with chickens' ability to alleviate poverty and improve nutrition. But Ethiopian farmers won't see increased profits unless there is increased demand for chicken. At ILRI, there's hope that Ethiopians will see chicken as the climate-conscious meat choice, at least among the eco-minded cosmopolitans and techies in Addis. Dr. Dessie believes that doro wat should be eaten more often, and that general attitudes about chicken "need to change."

The sleek outer walls of the Poultry Research Facility at ILRI are plastered with two giant chicken portraits, large-scale reproductions of photos by Vanmechelen. The busts of the chickens face

each other in an eternal staring contest, the rubbery red skin around their faces uncannily glossy, their eyes empty but serious.

We're trying to get people to think—about chicken, says Hanotte. *People can see this from the mall.* So I went down the street to the newly constructed Century Mall, stood on the sixth floor, and looked out. He was right: you can see the research facility clearly, adorned with two giant chicken heads. For Hanotte, these chicken glamour shots are an "Ethiopian landmark" and part of a concerted effort to increase chicken consumption.

But the ILRI Poultry Research Facility's strangest feature is a small white room, in which a projection plays on the wall, 24/7. In the video, a white woman reads aloud a seemingly random sequence of four letters, which turns out to be the genome of the latest generation of the Cosmopolitan Chicken. In front of the projection, a lectern holds a book five or six inches thick, printed in eight-point font, containing the full gene sequence. This room was created by Vanmechelen, who insisted it was built inside the research facility. But the facility is not a public space; it doesn't have frequent visitors, and you cannot enter as an average Ethiopian.

The woman on the projection just stands there with a magnifying glass, chanting: AGCACCGCGTG . . .

My guide turned to me and asked if I wanted to read part of the sequence. "Oh . . . definitely not," I said.

He chuckled and shrugged, probably thinking, *But isn't this for her? Isn't this what foreigners want to see?*

A version of the book, called *The Book of Genome,* now lives in the National Museum of Ethiopia. At the presentation ceremony, Vanmechelen described it as "honor[ing] the generosity of the local as a prerequisite for the existence of global diversity."

But the researchers at ILRI clearly explained that they saw themselves as scientists simply trying to make a new bird for the good of the country, any potential cultural interventions aside. They want to leave the actual distribution of the new bird to the capitalists. The identity of some of these capitalists is unsurprising: Bill and Melinda Gates—or, rather, the Gates Foundation, in collaboration with an investment organization based in Dubai, and ten angel investors. They all fund EthioChicken, the now-multinational chicken enterprise founded by a white man from the United States that scales up production of improved breeds and sells day-

old chicks at very low cost to farmers who rear the poultry and then resell them at a profit.

The Gates Foundation is known for their pro-chicken efforts, which they tout as a means of providing protein and economic independence to countries struggling with malnutrition and poverty. The Bill and Melinda Gates Foundation also funds the African Chicken Genetic Gains program. Thus, the new Ethiopian Cosmopolitan Chicken has the potential to be distributed by EthioChicken. The development stars align in unexpected ways sometimes: chicken as low-cost poverty intervention, chicken as climate resilience, chicken as climate change mitigation.

When in Addis, I could buy eggs like those in the states—they're available by the pre-packaged, plastic-encased dozen at the *ferenji* market, a supermarket geared toward foreigners. But I'd much rather stop by one of the nearby *sooks,* tiny window shops that face Addis's streets, and pick individual eggs from those sitting out on a ledge. These are sometimes locally called habesha eggs—referring to the "dominant" culture in Ethiopia—from indigenous breeds, small and speckled. Ferenji eggs, from foreign breeds, are flavorless in comparison. Nobody wants them. I can only smell eggs in the United States once they are fried. In Ethiopia, eggs smell like eggs the moment they leave their thick shells. Their sumptuous funk is still new to me; catching a whiff is like smelling warm butter for the first time. My Amharic instructor, Belaynesh, would start class by asking about breakfast: Did you have habesha enkulal? It was a question full of pride, like she was letting me in on a delicious secret. I always chose those eggs.

When chickens are allowed to forage, the carotenoids from insects they eat make yolks a vibrant orange. In the global North, some chickens are fed supplements to deepen the yolks' hue artificially, just as salmon is often colored in the United States, as this coloring is associated with nutrition, but it is widely understood that there is no relationship between yolk color and nutritional content. Studies show there isn't even a relationship between color and flavor of yolks beyond the psychological—it's all in our heads. But these studies are based in the United States, and compare conventional and pasture-raised, organic eggs, which are not the same as truly free-range eggs on the other side of the world. Americans buy eggs in opaque, branded packages that contain a number of

identical objects; Ethiopians buy eggs, and meat—or the animals that become meat—as specific, individual things. No brand, no logo, no tagline. Even without the magic of the commodified presentation, Ethiopians still know what foreign chicken implies—it is bigger, grows faster, and tastes bland.

A bizarre artifact of the melding of private capital and state diplomacy: a USDA Foreign Agricultural Service report from 2017 outlines the problem of poultry supply and demand. Chicken demand "is expected" to grow, the report notes, although Ethiopians "prefer red meat" and, on special occasions, prefer indigenous varieties of chicken. The report recommends a drop in chicken price, to "spur demand" as the Ethiopian government seeks to rapidly increase poultry production. To achieve the state's goals, citizens are being told that ferenji chickens, and their eggs, will unify the country, will make its citizens more modern and more resilient to the climate disasters on the horizon. In the end, resilience meant giving Ethiopia more chicken that few people want. And if Ethiopians don't want to buy ferenji chicken, they'll simply be exported to foreign markets, as the USDA report claims. This makes clear that climate-smart poultry is simply convenient rhetoric: exporting will exacerbate the same carbon problems that eating chicken was supposedly intended to alleviate.

In Ethiopia, to think about chicken is to bring yourself into an environmental consciousness—or as Arun Agarwal calls it, an "environmentality" that situates individualist ethics at the fore. To think about chicken is to be a good citizen, to mitigate climate change. The face of the chickens plastered on the side of the International Livestock Research Institute thus become a moral imperative, especially to those environmentally minded techies in Addis's sustainable incubators.

To ostensibly battle climate change, receive climate-related development funds, and alleviate poverty through chicken consumption, someone needs to demand chicken—500 percent more chicken. Maybe Ethiopia's techies will, but my friend and one of blueMoon's 2018 interns, Denat Ephrem, won't be joining them. We spent one rainy afternoon in Addis looking for lunch that would satisfy both our needs. "I mostly like salad or fruit for lunch," she told me. "Shouldn't we be trying to eat less meat?"

For all the development world's emphasis on chicken availabil-

ity to solve nutrition problems, one study by IDinsight found that even when farmers purchase improved chickens, their incomes increased, but nutritional outcomes remained unchanged. Their children didn't even eat more eggs.

Fried chicken in Addis isn't a story of foreign capital wiping out local tastes and practices. It's part of a wider effort by international development institutions and the federal government itself to turn chicken into a handmaiden of resilience to create a unified Ethiopia. We in the states talk less about resilience to climate change and more about mitigation. We still feel some false sense of subject agency, that we could possibly determine whether or to what degree climate change will happen. But in Ethiopia, there's an understanding that no set of actions taken will meaningfully affect the rate at which the climate changes. Resilience is a reactionary quality; it suggests a relationship with a course of events that you're not able to influence.

Drought and agricultural devastation as a result of climate change are the looming specter, resilience against which is the stated impetus for agricultural interventions by neocolonial NGOs and anti-colonialist, Afrofuturist startups. What remains baffling is the sense that commodity-driven interventions are the solution in the face of climate precarity, when it is the wasteful excess of the unchecked free market that has skyrocketed carbon emissions. The discourse of resilience is taken up by development specialists, bureaucrats, and capitalists alike and dropped the moment it loses its usefulness.

Meanwhile, as COVID-19 moves throughout Africa, restaurant patronage and tourism has plummeted, drastically decreasing chicken consumption. Over the course of five weeks in May and June of this year, EthioChicken killed nearly 650,000 chicks and destroyed many eggs to avoid flooding the supply chain. Perhaps the pandemic will signal the abrupt end of these nationalistic chicken efforts. At the same time, though, many tech-savvy Ethiopians and foreigners have turned to Addis's nascent restaurant delivery apps, such as Deliver Addis, which can bring you mesir, injera, hamburgers, and a wide variety of chicken meals by motorbike. Addis Chicken, which uses the delivery platform, is a completely vertically integrated poultry manufacturer and purveyor of unfamiliar meals such as chicken meatball sandwiches and doro

tibs, a dish that is popular in Ethiopian American cuisine but utterly foreign in Ethiopia itself. Addis Chicken's recent Facebook post deploys COVID as yet another reason Ethiopians should be eating more chicken: "They say protein helps support our immune system. In support of fighting COVID-19, Addis Chicken is promoting its delicious chicken starting on Monday 4th of May through Sunday 10th of May by offering 50% discount . . ."

But the most intriguing post on Addis Chicken's Facebook page is an image of an intrepid chicken clad in armor holding what appears to be an Amhara warrior shield above the text አድዋ, Adwa, Victory for All Africans. The post reads: "Addis Chicken wishes you a Happy and Joyful Adwa Victory Anniversary! It's a victory for all Black People." It might appear that this nascent poultry processor is simply shoehorning their product into a holiday, but I believe the association between fast-food chicken and pan-African modernity is not a coincidence. Adwa Victory is an essential part of a renewed vision of Ethiopia as a leader of neocolonial resistance, a unified Ethiopia without internal differences. But the recent Oromo protests, widespread violence, and now civil war in the Tigray region reflect the deep tensions between ethnicities that undermine the prime minister Abiy Ahmed's attempts to cultivate a cohesive national identity myth—one that many have argued fails to reckon with Ethiopia's violent, imperialist past. In an Ethiopia vying for different visions of the future, it is unclear to whom chicken nationalism will appeal.

Belaynesh spent one afternoon teaching me how to make doro wat on her living room floor. Despite my disappointment, she said that on short notice, we didn't have time to prepare a live habesha bird from the market, and needed to get a frozen ferenji bird from the store. At a spigot outside of her home, Belaynesh crouched down and washed the bird the same way she would have with one that had just been slaughtered, traditionally by the man of the household. We peeled shallots by the dozens and stewed the chicken over a gas hot plate, sitting atop a thick protective plastic over her living room carpet. We spent hours prepping this large, ceremonious dish, surrounded by her husband, children, and stepchildren.

But in the end, Belaynesh wanted nothing to do with the stew.

Her family picked at it, but no one was really interested—maybe it just didn't seem right to eat such a special food on an ordinary day. I was handed the rest in a huge Tupperware, and my hosts were insistent the food was for me—ferenji for ferenji. I still haven't had real doro wat, made from an indigenous bird. Belaynesh's family knew what a disappointment that stew was going to be.

LIZA MONROY

Soli/dairy/ty

FROM *Longreads*

ON THE VERGE of turning forty, all my habits felt ingrained. So I was surprised when, late last February, I became vegan one morning, following an intuitive stab out of the ether. It made no sense, not yet, and Joaquin Phoenix's viral Oscar speech was still a year into the future, but I'd promised myself to always follow my instincts after, ten years prior, that little voice within had attempted to warn me to hide my laptop before leaving my apartment. Perplexed by the absurdity of this non-thought, I'd ignored it only to return to find the laptop submerged in the bathtub, fallen victim to a vengeful ex-boyfriend's rage. Life had since quieted and so had the little voice, until it resurfaced whispering, *be vegan for the month of March.*

As a twenty-year ovo-lacto vegetarian-with-a-sushi-exemption, I found the hunch puzzling. Still, the voice had spoken, so I didn't question it, though I did start searching for reasons. As a second-time mother to an infant, then seven months old, I felt lacking in structure, focus, and goals, and veganism gave me a way to try and put some version of that back into my life. Or perhaps, like a culinary Oulipian, further constraints would spike creativity, breaking my egg-and-cheese-bagel-salmon-nigiri routine with more colorful vegetables. What I definitely wasn't thinking: dairy cows, other than to joke that, hooked up to my mechanical breast pump, I felt like one.

Though I couldn't pinpoint a rationale for my non-choice, I knew what I wasn't and would never become: one of those unpleasant extremists who espoused "radical vegan propaganda,"

who harass you with pamphlets depicting horrifying conditions of factory farms.

And then I went to VegFest. The pamphlet was lying on a table with others containing recipe ideas and shopping lists. But this one, about the practices of the dairy industry, caught my nursing-mama attention in a new way: "A cow must regularly give birth to produce profitable amounts of milk," it read. Though I was against killing animals, I'd believed dairy was only a matter of taking something that was already there. I'd operated under the assumption that milking a cow was taking a nutritionally beneficial substance that would otherwise go to waste, as if all dairy cows were overproducers like me, milk running in streams. I'd never encountered this simple information about their pregnancy. "Similar to humans," the pamphlet continued, "a cow's gestation period is about nine months. In that time she develops a strong desire to nurture her baby calf—a calf that will be taken from her hours or days after birth. Cows can live more than 20 years, however they're usually slaughtered once lactation decreases at about 5 years of age."

At first it was the babies being taken away that got me. Motherhood had instilled in me an understanding of the deep, cellular-level, biological attachment to the calf. *It must not be entirely true,* I insisted to myself. This pamphlet was the dreaded "militant vegan propaganda." I went online in search of contradictory information, but even meat-industry trade publications indicated this process is but simple fact-of-the-matter, nothing to get worked up about.

An article by rancher Heather Smith Thomas in *Beef* magazine states that, "There's a complex hormone system involved in causing birth and initiating lactation." Pregnancy and birth for a cow entails a physiological process nearly identical to humans'. The mother's body produces oxytocin during labor, bonding her to her calf and bringing on a strong desire to nurse. Exactly like the pamphlet said. Exactly like my own experience.

Suddenly, I felt a little, well, militant in spite of myself. The timing of having recently become a small-scale milk producer again made it obvious in retrospect: milk wasn't just *there,* in mammals' mammary glands. You had to have a baby to get it there. I didn't just happen to have milk in my udders either—I had to get pregnant and give birth before it came and turned my breasts into hot, painful footballs only my baby or a horrible breast pump could

relieve. I'd had no idea my beloved ice cream and pizza were the cause of suffering. But dairy cows with lower production rates are not economically viable. They are sent sooner to slaughter.

Sailesh Rao, a Stanford PhD and former systems engineer who founded Climate Healers, a nonprofit fighting climate change, told me: "During a visit to the Kumbhalgarh Wildlife Sanctuary in India I observed how the forest was being destroyed by cows eating anything new growing out of the ground while old-growth trees were being cut down. I realized it was even better to eat some beef to finish off the cows after I had exploited them for milk. I resolved to go vegan on the spot."

Environmental reasons were obvious, but on the compassion front, for years I'd taken imagery on dairy-milk cartons literally: peaceful cows standing in fields beside gentle farmers seated on stools, red barn in the background under a vast open sky. Was that the real propaganda? In YouTube videos of the routine dairy-farm practice of taking newborn calves from their mothers, the distress cries sound chillingly like day care drop-off, except the afternoon reunion will never come.

I grabbed a couple of magnets and affixed the pamphlet to the fridge.

What is human responsibility to other species? In his seminal essay "Consider the Lobster," David Foster Wallace tackles the question of animal pain and the ethics of boiling a sentient creature alive. Of gourmet foodies, Wallace asks, "What makes it feel okay to dismiss the whole issue out of hand? . . . is it just that they don't want to think about it? Do they ever think about their reluctance to think about it? . . . Or is all the gourmet's extra attention and sensibility just supposed to be aesthetic?" Wallace admits that his line of questioning, "while sincere, obviously involves much larger and more abstract questions about the connections (if any) between aesthetics and morality, and these questions lead straightaway into such deep and treacherous waters that it's probably best to stop public discussion right here. There are limits to even what interested persons can ask of each other."

I'm not sure Wallace meant the concluding line literally. It's a rhetorical move on which to end the essay so the conversation might continue off the page, with "interested persons" transcending perceived limits and having those conversations. Wallace

leaves it to readers to weigh what he's shown and make up their own minds.

My new project, I would have spent a few weeks telling you, was to write the "Consider the Lobster" equivalent for dairy cows. But my mental wiring changed after I became a mother. I operate on instinct. I feel everything more intensely. I get worked up. Is that not palatable, though? Writing a "Consider the Lobster" of dairy cows was impossible, I realized, because it would be as if, rather than landing a magazine assignment about a lobster-eating festival, Wallace awoke one morning in a Gregor Samsa–esque horror to discover he'd been turned into a lobster himself, his own body at risk of comprehending firsthand the feeling of being boiled alive. As a lactating mammal, I was too close to my subject to risk attempting objectivity. Even the word "mammal" has its roots in Late Latin, "of the breast."

My sweet, patient husband was left questioning whether his marriage vows extended to living with a lactating mom gone vegan who was channeling the souls of dairy cows. But when I forced him to watch five minutes of footage of a moments-old calf learning to latch and nurse in extreme close-up—along with every top-rated plant-based documentary, titles like *Vegucated, The Shame of Point Reyes, Vegan: Everyday Stories,* and *Cowspiracy*—, he offhandedly observed: "That's just like Aleshandra." Our baby.

Not only could I see it, I could identify. The newborn's rooting and searching, failed attempts before the first successful latch, the satisfaction in the result, the baby guzzling and gulping the milk her mother's body had created to sustain her. I had a chilling vision of a dystopian future where aliens colonize Earth and decide that human milk is the ultimate delicacy.

"Can you imagine," I said to my husband, "if, right after birth, someone took Aleshandra away, hooked me up to an industrial breast pump, and I never saw her again?"

"You're anthropomorphizing cows," he replied. "Animals don't experience loss or pain the same way."

I was unsure. Our two pets, a pug and a potbelly pig, Señor Bacon (subsequently renamed Señor Vegan), are practically human to me. When I mention them, people think it's normal to have a dog but are astounded to find we have a pig living in our backyard. Why was the dog normal but the pig strange? When one of them

had a shoulder injury, our vet said not to presume it wasn't painful because they don't vocalize pain the way humans do.

Research has shown that cows aren't "dumb beasts." They develop strong friendships, communicate, invent games, babysit, and self-medicate. If they don't care to be forced into childbirth, again, a process nearly identical to humans', they can't express that either.

"It's not even about cows," I said to my husband. "They may not perceive it. But *I* feel it. *I* know."

Given that my identification with dairy cows was overflowing more than my own milk ducts when I skipped a feed, it followed that I wanted to meet with one.

Vegan chef and dairyless-cheese innovator Miyoko Schinner co-founded a farmed animal rescue sanctuary, Rancho Compasión, on her home's land in Marin County. On a sunny Saturday morning, my husband and I made the two-hour drive from Santa Cruz to Rancho Compasión to visit rescued former dairy cow Angel. I wasn't sure what I was hoping for. It wasn't as if I'd be able to interview her. Angel couldn't tell me anything about what she'd been through. Still, spending some time with her, I hoped, would be what gave me some ammo to write the "Consider the Lobster" equivalent for dairy cows after all: I would go up to her, look into her eyes, pet her, and have a moment that would allow me to form, at last, a central thesis for my essay.

Upon arriving at Rancho and glimpsing Angel, I awaited the stab of connection, of identification, I'd been certain would come. It didn't. Angel was accompanied everywhere by her best friend, a goose, and when I tried to approach the cow, her goose charged me. It brought to mind the ways differing species have complex relationships between themselves too; it's not just humans and their pets. The relationship between Angel and her goose reiterated the intelligence of animals—and how we don't fully understand that intelligence. Defensive goose aside, I was also a little bit nervous. Angel was massive. I got distracted from my quest by adorable frolicking pigs, like Oliver, who was saved from being roasted for a luau, and numerous friendly goats. Finally, I stared down Angel from a distance, ready for transcendence. Then she lifted her tail and peed a proverbial river. The gushing stream brought to mind Rao's environmental argument for veganism. Every minute, seven

million pounds of excrement are produced by animals raised for food in the United States. When Angel finished her contribution, I finally approached.

Running my hands over her soft coat led to no deeper insight, no flash of revelation, no central thesis for my essay, but as we drove away from the ranch a couple of hours later, Angel, her bull friend, and the goose—this interspecies family—stood together in the field, watching us go. Something shifted. Post-Compasión, veganism didn't feel so radical anymore. Spending time with the animals even somehow inspired my husband to no longer purchase meat or dairy products.

"Being there and seeing it reminded me of the environmental cause I'd fallen off the wagon about," he said. "During the tour they mentioned that factory farming is not only cruel but a huge pollutant, and it reminded me. The diary and cattle industry is the biggest offender so I'm not going to eat meat or drink milk—you forget the milk industry is the same thing. Meat is cruel and dairy must be cruel too."

I was so surprised by the words coming from his mouth I wrote them down for the record. Even more surprising: the next time we went to our favorite local café, he ordered his cappuccino with oat-milk. It wasn't a major change but it felt like one.

In her talk "The Hidden Cost of Patriarchy," self-proclaimed "feminist killjoy" Jennai Bundock states that "understanding that animal agriculture is an exploitation of female animals' bodies" made her vegan. "It's breeding programs that make meat," she says. "Eggs and dairy are both feminized proteins. They're exploiting the reproductive systems of female animals exclusively . . . across species. I don't know why we don't call that out, because this is a feminist issue. As soon as I made that connection, there was no way I could unconnect it."

I couldn't, either. While a bull gets "collected," a dairy cow is artificially inseminated, impregnated, goes through the labor process, and endures hormones that bond her to the calf, only to have the calf taken in the moments after the birth while she's hooked up to the industrial breast pump. I didn't mind nursing but I hated pumping. I was consumed by a new question: Can you be a feminist if you consume dairy? Is milk a product of violence against female bodies?

For the bull, "collectors" use a so-called "teaser animal" to prepare him to mount. Then they use a fake vagina with 66-degree water and K-Y Jelly. One collector told *Vice* magazine of the bulls, "The majority of them know what they're coming out to do." They also know when they're headed to slaughter. In the *Guardian* article "Cows Are Intelligent, Loving, and Kind—So Should We Still Eat Them?," farmer Rosamund Young, author of *The Secret Life of Cows,* says, "The young animals that go to be killed, I would guess most of them don't know what's going to happen. Most. The older cows know more. Some of them think, 'This isn't right, why am I not at home? That smells funny.' There are levels of intelligence and therefore levels of stress and suffering." Though dairy cows are also slaughtered, their lives are shorter and more brutal than their male counterparts'.

When I first wrote the phrase "babies being taken away" at the outset of this essay, my mind instinctively flashed to migrant children and the Trump administration and I cringed. I feared making that comparison, of entering that into discussion here. *Are you comparing cows to people? In an age when the government puts human babies in cages?* In conversation with a friend, speaking of social justice and how there are "more important things" in the human world —income inequality, poverty, racial and gender injustice—*why should we even be talking about cows?* But we were putting up a false binary, as if caring about animals could detract from caring about humans. If anything, it can only increase our compassion: animals are sentient, yet it's easy to "other" them; they are literal others. How can we stop treating people like cattle until we stop treating cattle like cattle?

Schinner, *la dueña* of Compasión, is something of an expert in this. Writing in the *Point Reyes Light,* she says, "While we strive to overcome racism and sexism, another social-justice issue challenges our times: speciesism. A rancher in West Marin once said, 'I've given them a good life. Now I get to end it.' Had he been talking about dogs instead of cows, we would have cried abuse. But why do we feel okay—even that it is necessary—to do as we want with cows, pigs, chickens, sheep and other farmed species? Why do our rules differ based on species? Ultimately, what we call 'animal rights' is about us—humans. It is about our own humanity and the choices we make to shape the future."

Why had I wanted that pamphlet to be "militant vegan propaganda" so I could dismiss it? It would have been easier to go on not having seen it, to continue accepting the placid images those milk cartons would have me believe. And why was I familiar with that phrase, but not "animal-agriculture propaganda"? Certain things are cultural norms, and to disturb that frankly disturbs the very fabric of our by nature fabricated realities. As with the Trump administration separating migrant children, if we don't see it—even if we can see it—in the news or online, there's still an element of unreality: *Can that really be happening?* And *could it really be as bad as it appears?* Though we know the answer, as with bad slaughterhouse footage, it's tempting, after the momentary horror, to revert to doing whatever we're doing. But what if you try to really know it? Internalize it? What if we awoke in a new way to what William S. Burroughs famously termed the "naked lunch," that frozen moment when everyone sees what is really on the end of every fork?

Angela Davis asks how we can develop compassionate relations with other creatures with whom we share this planet. "That would mean challenging the whole capitalist industrial form of food production," she states. Davis points out the "lack of critical engagement" with the food we eat. "The commodity form has become the primary way we see the world. We don't go further than the exchange value of that object, whether it's food, clothes, iPads . . ." Davis suggests developing "a habit of imagining the human relations and nonhuman relations behind all the objects that constitute our environment."

It's difficult terrain. There are certain paths on which it becomes a little scary to tread, lest one end up living in a yurt off the grid on a permanent silent retreat, naked and living on beans.

As it is, the refrigerator in my small household is completely plant-based, yet stocked as ever. We aren't at a want for anything and our budget isn't crazy impacted. My husband, who claimed he wouldn't like the plant-based products because the taste would pale, has trouble telling the tofu veggie cream cheese from the regular, the pizza cheese from vegan replacements. On two occasions he has been wrong—twice not able to tell the difference.

"Isn't it interesting?" I said. "It's not taste; it's mental conditioning."

Small children aren't yet wired with these social norms. When my four-year-old, Olivia, and I talk about the reasons why mommy

is vegan, she latches to the mothers-and-babies part. The other morning at the breakfast table, over cherry cashew yogurt, she asked for the thousandth time, "Why do the babies get taken?"

"You mean the cows?" I asked.

She nodded.

"It's the way mommy's body makes teeny [aka breast milk] for Aleshandra. A mommy cow's body makes teeny for her baby, too, but they take the baby away and put the mommy on the 'pumpers' so people can drink it instead."

"And where's the baby?"

"They put the baby in its own separate little hutch."

"By self?"

I nodded. Olivia got quiet.

"How do you feel?" I asked.

"Really sad," she said.

"Yeah," I replied. "It is."

I remember, as a child, being presented with a glass of milk and instinctively reacting with repulsion, but feeling something was wrong with me. Wasn't I supposed to like this stuff, at least if it had chocolate in it? Didn't my body need it for healthy bones? (Propaganda!)

My early twenties saw barely the dawn of soy milk at Starbucks. Eighteen years later, almond, oat, macadamia, and hemp are café menu staples and cashew-based cheeses are a far cry from rubbery replacements of the not-so-distant past. While some dairy proponents counter that almond milk is an unsustainable option because of land and water use, all of the plant-based milk options ultimately use less land and water than what it takes to keep dairy cows fed and watered over their lifetimes—they eat and drink so much more than humans. And while almond is the worst as far as environmental impact, oat-milk is a sustainable option, according to a recent University of Oxford study.

My tastebuds are awakened in a new way by the deliciousness of plant-based foods: creamy, coconut-milk ice cream, cashew-cheese pizza, and the simple variety of plain old vegetables. I wonder if, by attempting to raise two vegans in this era of awareness and better substitutions, the domino effect can spread to the point where future generations will look back on an uncivilized past society of bull masturbators and planet damage just so people could engage in the bizarre custom of drinking another mammal's milk and

think, *Why did they ever do that when we get a similar-enough substance from nuts not attached to sentient beings?* A mother can hope.

Maybe I get so worked up because, after birth and during breast-feeding, my social mores got stripped away. I dwell in a primal mammalian state. The calf is everything. Is the calf crying? Is the calf hungry? Does the calf need a diaper change? And, if momentarily out of sight, where is the calf? Is the calf attempting to climb the spiral staircase or stick a fork into an electrical outlet? Relief arrives when holding the calf, nursing the calf, staring intently into the calf's eyes and experiencing this connective, beautiful light. The urge to nurture the calf. I can't know what new motherhood feels like to a cow, but this is how it was for me—simply animal instinct.

Get Fat, Don't Die

FROM *Hazlitt*

IN HIS INAUGURAL food column, Beowulf Thorne included recipes for gingerbread pudding, Thai chicken curry, and vanilla poached pears, plus a photo of a naked blond man spread-eagled in a pan of paella. *Eat your cereal with whipping cream,* he advised readers, *and ladle extra gravy onto your dinner plate.* "Not only does being undernourished reduce your chances of getting lucky at that next orgy, it can make you much more susceptible to illness, and we'll have none of that," Wulf wrote.

Get Fat, Don't Die!, the first cooking column for people with AIDS, ran in every issue of *Diseased Pariah News,* the AIDS humor zine that Wulf started and edited from 1990 to 1999. Under the byline "Biffy Mae," he passed along reader recipes, mocked nutritional supplements marketed to people with AIDS, and leaned into Bisquick, his tastes alternately cosmopolitan and straight-from-the-box comforting.

Telling readers with T-cell counts in the double digits to lard their food with Paula Deen–ian levels of cream sounds like nutritional heresy. Yet Wulf's advice echoed the recommendations that doctors and nutritionists were giving patients with AIDS wasting syndrome. "The famous expression 'You can't be too thin or too rich' was obviously coined before the AIDS epidemic," Wulf wrote. As the paella nude signaled, his column claimed the right to pleasure, but in each recipe was embedded an urgent appeal that recipe writing of the 1990s had dispensed with: eat so you can survive.

I came across Get Fat, Don't Die! in a queer library in Minnesota in 1991, the summer after my sophomore year in college,

and its raw, punk camp electrified me. The memory erupted out of some dark pool several years ago, and I eventually traced the column to the archives of the GLBT Historical Society in San Francisco, which had accepted Wulf's papers as he was dying. The organization had digitized all eleven issues of *Diseased Pariah News*, they told me, and emailed the link. It electrified me all over again.

According to his friends, Jack Foster's arrival in the Bay Area in 1983 was as much an escape as a pilgrimage to the West Coast's gay sanctuary. Escape from the denunciations of his father, a military contractor in Southern California. But also escape from the older gay men who'd taken him in several years before as their underage sex pet. He moved to Palo Alto and began attending the Stanford Gay and Lesbian Alliance, which was open to nonstudents. He was eighteen, and already infected.

Jack soon moved into a household whose inhabitants and visitors—Stanford grad students, activists, budding software engineers—called it "Listing Shambles." Birth names at Listing Shambles were shucked as readily as the sheets at their toga sex parties. Jack Foster rechristened himself Beowulf Johan Heinrich Thorne, or when the camp flared particularly hot, Biffy Mae.

Tall and lean, striking or anonymous depending on the angle, Wulf had a slim face whose stern, L-shaped nose fought against the sensuousness of his bottom lip. He wore round wire-rim glasses with lenses thick enough to form a white ring and moussed his blond bangs into a studied flop. He considered himself a perennial twink. Or, really, a nerd, his friend Kira Od said, whose big feet always seemed to be in his way. And yet, she added, he was *naughty*.

"He had a deep and abiding sense of black humor," agreed Arion Stone, his roommate at Listing Shambles. Friends remembered that Wulf gardened masterfully, but only toxic plants, and burrowed into esoterica like tillandsias or Russian noun declensions. He cooked and cartooned and wrote and gardened with what Arion called a "sublime self-assurance about his abilities."

After a year or two in Palo Alto, Wulf earned a scholarship to study bioscience at UC Santa Cruz, working on safe-sex education causes with the Stanford crew in his spare time. But as his senior year approached, the virus began making sorties in his system, and

Wulf realized he wasn't going to live long enough to earn an advanced degree. He dropped out of school and took up graphic design, just as desktop publishing software supplanted pasteup boards and typesetters. A job at Addison-Wesley designing scientific textbooks allowed him to move to San Francisco in the late 1980s. There, his roommate was Tom Shearer, a technical writer with an acerbic wit and a lower T-cell count.

Inspired by ACT UP but too introverted to join its protests, the two came up with their own way to fight the stigmatization and mawkishness of the epidemic: humor.

Twenty-four years after protease inhibitors and combination antiretroviral therapy (the "cocktail") brought the immune systems of millions of HIV-positive people back into healthy ranges, it's hard not to read *Diseased Pariah News* without straining for a happy ending. *Hang in there for a few more years!* the brain shouts at each page. The same thinking that collapses World War II into a moral victory and the civil rights movement into a triumph has recast the plague years as a self-contained tragedy.

Yet to laugh at Wulf's and Tom's jokes—to take in the full spectrum of the rage and grief coded into each shocked laugh they dragged up from your chest—requires you to strip away the safety of history.

In 1990, the cocktail was an untested theory; on the market was nothing but death and toxic drugs. Despite the rising numbers of infected women and children, and the devastation the plague wreaked on the trans community (with little mention in the press), AIDS in North America was twisted up with gay identities. When US scientists first observed a cluster of strange illnesses and deaths they dubbed Gay-Related Immune Deficiency in 1981, the LGBT movement had only asserted itself publicly for a decade or so. It was still so fragile, so niche, that most people outside major cities had never encountered LGBT people before they saw photos of young queer men with sunken faces, covered in purple lesions, in the news. It confirmed to some that God was punishing this aberration the moment it denied its sinfulness.

For many older gay men and trans folks, AIDS snatched away everything they'd made of their lives and poisoned the raucous liberation of the 1970s. To children like me, only ten when GRID

appeared, coming out into the plague meant love and rejection and sex and hideous death would knot themselves up so tightly we could never tease the strands apart.

By the time *DPN* published its first issue in 1990, four people were dying of AIDS every hour, and the US death count was rocketing up to 100,000. According to David France's *How to Survive a Plague*, by then at least twenty US states had considered quarantining people with HIV in camps, arresting them for having sex, or even tattooing their status on their bodies. Hate crimes spiked across the country, to the indifference of many police departments.

For all the services—hospital wards, pet care, volunteer housecleaning, support groups, hotlines, meals—that community groups constructed in the absence of government support, the first generation of helpers were burning out and the death rate wasn't slowing down.

That year, many say, marked the darkest period of the epidemic. For Wulf and Tom, turning the plague into a sick joke was a radical act of self-love.

"A few years before I had seen a bitter little cartoon," Tom wrote in the introduction to the first issue. "An airline had refused passage to a person with AIDS, and there was a big stink about it. The cartoon showed a man at an airline counter, and the clerk was saying 'And would you like the smoking, non-smoking, or diseased pariah section?' Mr. Tom was much impressed by this terminology and began to refer to himself as a diseased pariah, to much dismayed fluttering from his friends. At the time, remember, the only acceptable role for an infected person was Languishing Saint and Hug Object."

Tom wrote half of the text, Wulf the other half, under such pseudonyms as "Serene Editor" (Tom) and "Cranky Editor" (Wulf). Wulf repurposed the "Captain Condom" comic he had invented in the course of his safe-sex education work and laid out the issue on legal paper, folded in half and stapled. They filled *Diseased Pariah News* with stunts, porn reviews, comics, naked centerfolds, erotic anecdotes from a well-known sex worker titled "How I Got AIDS," and personals.

The recipes in the second issue, printed alongside recommendations for eating when you had diarrhea, ranged from the ambitious to gluttonous convenience: Biffy Mae's Totally Amazing

Gumbo. Marcus Mae's Roast Chicken of the Ages. Danny Mae's Fat Boy Shake, which combined Ovaltine and instant breakfast powder and could be powered up with two scoops of ice cream. Wulf tested every recipe, nudging them into shape. He took the column's blunt title in earnest. The jokey names and camp flourishes kept his earnestness at a safe distance; too close, and the fear and physical discomfort and bitterness could smother.

As Biffy Mae wrote in that second issue, "One of the most exciting aspects of the HIV Early Retirement Plan is what it may do to your innards."

Wasting syndrome, which one-third of all people with AIDS experienced then, wasn't just one of the most common effects of HIV. It was the *look* of AIDS: Arms devoid of muscle and fat, the humerus, radius, and ulna so exposed that you could read the knobby topography of the joints that connected them. Hips that were no longer hips, legs no more fleshy than a water bird's. Faces whose skin draped lightly over bones and hollows, faces made unrecognizable by the obliteration of fat and muscle. You could go back to work after a case of pneumocystis pneumonia (PCP) and pretend it was a regular illness, or cover Kaposi's sarcoma (KS) lesions with clothing if they were in the right places. There was no disguise for wasting.

And yet the most prominent memoirists and fiction writers who chronicled the plague years—Harold Brodkey, Larry Kramer, Paul Monette, Hervé Guibert, David Wojnarowicz, Adam Mars-Jones, Allen Barnett—barely invoked its horrors. So many of the narratives of the time circled around two themes: memorializing the terror and adulterated sweetness of being alive as everyone they knew was dying, and shearing through the cordon of dehumanizing indifference that the public had erected around plague-struck communities. The experience of daily diarrhea or constant nausea may have been too visceral, too private, or simply too grinding to fit into the arc of a plot. And so, for all the poignancy that lingers in the public's understanding of the plague era, the lived experience of wasting has faded out, vivid only in the memories of survivors and medical researchers who had tried to halt its progress.

Wasting only appeared when the body's CD4, or T-cell, count dropped from over 600 per cubic microliter of blood to under 200, Mark Jacobson, a physician and researcher who worked at

San Francisco General Hospital in the 1980s and 1990s, told me. People weren't only dying of opportunistic infections. They were dying of sheer malnutrition. "Loss of lean body mass was one of the most powerful predictors of when people were going to die," he said.

As the body's immunological systems shut down, bizarre symptoms seemed to pile up. Diarrhea could last months, the intestines gleaning whatever nutrients they could catch as the food luged through them. The diarrhea could be caused by mycobacterium avium-intracellulare or by parasitic infections like cryptosporidium and microsporidia that wouldn't respond to drugs. HIV alone could cause the entire gut to become inflamed.

But diarrhea was only one of the factors that caused wasting, said Kathleen Mulligan, a retired faculty member in the UC San Francisco endocrinology department who studied wasting in the 1990s. "It turns out the main factor contributing to wasting was the inability to eat enough food to cover their energy needs," she said.

Even people never given a formal diagnosis of wasting syndrome struggled to eat. "It's striking how rapidly eating becomes a chore when it ceases to be pleasurable," she explained. "The drugs made the food taste bad or different. People had painful ulcers or sores in their mouths, so it was difficult to tolerate food. Couple that with stress and depression, nausea from both the disease and the drugs to treat the disease—it was easy to tell people to eat more, but not that easy to find a way to motivate people to get the food they needed."

Any relief was worth trying. Anabolic steroids. Human growth hormone. Testosterone. Megace, a drug that exchanged weight gain for sexual desire. Heaps of vitamins. Wheatgrass juice. Kombucha. Pau d'Arco. Synthetic THC. Homeopathic drugs. Macrobiotics.

If the scientific consensus was that high-calorie food was the best treatment, sometimes improbable measures brought relief. Vince Crisostomo, who now leads the San Francisco AIDS Foundation's network of long-term survivors, was diagnosed with wasting in 1989, when his weight plummeted from 145 to 119 pounds. He felt as if his body was eating itself alive. He wore baggy clothes to cover his too-thin limbs, but his skin turned gray.

With an immune system so dysfunctional, everything made him

sick. "I learned that if I ate certain processed foods I'd get chemical burns in my mouth," he said. "I drank white rice and it turned to alcohol in my stomach." Hosts of food allergies appeared.

A friend helped him attend an "instinctive eating" program in Europe that put him on a raw-foods diet, and that infusion of nutrients, he said, made a massive difference. For months at a time all he could eat was macrobiotic broccoli and brown rice. He had grown up in Guam, where the food was highly flavorful, and he thought to himself, *Well, if this is how I have to eat for the rest of my life, I will do it.* The weight returned, and stayed with him long enough for the cocktail to come along.

Between the publication of issue two and three of *Diseased Pariah News,* two significant events occurred.

Surprising its editors, the zine got famous. In 1991 *SF Weekly, New Republic, Los Angeles Times,* and *Newsweek* all wrote about the shocking notion that people could make fun of the disease killing them. In the contact sheet from *DPN*'s first publicity shoot, which provided photos for some of these articles, a healthy Wulf and a cavernous Tom posed on Tom's hospital bed. They played it straight for a few frames, then Tom lolled on his bed like a 1930s pinup girl, two wrist-thick thighs emerging from his gown. Wulf joined for another frame to strangle Tom with his oxygen tube.

Tom, whose dementia had made a begrudging caregiver of his roommate, died a few weeks afterward. Before, though, he used his credit cards to charge thousands of dollars of equipment for Wulf to use on the magazine. With Tom's creditors harassing him daily and more symptoms appearing, Wulf left San Francisco to return to Listing Shambles in Palo Alto.

"Darn! One of Our Editors Is Dead!" Wulf titled Tom's obituary, and promoted him to "Deaditor." Daniel Bao, one of Wulf's best friends who took charge of the magazine's operations, said their circle of friends sprinkled some of Tom's ashes into plastic resin to make nightlights.

A newcomer named Tom Ace, a computer engineer who had first encountered Wulf through his personal ads, stepped in as the publication's Humpy Editor. What drew him to *DPN,* Ace says, was a stance no other publication dared take on. "No denial," Ace said. "No pretending it isn't the way it is." No spiritual balms, no stigma, no shame, no sentimental bravery. They were people dealing with

an illness, not the victim-perpetrators the media made them out to be. They were still having sex, and watching porn, and posing for nude centerfolds that ran with their T-cell counts and list of meds.

"We think that if you're going to croak sooner than you'd like, at least you can live while you're alive," Wulf told the *Los Angeles Times*.

> NED: Why are you eating this shit? Twinkies, potato chips . . . You know how important it is to watch your nutrition. You're supposed to eat right.
> FELIX: I have a life expectancy of ten more minutes. I'm going to eat what I want to eat.
>
> —Larry Kramer, *The Normal Heart*

Paul Monette wrote in *Borrowed Time*, a memoir about his partner's 1985 death, "It turns out a home-cooked meal offers a double dose of magic. At the same time you're making somebody strong again—eat, eat—you are providing an anchor and a forum for the everyday."

Sometimes cooking, like black humor, could save the life of the cook too.

Fernando Castillo, whose recipes formed the culinary backbone of Project Open Hand in San Francisco, said that cooking for the organization in the 1990s was the only thing that assuaged the pain of a decade of horror.

After his lover died of AIDS in the very first wave, Fernando had moved into a large Victorian flat in the Mission, San Francisco's Latino neighborhood, with his closest friends. But death chased him. One by one, his "babies"—his brothers, his sisters, his chosen family—got sick. So did the landlord upstairs. The Polk Street Mexican restaurant where he was chef closed in 1986, and he was too busy caring for his babies to look for another job.

He became the building's main caregiver, bringing in more friends after others died. He would go from one bedroom, where one of his babies was vomiting, to the next, where another's fever was spiking. He would take them in taxi cabs to the hospital so frequently the nurses knew his name. And, from morning to night, he cooked.

"I learned that I had to give them something not too heavy, but at the same time nutritious," Fernando said. That meant chicken

soup loaded with vegetables, stews made with the best meat he could afford, rich stocks with bones or fish heads. A lot of rice, and a lot of beans.

Some of his babies had such bad cases of thrush—an overgrowth of yeast that coated throats and tongues in irritated white fur—that he had to puree the stews. Others, who were taking AZT by the fistful, developed weird allergies or lost the ability to digest dairy or beans. There were few social services for people with AIDS in those days, but people in the Mission found out about what he was doing. They would pass along some money. Markets would slip in extra meat, or charge him less. He took care of his seven friends until they died.

In 1991, the last of his babies gone, he was considering whether to accept his sister's offer of a plane ticket back to their hometown in Mexico. Then Ruth Brinker, the founder of a San Francisco meal service called Project Open Hand, asked him to come into the kitchen to help her out. "Instead of being in mourning in an empty apartment, I joined Project Open Hand," he said. He adapted all the dishes he had written down in a tiny booklet so they fed thousands of people a day.

In the middle years of *Diseased Pariah News*'s run, Wulf and Tom Ace were joined by a Sleazy Editor, Michael Botkin, a journalist famous in the Bay Area LGBT community for his AIDS Dispatches column and equally dark sense of humor ("dead meat specials," he once called people with AIDS). The zine's circulation rose to 3,000, sold at LGBT bookstores and Tower Records around the country. Tom now recalls that people would stumble across an issue, write to the editors, and order the entire back run.

The editors always intended to publish four issues a year, but only managed two or three. They'd call in their friends for assembly parties, Wulf fretting over the placement of each NOT SANITIZED FOR YOUR PROTECTION paper band they wrapped around the zine, scaring off casual browsers.

Any idea that would double the editors over with laughter made it into the magazine. They recorded parody songs on a flexible vinyl single and stapled it into the zine. Wulf devoted a number of spreads to AIDS Barbie and KS Ken, wasting away so attractively, their lesions courtesy of a blowtorch. KISS ME, I'M A DISEASED PARIAH! T-shirts and buttons sold by the hundreds, helping to cover

the production costs. They also marketed "AIDS Merit Badges," each depicting an opportunistic infection or alarming T-cell count (achievement unlocked!), for people to wear on a sash to their medical appointments.

Readers sent in poetry and essays they hoped *DPN* would run, not to mention dozens of recipes, each of which Wulf would re-test: Calorie-Packer Hash. Mysterious Cheese and Nut Loaf. Hard-Hearted Hannah's Pecan Buttercrunch. It was food for when you weren't sure you wanted to eat, food that might just keep you alive. But Wulf wanted it to offer pleasure too—and whether the appeal was trashy or refined didn't matter. Larding a zine about AIDS with recipes didn't just add a note of domestic camp that Biffy Mae, toxic-plant aficionado, clearly delighted in, the recipes interrupted the zine's dark humor, visually as well as psychically. You may be dying. Fuck. Buy yourself a box of Bisquick and make this berry dessert.

Alongside the recipes, Get Fat, Don't Die! covered avoiding possible parasites in sushi, eating when you had nausea, shopping on food stamps, and compensating for the taste perversions caused by drugs like AZT. ("Some liken it to a metallic taste, sort of like having a bloody nose all the time," Wulf wrote.) *DPN* may have been the first AIDS-related publication to instruct readers on making pot butter to bake into brownies to combat nausea and lack of appetite. The medical marijuana movement took off in San Francisco in the early 1990s, when Brownie Mary delivered edibles to AIDS wards and activists set up smoking lounges for the chronically ill.

In my favorite column, Michael and Wulf, who had "AZT butt" themselves, tasted every chocolate dietary-supplement shake doctors were pushing people with wasting to drink. Every one of them was chalky and tasteless, they concluded, and ran a recipe for mole poblano alongside.

These were the issues I must have encountered in Minnesota, and I remember flipping through them with a mix of awe and shame. Was it worry that someone might see me reading an AIDS zine and think I was HIV-positive? The sense that I had stepped into a room that wasn't built for me? The constant guilt I felt, as a healthy twenty-year-old, as if I was skipping across my elders' graveyard? All of those, most likely.

Now that I am decades older than Wulf was then, the gall of the magazine—to mock death, and shame, and governmental ne-

glect, and all the squeamish attempts at empathy AIDS occasioned —strikes me as a form of redemption. And to snicker at Wulf's jokes, each laugh tinged with the grief and horror I thought long buried, feels like the best way to honor him.

As neuropathy—probably from the fistfuls of AZT—made walking harder and cytomegalovirus retinitis ate away his field of vision, Wulf secured disability leave from his day job in the mid-1990s and retreated to a house he shared with Arion. *DPN* remained one of his main pursuits, along with gardening and fighting with his insurance company, but it took longer and longer to put out a new issue. Six months. A year. Two. Michael Botkin, Sleazy Editor, died in 1996. Tom Ace, Humpy Editor, left the Bay Area for the California desert. Protease inhibitors appeared, but Wulf's body was too worn out by then to benefit from them.

When Wulf died in 1999, at the age of thirty-four, he had readied the eleventh and last issue of *Diseased Pariah News,* complete with a years-old obituary for Michael ("He had looked like death warmed over for so long, we never thought he'd really die!") and a parody ad for AZT Lite. Tom Ace and Wulf's friends added a tribute to Wulf and sent it out, secretly sprinkling Michael's ashes into a few copies.

They played around with the idea of turning Wulf into a snow globe, but they couldn't figure out how to make cremains float in a viscous mix of Astroglide lube and water, and they didn't want to offend his mother, who had come up from Southern California to tend him in his last few weeks. At the "celebration of his extinction," she surprised them by wrapping the box of her son in shiny gold paper. "I think he might appreciate it," she said.

What It's Like to Self-Quarantine with a Michelin-Starred Chef

FROM *Grub Street*

HERE'S MY LOVE story, playing out in a fifteen-foot by thirteen-foot room. The single window faces a brick wall close enough to touch, and welcomes no sunlight. Under the glare of an overhead light, my boyfriend cooks, and I stare at the blue-gray walls, waiting to eat.

The gentleman is Kevin Rose, the chef of research and development at Atera, a fine dining restaurant at 77 Worth Street that's held two Michelin stars since it opened in 2012. If things were normal right now, you could book a seat around the open kitchen and pay $285, and Kevin would be there to serve you a series of beautiful courses, a play in seventeen stunning little acts.

He'd hand you a Shigoku oyster with a yuzu béchamel and a mound of Ossetra caviar. He'd slice a perfect scallop into a bath of white miso and sunchoke and Granny Smith apple. He'd set down a plate of rabbit loin and help you to figure out what flavor's poking through its accompanying bisque (fennel seed, maybe, or green peppercorn). Why, yes, they did burn oak to bring out the flavors of pilsner in that jus. Yeah, that pear was poached with pine needles.

But of course you can't do that right now, because Atera is closed.

While I'm a freelancer accustomed to working from home, accustomed to sitting very still, Kevin is used to standing for fifteen hours a day. He hasn't gone this long without serving people food since he started working in kitchens in ninth grade. So he

cooks for a clientele of one, of me, and every morning around 11 a.m., while I'm answering emails and trying my absolute hardest to maintain the pace of my breath, he interrupts to ask, "What should we eat tonight?"

It's the only source of joy, the only routine. We must eat, and we'll make it beautiful, and I'll feel obscene and grotesque in my luck, and also sated and okay, for a few hours.

What's it like to date a professional chef? people ask in a thrilled tone, about this rom-com boyfriend job, especially if they're New Yorkers. *Does he cook for you all the time?* Well, no, because when he's not working he doesn't want to be working. He wants to seek out food that is not like the kind he makes—so it's pho and sushi and curries and ramen and the sweetest, spiciest Szechuan we can find.

It's like this: I only see him on Sundays and Mondays, because he works from 10 a.m. to 1 a.m. the other days. It is downtime spent watching hours upon hours of YouTube videos about some old farmer in Japan fermenting miso in a barn, or researching new purveyors, or typing up recipes.

The walls of his small, dark room are lined with shelves as tall as I am holding cookbooks by Michel Bras and René Redzepi, Thomas Keller and Daniel Humm, Michel Guérard and Auguste Escoffier, or his former employer Daniel Boulud. When you open the closet you find seven button-up shirts and yet more cookbooks, or four encyclopedias about the wine regions of the world. His nightstand is a mini wine fridge. Under the bed and under the sink are plastic containers filled with pasta tools, silicone molds, madeleine pans, a milk frother, and a tamis for refining sauces until they're silken. He possesses those little steamer baskets for soup dumplings, plus the gelatin needed to make them himself, plus six jars of seaweed ordered from Japan and South Korea. His skinny, only-in-NYC refrigerator has a shelf of pickling jars: Meyer lemons preserved in sugar, lacto-fermented carrots, umeboshi plums floating in pink liquid.

It means he'll get a faraway look and ask, on a walk, how do you think it'd go if we added yeast to lighten the gnocchi?

And so he doesn't usually cook for me, no, but he does now. I request pasta and naan and pizza because heavier food slows down my hummingbird heart and makes it possible to sleep. He preheats the oven to 590 degrees for pizza, the highest it can possibly go, making a sauna of the Lilliputian space, but he's trying to

replicate the effects of the brick ovens in Naples. When that's too much, we have a night of asparagus in ginger and black vinegar and sunflower seeds, eggplant suffused with orange marmalade, cauliflower swimming in creamy saffron.

At the nearby Whole Foods, life-saving staffers with walkie talkies now socially distance customers and create a long line down Third Avenue, so we try Gristedes for once. When Kevin faces the olive-oil display, lines of generic gold, he sucks his teeth in dejected disgust. "Is Gristedes always this bad, or is it because of the virus?" he asks.

He forms the gnocchi with his fingers and tries the yeast component and hates how they turn out anyway and wonders to me, "If Atera is closed for at least six more weeks, I could maybe make gnocchi six more times? I want to get it right. Is that okay?" Sure, yeah, I'll eat potato dumplings every seven days. Where am I going?

We start cooking around 4 p.m. every day, and we start drinking wine, and we fret about our dwindling wine supply. And I worry about how my body will feel after six weeks or six months of sitting still and eating and eating and eating with a daily bottle of wine, but I already know how it feels: terrible and great and absolutely necessary.

I try to contribute by chopping veggies or stirring pots, and he controls his face and his breathing very well but I can still feel his pupils dilating when I burn the very basic scrambled eggs or get the timing wrong when sautéing onions. So I get enraged and stomp away (I have six feet of runway for stomping) and I say, "Okay, *you* do it then!" If I walked back to my own apartment uptown, with its single pot and single pan, I'd be eating a can of chickpeas every night and we both know that.

So he calmly whisks and measures and froths the sauces, and pauses only to comfort me through anxious rages. Only three days in, I read the wrong *Times* article at 1:30 a.m. about an eighteen-month vaccine timeline, and convince myself I'll probably never see my grandmother again, and I cry until I can't catch my breath and my eyelids are too swollen to blink. He strokes my hair and holds my angry arms, then boils water for elderflower tea.

The keen awareness that I am the luckiest person in this city, in this country, on this whole ravaged planet, and thus don't deserve despair, only serves to heighten the despair.

When I'm irritable and exasperated and short in my demands — for quiet, for a hug, for the last piece — his quick joke is to answer with, "*Oui,* chef!" the response taught to every young apprentice and student and line cook. This is how you grapple with the command to stay inside, indefinitely. You do what is necessary, you do what is asked, and you do it beautifully.

So on we go. He cooks, I eat. We take it one meal at a time.

Making Reservations

FROM *Gossamer*

WE PICKED UP phones. We put phones down. We picked up more phones. We typed names. Numbers. We put more phones down.

We did it in a SoHo loft, wearing jeans and tees, taking reservations for a gaggle of top-tier Manhattan restaurants, places that played themselves on *Sex and the City* and in the opening credits of *SNL*. Page Six sightings hubs. Places that act as central nodes for media movers, go-to celebrity cafeterias, and other platonic ideals of a glittering New York City restaurant scene: buzzy, beautiful, smartly controlled chaos.

The people on the lines were separated into four groups:

No Status

PROFILE: Plebes. Normies. In binary, zeroes. The largest of the four groups. On average, well over half the calls. Almost never got what they wanted. Almost always pissed.

PX (Or: Person Extraordinaire)

PROFILE: Magazine editors and food writers, gallerinas, flacks, fashion girls, low-D-to-mid-C-list celebrities. Sometimes got what they wanted. Often felt they deserved better. Often annoyed.

PPX

PROFILE: A rare, exotic bird. Important. Memorable. At least one person in the restaurant knows who they are on sight, sound, or name. An A-to-high-B-list actor, editor in chief or of note, a *Times* writer or Page Six gossip, a novelist, artist, or top-tier chef. Tina Brown, Graydon Carter, a Gosling, a Hemsworth, a Bushnell, a Rushdie, or (groan) a McInerney. Maybe a regular or neighbor. But mostly, bona fide celebrities. Maybe 10 percent of the calls. Usually got whatever they wanted.

PPPX

PROFILE: The ninety-ninth percentile. Royalty. No, really: actual, literal royalty. Wills and Harry. People who only need first names: Anna, Bono, Hillary, et al. Also, the owner, the owner's family, investors, the chefs, and anybody who'd racked up visits in the triple digits. This list was so small, you were able to memorize it, and probably should. Always got whatever they wanted.

Bonus: PAB

PROFILE: The PAB code flew under the radar of the owner, but was a secret language shared between Mission Control and the restaurants. Were you a dick to the maître d' or your waiter? Tip below 15 percent? Consistently late to reservations? A prick on the phone? The person with the thick Joisey accent who claimed to be a "friend of the ownah!" without even knowing his name? The entitled food writer who constantly bitched about the place in public but clamored for reservations privately? Were you the big-time editor who got caught fingering his mid-aughts microcelebrity date under the table and had to be asked, repeatedly, to stop? If so, congratulations, you've earned yourself a PAB code: "Punk-ass bitch."

 If you were a PX or PPX with one, we'd call you back after finding out what you did to earn the code, gossiping with the office

and maître d' about you, and deciding your night's fate in a for-
ty-five-second ad hoc kangaroo court.

(There'd never be a triple-P with a PAB.)

And that's how it went.

For the most part, the job represented little power. We stuck
to the playbook. Most of the day involved picking up a phone,
disappointing most of the people on the other end, hanging up,
doing it again. I can't speak for the others, but I was broke and
could barely afford my rent, much less a meal at these places. I'd
be lying if I didn't tell you it didn't feel good, sometimes, to deny
people their supposedly rightful place among the bistro chairs and
antique distressed mirrors. Our own slight act of anti-capitalist re-
venge. But whatever weird little thrill that provided soon boomer-
anged when you inevitably had to give that table to someone *more*
than them—more famous, more beautiful, more powerful—yet
another reminder of just how subjugated you were. This cycle only
deeply reinforced the truth of all the shit you were eating.

It was all the places those people got to go to that you couldn't.
In 2006, it was Don Hill's; it was Stereo on Halloween. It was
Lit Lounge or Sway—which you could get into, but would you
know anyone there? Later, it would be the cliques of writers who
all hung out together, who shared secret shit-talking Slacks and
bylines at all the right places. Long before that, it was in fourth
grade, when Billy Gaughn called you a kike and pushed you over a
pick in flag football. Everyone laughed. Of course, you'd run with
a good crowd of skaters in middle school, but none of them stayed
friends, and most of them ended up stuck in one way or another.

Twenty-five-some-odd years after that, you'd get into the *Pur-
ple* magazine Fashion Week party at the Boom Boom Room, only
to realize the only person as bored as you was Andrew Garfield
(PPX?), his head in his hands at the gold-accented bar, looking ab-
solutely dejected, forced into place like a zoo animal reminded of
his fake preserve, dead behind the eyes. And the people you'd run
into there, they weren't your real friends, the ones who wouldn't
know *Purple* magazine from your shitty purple prose. And you'd
go on to talk shit on your own secret Slack about others. You'd be
a gatekeeper of things where you could employ discretion: jobs,
bylines, parties other people would want to be at, where you might
not want them. Did they deserve to be excluded? Is there ever a
good way to answer that?

Occasionally, the calls were fun. People made small talk. Some-times, on a No Status or basic PX call, they'd make a joke out of begging. You could bond, momentarily, over the Sisyphean nature of both your roles. But occasionally, you'd get a call that started the right way, hit all the right notes. You pick up the phone, and they're earnest.

"We're gonna be in town for a few nights, and my girlfriend is a huge fan of *Sex and the City,* and we saw it on the show . . ."

And then, they'd say a thing, speak a shibboleth, gently lob an aside which emerged through the static of the hundreds of calls you've answered that day, a signal from the noise: some tender glint of awareness that recognizes just how unlikely this ask is. And you realize that they share in the same struggle that you do, to want things you can't have, and fret about how they, too, rate in the same way in the same unseen system. And you're also, both of you, maybe, trying to fight the feeling of whether or not entry to these places, or even the mere longing for it, somehow denigrates something essential about you to begin with.

". . . and I know you guys are a busy restaurant. So I'm probably screwed, here. But I figured it'd be worth a try."

There's a line from a movie: "Isn't it funny? The truth just *sounds* different." That's how the special words went. Never really anything specific so much as a general tone. Or some offering of vulnerability. Just two people, over the phone, dealing with an ar-bitrary, often capricious threshold of entry, and the desire to cross it. All these ways we keep people out, or let them in.

"If it helps, at all, it'd mean a ton. She's awesome, I promise. I'm okay, but she's awesome."

We weren't supposed to. I don't know if the others did. But with these, I'd always try. I'd ring up the host stand. Tell the kingsguard: *Cal, this guy isn't anybody. He's just really nice. He's someone we want around.*

Sometimes, I'd get back on the line, announce that they were good to go, to have a good time, and slot their name in. I never thought about how gratifying it was then, or how much it saved me and my sanity. I look back at all the times in my life I was selfish for years on end—not volunteering, not listening, not extending these small moments of unnecessary grace to a stranger—and that time in my life, specifically: angry, dejected, discouraged, beaten down. This dumb job gave me nothing more and nothing less than

the memory of these small graces, these micro-redemptions. The memory of: you weren't all bad. And you maybe—just maybe—might not be now.

I wouldn't discover the art of Jenny Holzer—the pithy, hilarious, angry platitudes she calls "truisms," often printed in large type, often projected in light, in public places, for anyone to see—until years later. Anyone familiar with her art knows the most famous of these truisms: "ABUSE OF POWER COMES AS NO SURPRISE." But I didn't fall in love with her art, helplessly, until I saw it alongside one of her lesser-quoted lines, among the obscure few of her unapologetically softer verses:

"IT IS IN YOUR SELF-INTEREST TO FIND A WAY TO BE VERY TENDER."

LEAH ROSENZWEIG

The Nazi Origins of Your Favorite Natural Wine

FROM *GEN*

WHETHER OR NOT we want to admit it, we are consuming a lot of alcohol while in quarantine. Nielsen, the market research firm, estimated that online sales jumped 243 percent during the prime stock-up weeks of the pandemic, with wine sales alone increasing by 66 percent. After a year of declining alcohol consumption, responses to COVID-19 have effectively undone last year's teetotalist trends and made alcohol easier to get. Wine shops and restaurants have begun liquidating their inventories, increasing the number of weird, natural, and rare options for wine drinkers to explore at home. Many of these come from places like the Czech Republic, Mexico, or Croatia, containing unusual grapes like malvasia, rebula, or blaufränkisch. And if you've been enjoying an Austrian wine called "zweigelt," you've got a lot to learn about a wine with a history you may not want to hear.

Zweigelt is a red grape used in wine that typically bears its name; it tastes like pinot noir, but with a bit more boldness and only a fraction of the *Sideways*-attributed success. The export value of Austrian wine has increased tremendously in the last few years, with a nearly 20 percent volume increase in the United States in 2018 alone. Accessible to every level of red wine drinker, a bottle of zweigelt typically costs between $14 and $30 and pairs well with a vast range of foods. It is Austria's second most important wine after Grüner Veltliner. Of the thirty-five organic wineries officially certified by Sustainable Austria, thirty-two of them grow zweigelt.

The sharp, blue-colored grapes grow easily and in spades, making it readily available for bottling.

A maverick in the "natural wine" movement—which generally refers to wine made from certified organic grapes, fermented with yeasts found in the vineyard, and bottled without additives like tannins, coloring matter, or sugar—Austria now occupies entire sections on wine lists of swank and experimental wine bars and restaurants. Zweigelt is a complex grape with a rich history—one that is currently in crisis in the wine community as it confronts the legacy of Dr. Friedrich Zweigelt, an early architect of Austrian viticulture, and a fervent Nazi.

Born in Hitzendorf, Austria, in 1888, Friedrich "Fritz" Zweigelt was an early lover of natural sciences who studied zoology and botany at the University of Graz, where he would also pursue a doctorate in 1911. The next year, he began work at the Klosterneuburg Institute of Viticulture near Vienna. Although his initial work as a researcher barely touched on issues of wine production, he would eventually become the institute's director, leading Austria in its efforts to build a national wine industry—separate from that of Germany.

Zweigelt made it his mission to improve domestic grape varieties by selectively cross-cultivating already existing vines. In 1933, Zweigelt joined the Nazi Party, which was banned at the time in Austria. At first, he barely acknowledged his affiliation, but over time his allegiance grew. In 1938, he expressed acquiescence— glee, even—at the seizure of power by the Nazis. The next year, Zweigelt began collecting information on his colleagues ranging from objective criticism of their politics to accusations of ideological unreliability, which he reported to the Reich Minister of Agriculture.

These outings of colleagues, or "cleansing measures," reached a new level when Zweigelt refused to issue a character reference for a young employee arrested by the Gestapo for potential ties to the Austrian resistance. Zweigelt's compliance resulted in praise and reward from other influential wine authorities. In *Das Weinland*, a wine magazine where Zweigelt served as editor in chief from 1929 until 1943, he was applauded for "overcoming resistance within a short space of time and in making the institute a stronghold of National Socialism." In 1941, the Gestapo dissolved a neighboring

monastery, awarding the viticulture institute forty additional hectares of land for cultivation.

Zweigelt was arrested by the Red Army in 1945, following the collapse of Nazi rule in Austria, and placed in a labor camp near Vienna. During his interrogation by the Soviets, he gave only small amounts of personal information, casting himself as a mere "follower" of the Nazis and not an active participant in the regime. He was released after six months in custody, and by 1948 criminal proceedings against him at the People's Court in Vienna were halted on the grounds that he had not abused his position at the institute to benefit himself.

The more powerful rationalization, though, was not what Zweigelt did or didn't do for the Reich, but who he was—the indispensable viticulturist, the man who moved Austria's wine market forward. It was this narrative which in 1958 enabled Lenz Moser, one of Austria's most esteemed winemakers, to pay tribute to his friend Fritz by giving his hybrid grape a new name, one that would "make the name of Dr. Zweigelt immortal."

Although no detailed investigation of the Aryanization of Austrian wine trade has yet been carried out, we do know that the viticulture school in Klosterneuburg was, with Zweigelt's influence, a bastion of National Socialism. At the height of Nazi-occupied Austria, flags bearing swastikas flew outside the viticulture school building. Though Zweigelt's grapes might not have been on the same level as wines with French or Italian provenance, they were considered important enough to be protected by the Reich. When southern France fell to the Nazis in 1940, German troops set about looting local valuables, and high-ranking Nazi officers pillaged French wine cellars as a means of flaunting victory. Even Hitler, who himself did not drink, kept around half a million vintage bottles as trophies. To the Nazis, wine—much like the Reich's hoarding of fine art—was a cultural asset to be seized and protected.

In 2016, the Austrian Wine Marketing Board, an organization dedicated to fostering the commercial success of Austrian wine, launched an investigation of Friedrich Zweigelt's role in the Third Reich. The results, which appear to downplay Zweigelt's importance, included a piecemeal biography assembled by German wine historian Daniel Deckers. In it, Zweigelt appears as an oenological Adolf Eichmann, ensnared by the banality of evil, following or-

ders to better his agenda, or simply to stay alive. The report seems
to suggest that Zweigelt's complicity was, in comparison to others
who pledged allegiance to the Nazi Party, not egregious. Following
a grassroots campaign by an Austrian performance art group to
change the grape's name, a December 2018 video segment pro-
duced by Austrian media company *Kurier* described red wines like
zweigelt as the vessel in which Burgenland—Austria's easternmost
and richest wine region—"stores its gold." In Burgenland, zweigelt
is associated with red wine but not its Nazi creator, says a reporter,
who ends the segment with a single, resounding question: Does
Friedrich Zweigelt acquire more importance by this discussion
than he's entitled to?

"In our generation, zweigelt is not linked to the person Zwei-
gelt," says Austrian natural winemaker Werner Meinklang. For the
Meinklang family farm, growing organic zweigelt is about as stan-
dard as a New Jersey farmer growing tomatoes in the summertime.
He says that among those who know the history, nobody in Austria
denies that Zweigelt was a Nazi. The question, then, for Meinklang
and other winemakers, is how to acknowledge the grape's history,
if at all.

Much of twentieth-century wine cultivation and trade in Cen-
tral Europe was entwined with Nazi occupation and the rapid
spreading of its ideology. In Germany, under the guidance of Gau-
leiter of Westmark—and eventual Reichsstatthalter (governor)
of Austria—Josef Bürckel, the military succeeded in building the
Weinstraße, a fifty-three-mile road connecting the most prominent
wineries along the Rhine, all the way up to the French border.
Bürckel, who would go on to lead the Reich's efforts in annex-
ing Austria, thought that by building a road to connect German
vintners' villages, he could boost wine sales across Germany. Offi-
cially opened in 1935, the Weinstraße holds the title of the oldest
commercial wine trail in the world. Each September, the German
village of Bad Durkheim, the site where Bürckel inaugurated his
wine route, hosts a massive Oktoberfest-like festival. In 2015, CNN
Travel called the trail a "best-kept secret," stating that it might be
a secret kept purposefully since many Germans seemed "reluctant
to advertise it."

While Nazi officers built wine trails across Europe, groups of oc-
cult Nazi agriculturists—whose work may, or may not, correlate to

the production of what we know today as "natural wines"—began to take hold of Eastern Europe. Groups like the Reich League for Biodynamic Agriculture advocated for a landscape that fused both environmental and national sentiments; the league flourished under the quiet support of early occultist Heinrich Himmler, whose own home featured a biodynamic garden.

Established six months after the Nazis seized power in Germany, the league combined blood-and-soil ideology with practical arguments around the economic advantages of biodynamic farming methods. While some Nazis worked actively against bureaucrats backed by chemical industries, others argued that "cosmobiological knowledge" was a necessary pathway to attaining proper soil tillage. For the 1936 Summer Olympics, Berlin's athletic fields were treated biodynamically, without artificial fertilizers and pesticides, relying instead on manure, compost, and a variety of homeopathic preparations meant to channel astral energies. Select Nazis even embraced anthroposophy, a central element of biodynamics, which presupposes the existence of an intellectually comprehensible spiritual world, accessible to humans. As historian Eric Kurlander writes in *Hitler's Monsters: A Supernatural History of the Third Reich,* "By drawing on the same currents of Lebensreform as the occult movement, anthroposophy—and its successful outgrowth, biodynamic agriculture—epitomized the deep antagonism toward conventional medicine and a strong conviction that modern life had damaged their souls and bodies."

National Socialists gravitated toward organic growth of plants, fruit, and wine not merely because of their agreement with pseudoscience, but because it offered a means of political and social control over the land. As Peter Staudenmaier, a professor of German history at Marquette University, writes in *Organic Farming in Nazi Germany: The Politics of Biodynamic Agriculture, 1933–1945,* "it opens a new perspective on the tactics adopted by allegedly non-political environmentalist networks attempting to accommodate themselves to a totalitarian state."

"It's not necessarily all that shocking to find that while some Nazis are fine-tuning organic farming practices," Staudenmaier told me, "other Nazis are using highly industrialized methods to launch attacks over Eastern Europe or mass murder Jews."

Friedrich Zweigelt might not have been a member of the Reich

League for Biodynamic Agriculture, but he tried desperately to gain the approval of Adolf Hitler. Shortly after the Anschluss in 1938, in an editorial for *Das Weinland,* Zweigelt wrote: "Adolf Hitler, the Führer of us all, has saved his home country. Only those who have suffered the infinite pain and terrible subjugation of an alien system over a period of five long and bitter years will be able to appreciate what we Austrians have felt and experienced during these great days."

In 1958, on his seventieth birthday, Zweigelt was honored with the eponymous naming of his hybrid grape by winemaker Lenz Moser. The last time Zweigelt spoke in public was to accept an award honoring his work with wine. In his acceptance speech, he spoke about grape hybridization, explaining that even the discovery of only one valuable new hybrid can pay handsomely.

When the campaign to change the name of the zweigelt grape launched two years ago, many lobbied to have it changed to its lesser-known alternative: rotburger. A top-down change would have to come from the Austrian Wine Marketing Board, which has left the debate in limbo for more than two years. (An official press release says they are still carrying out a systematic evaluation of their recent findings about Zweigelt's biography.)

How to engage with the life of Friedrich Zweigelt is a question facing not only Austrian winemakers, but also US importers of Austrian wines. "I think we're more politically correct here than they are in Europe," says Zev Rovine, a Brooklyn-based natural wine importer. "People in Europe have been through a lot of wars . . . so reconciling with the past is just so much more overwhelming."

Jenny Lefcourt, founder of the natural wine importer Jenny and Francois, says the name change would only serve as unnecessary erasure. "My general feeling is that it's important to talk about history and not cover it up. We shouldn't be afraid to say this grape was named after this guy who was a Nazi. We can acknowledge that it doesn't belong to him anymore, that it exists outside of Nazi Germany and has a new history comprised of all kinds of people growing it."

Others who have decided to print the name "rotburger" on their labels have done so while acknowledging that at an institutional level, it will likely remain a hard sell. Zev Rovine believes that

zweigelt will probably win out in the end, but that hasn't stopped him from having conversations with his producers about moving forward with the name rotburger.

The initiative has trickled down to a couple of winemakers and producers. Wachau-based winemaker Maximilian Brustbauer decided to change the name last year. "Renaming zweigelt isn't just about dishonoring Friedrich Zweigelt. It's about how people reflect on their own history and the history of their past in general," Brustbauer wrote to me in an email. "People who say that it doesn't matter what Zweigelt did or that he was a Nazi because it is the past and it doesn't define who they are, well, those are the same people that are proud of traditions of Austria."

His assessment sounds a lot like an encounter wine writer Jason Wilson catalogues in his 2018 book *Godforsaken Grapes*. While having dinner alongside two Austrian winemakers in Burgenland, Wilson asks a young winemaker why he's chosen to label his zweigelt as rotburger. His answer is at first technical: He's Hungarian. Hungarians use the name rotburger. But it soon becomes more complicated, twisted with age-old political gripes, as he tells Wilson that although Austrians consider themselves the first victims of the Nazis, 100,000 Viennese sympathizers "turned out to cheer for Hitler as he rode into town." And maybe that's enough to merit at least further consideration of what Austria is ignoring, if not changing.

For what it's worth, Werner Meinklang seems less concerned with the name zweigelt and more consumed by the interaction of grape and soil. Using holistic methods to farm a grape named for a Nazi may seem contradictory, but it might also act as a means of restoring the natural order of things. There have been some problems with the farming of zweigelt recently, Meinklang tells me. The grape cannot handle new climate change–induced dry conditions in Austria, which has led to the vines becoming stressed, unable to absorb calcium from the soil. In August, the grapes are blue, bulbous, and quite beautiful, but by harvest season in the fall, they appear to collapse, their sugars released abruptly from their roots, and their juices soured.

Meinklang, who is himself a bit of an anthroposophist, believes this is happening due to the grape's unhealthy political origins. Whether it's being killed off by the cosmos or dying from drought,

zweigelt is not growing as it used to. What you see in your glass of natural red or rosé contains epochs of bad ideology, cultural contention, and forced occupation. It is a complicated bit of juice, one that has a chance to be reclaimed and re-rooted and emerge as something new—something perhaps, even better than what it was before.

KELSEY MILLER

What a 1944 Starvation
Experiment Reveals About
2020 Food Insecurity

FROM *Elemental*

THE EXPERIMENT BEGAN in November 1944. Thirty-six young
men, each thoroughly vetted for physical health and mental
soundness, entered a laboratory beneath the football stadium of
the University of Minnesota in order to be starved. A year later,
thirty-two walked out, changed men in a changed world.

The landmark study, now known as the Minnesota Starvation
Experiment, was conceived by physiologist Ancel Keys at the height
of World War II. With support from the US Army, Keys intended
to study the effects of starvation to help guide relief efforts among
the famished populations of Europe and Asia. In the end, it served
a very different purpose. Today, seventy-five years later, Keys's study
informs the treatment of eating disorders and highlights the con-
sequences of diet cycling—two issues endemic to postwar America
more than anywhere else.

What happened in that lab reads like a prologue to the long,
strange chapter of American eating that began with the war's end:
an era of unparalleled bounty juxtaposed with gnawing hunger.
The diet business boomed into a multibillion-dollar industry, as av-
erage- and high-income Americans paid to go hungry. Meanwhile,
millions suffered scarcity, struggling to afford food or unable to
access it. Food insecurity, both genuine and self-imposed, spread
like a quiet plague in the years after World War II.

Today, as we fight a new great global battle, stocking our cabi-

nets against an uncertain future, the Minnesota experiment may tell us even more about what and how we will be eating when the next chapter begins.

Keys's plan was fairly simple: The study began with a three-month control period, during which subjects were fed approximately 3,200 calories a day—there were slight variations depending on height and activity level—to bring each man to his "normal" weight. Throughout the experiment, subjects could eat only the food Keys prescribed, taking all meals together in a university dining hall. Each portion was carefully prepared and weighed before serving, and every meal was eaten under the watchful gaze of Keys's team. During the control period, meals were designed to replicate those they were used to: roast beef, fricasseed lamb, carrot-raisin salad, and ice cream.

Next came the hard part: six months of starvation, designed to reduce each subject's body weight by 25 percent. Calories were cut to approximately 1,570 per day, and cuisine was limited to what might be available in the food-scarce areas of Europe: cabbage, bean soups, macaroni and cheese, and, most of all, potatoes.

In reality, this deprivation was nothing compared to the terror abroad. The *hongerwinter* had just begun in the Netherlands, and food rations were dropping as low as 400 calories per day. In besieged Leningrad, civilians had first eaten their pets, then belts and bookbindings, and finally, each other. Americans had endured moderate food rationing since the start of the war—a measure imposed to stop rampant food hoarding—with limitations placed on items like butter and sugar. But most could not conceive of the famine ravaging those people "over there." And it would be months before the first photos of Nazi death camps would hit US papers and Americans would see the unspeakable horror of hunger weaponized.

Keys's subjects needed no convincing, though. These men, most in their early twenties, were conscientious objectors (COs) enrolled in the Civilian Public Service, a program through which pacifists could serve in nonmilitary roles: fighting forest fires, staffing psychiatric wards, and volunteering as "guinea pigs" for medical experiments. In the public eye, COs were historically maligned as cowards, when in fact they were willing to take great personal risks for their country—just not fight for it. "It's hard to under-

stand now how deep your commitment to pacifism would have to be to take this stance during World War II, which was almost universally regarded as a just cause," noted Todd Tucker, author of *The Great Starvation Experiment.* "You had to be almost painfully idealistic." More than 400 COs applied; Keys chose these thirty-six not just for their overall health but also for their exceptional moral fortitude, amiability, and sense of responsibility to humanity. Thus, the "guinea pigs" (a term the subjects used themselves) began the starvation phase in high spirits, welcoming the chance to suffer for the greater good.

As guinea pigs, they lived under near-constant observation: They ate together, slept together in a communal dorm within the underground lab, and were subjected to endurance tests, physical exams, and psychiatric interviews. But the men were also required to maintain some semblance of normal life to demonstrate how hunger affected it. They walked a minimum of twenty-two miles a week and found part-time jobs in town or on campus.

Hunger hits the brain fast. In the first few weeks after the control period, the jocular mood dropped to a simmering grumble. The subjects groused in their (mandatory) diaries about the interminable hours between meals. They complained of feeling tired and foggy, but mostly they just talked about food. During the control period, they had dated and socialized, and like all Americans, pored over newspapers to keep abreast of the war. But as the starvation phase continued, their focus narrowed to the plates in front of them.

Mealtimes grew tense as each man developed his own strange eating habits. Some gobbled down the food as fast as possible, while others lingered over every precious morsel, chewing in slow motion and infuriating their tablemates. They "souped" meals with water to make them feel more filling and licked their plates clean. One subject, Samuel Legg, refused to sit with the group during meals. Isolated at his table, he would pulverize and mix all the items on his tray—fish soup, cheese, lettuce, bread—pile it into a great gray lump, and eat the repulsive puree.

Some collected cookbooks, staying up all night to ogle recipes. They stopped having sex dreams and now dreamed of luscious feasts or had gruesome nightmares of cannibalism. Some frequented local restaurants, where they'd sit and stare at dining patrons, guzzling black coffee. (This was allowed in unlimited

quantities, as was gum, which subjects chewed constantly, up to forty packs a day.) Others couldn't stand the sight of people eating. They'd go to the movies, desperate for distraction, but find themselves so fixated on prop food in the background that they couldn't keep up with the story. It didn't matter anyway, they told the scientists. Romance, drama, comedy—none engaged them anymore. They could recognize a joke as funny but could not laugh.

In short, Keys's experiment was working: his subjects exhibited the same behavior as those persecuted and starving abroad—without actually being persecuted *or* starved. By modern standards, 1,570 calories a day wouldn't even be considered that strict. "The degree of restriction wasn't as much as we see today in diet culture," says Julie Dillon, a registered dietitian and nutrition therapist. Mainstream diets like Jenny Craig and the Noom app offer plans as low as 1,200. That's not to say the Minnesota subjects were well fed—hardly. "Technically, it's called 'semistarvation,' what they were doing," Dillon says. "But from a diet culture perspective, it was an amount of food that some people think is too much. And it was already having these effects."

What confounded Keys was that those effects continued—worsened, in fact—after the starvation phase ended. As Keys slowly increased their calories, the men seemed even more agitated and obsessed with food. Four had already been dismissed from the experiment for cheating. One confessed to eating garbage for months. Another said he'd blacked out in a grocery store and then came to shoving stolen food into his mouth. Two men were sent to the university hospital's psychiatric ward: One had been exhibiting psychotic symptoms, threatening to kill himself and Keys. Samuel Legg actually chopped off his own fingers with an ax. Lying in the hospital, Legg begged Keys to let him finish the study, insisting it was an accident. (Keys knew better; Legg had suffered a similar "accident" the week prior.) "For the rest of my life, people are going to ask me what I did during the war," Legg implored. "This experiment is my chance to give an honorable answer to that question."

The war ended sooner than expected—months before the study's conclusion in December 1945. It would be five more years before Keys would publish his groundbreaking text, *The Biology of Human Starvation*. By then, the dust had settled on a changed world.

While much of the world still lived in the shadow of the war, Americans were riding high on an economic boom—the white wealthy Americans, specifically. Wartime rationing was long gone, but now dieting was de rigueur. This was the era of slimming creams, doctor-prescribed weight-loss pills, and quick-fix diets of 1,000 calories or less. "Starvation" was no longer an atrocity, but a fad.

As for the Minnesota subjects, Keys had expected they would recover quickly once they were allowed to eat normally again. But they didn't seem to know how anymore. "It was remarkable how much they ate," says Elke Eckert, MD, a psychiatrist who led a follow-up study on nineteen of the Minnesota subjects in 2002. "One of them ate so much he had to go to the hospital and almost died." What surprised both Eckert and Keys was how long these extreme eating habits lasted. Before the experiment, none of these men had experienced food scarcity, nor had they dieted; six months of deprivation transformed them. According to Eckert, they gained an average of twenty-two pounds above their starting weights, and some struggled with "abnormal eating" for years. Their perspective on food, they said, was irrevocably changed. Still, all but one said he would do the experiment again, regardless of the damage it did to them personally. Several went on to do relief work or world hunger advocacy. Again, Eckert notes, these were exceptional people living through an extraordinary moment in time.

Yet that's precisely what made the Minnesota Starvation Experiment so relevant in the decades after World War II—and even more so today, as we endure the greatest global crisis since. It demonstrates the primal wound of food deprivation and the scar it leaves on our psyches. The Minnesota subjects, Holocaust victims, adolescent anorectics, and chronic dieters all share common symptoms, despite vastly different circumstances. Our bodies don't distinguish between a crash diet and a famine.

"Restriction, whether it's from dieting or food scarcity, can lead to behavior that we would call disordered," Julie Dillon says. "Even the threat of limited food makes our brains overly fixated on it" —one reason for empty supermarket shelves as of late. Perhaps the most profound finding of this study is not the dramatic effects of hunger, but the fact that these effects are universal and timeless —and nothing can inoculate against them. "The study design was really robust in that they only studied people who were physically

and emotionally healthy," Dillon says. "No evidence of depression, anxiety, disordered eating, or any kind of emotional instability." Furthermore, they were white, male, and had never lacked for food. "These were people who had the most privilege and access," she says. "And many of us aren't starting in that place."

Indeed, many are starting at a drastic disadvantage. In 2018, the USDA estimated that 11.1 percent (approximately thirty-seven million) Americans were "food insecure"—meaning without consistent access to sufficient food. About a third fell into an income bracket just shy of the poverty line, unable to qualify for federal assistance but one missed paycheck away from hunger. Others lived in food deserts—areas without enough grocery stores or transportation to get to them.

Then came COVID-19 and the ensuing stay-at-home orders, making food even harder to come by for everyone but particularly those already struggling to keep their cabinets stocked. Basics like flour have become luxury items. Food banks are buckling under unprecedented demand, while the supply of donated food has dried up. And with the country at an indefinite (though crucial) standstill, the problem only grows. For context, Feeding America estimates that when the unemployment rate goes up a percentage point, approximately four million more people experience food insecurity. In March, the rate rose from 3.5 percent to 4.4 percent. It is expected to rise above 10 percent in April and upward of 30 percent by the end of the quarter.

The full scope of this pandemic's effect on our economy, and our very way of life, remains unknown. But one thing we do know is that despite the barren supermarket shelves, there is plenty of food in the country. The panic buying that began in February did cause major disruption in supply chains but not in the food supply itself. On April 16, USDA chief food economist Robert Johansson published a detailed analysis of what happened to our groceries —why milk got so expensive and flour disappeared—and what's to come. "Prices should stabilize or even decline," Johansson says. Wholesale egg prices in New York hit a record high of $3.07 per dozen in March, as the state prepared for an indefinite lockdown. Just a few weeks later, he points out, the price fell to $1.97. Furthermore, with the entire service industry essentially closed, restaurant and hotel suppliers are now redirecting huge volumes of ingredients to grocers. "But these changes will take time."

Things will normalize, but like everything else in the world, our food may never be "back to normal." There are still many unknowns about how this pandemic will affect the logistics of food production in the long term. The future of restaurants and brick-and-mortar groceries is in limbo. "It's also unclear how food consumption patterns will change," Johansson says. As our food and the way we buy it change, how will this crisis affect the way we eat?

I put the question to dietary historian Susan Yager, who literally wrote the book on how great historical events have influenced American eating. "Right now, it's a complete unknown," Yager says, given that we've never weathered a crisis quite like this one. "We're in a dire economic situation, and that's on top of a pandemic where we're told 40 percent to 80 percent of Americans will get sick one way or another."

Yager says of course people are panicked about running out of food—that's human instinct. "We all need food and water, and when they're threatened—especially by outside forces—it's traumatic." This is the natural first phase of a crisis, which will likely soon be over, along with the flour shortage.

As for what comes next? This is where personalities, backgrounds, and cultural differences come in. A pacifist might go on to fight world hunger. But average Americans, Yager says, tend to respond to deprivation with self-deprivation—thus, the rise in postwar diet fads that began even before rationing ended. "Even in the 1930s, when the country went through the worst depression ever known, all these crazy diets came about: bananas and skim milk, apple-only diets, lamb chop–only diets."

Yager believes the country was seeking a sense of control during a time of dire uncertainty. "When you have control over nothing in your life, at least you can control what you're having for breakfast, lunch, and dinner. Even if it's only bananas and milk." That's what she thought of when she saw the empty shelves in February: "People trying to make order out of chaos by getting all these cans of beans and soup, and lining them up neatly, knowing that they're going to take care of their family."

That's just what we do. If history repeats itself, Yager says, "Bizarre diets will come flooding back. I would expect it."

But really, no one knows what the world will look like when we step out into it again. All we know is it will be changed. Perhaps we will be too.

Stewed Awakening

FROM *Eater*

ALISON ROMAN IS the "prom queen of the pandemic." Or, at least, she was. The cookbook author and YouTube star, who rose to fame on the strength of her heady-yet-approachable recipes, low-key glamour, and self-effacing charm, recently experienced what she referred to as "baby's first internet backlash." It stemmed from a recent interview that Roman gave in which she criticized both minimalism icon Marie Kondo and cookbook author Chrissy Teigen for peddling branded merchandise, implying that they were sellouts—while discussing her own "capsule collection" of cooking tools, no less. A low hum of outrage greeted Roman's choice to rebuke two women of color, then positively exploded after Teigen created a long thread on Twitter to talk about how hurt she was, as someone who "genuinely loved everything about Alison."

The backlash to Roman's comments, like most backlashes, was a combination of legitimate grievance and the way that Twitter refracts and concentrates reaction. All the same, there was a whiff of inevitability to the suddenness and vociferousness of the anger directed at Roman, who had become ubiquitous thanks in part to her knack for proselytizing ostensibly "ethnic" ingredients like tahini, turmeric, and yuzu kosho to a broader American audience. Roman's critics charged that she was not only a hypocrite but a racist, one who had moreover very successfully capitalized on the ingredients of other cultures. If it felt as though people had been sitting around waiting for her to mess up, it was probably because many of them had.

Roman, after all, is arguably the most fashionable avatar of a

broader shift. We are living in the age of the global pantry, when a succession of food media–approved, often white figures have made an array of international ingredients approachable and even desirable to the North American mainstream—the same mainstream that, a decade ago, would have labeled these foods as obscure at best and off-putting at worst. This phenomenon is why you now see dukkah on avocado toast, kimchi in grain bowls, and sambal served with fried Brussels sprouts. It's a kind of polyglot internationalism presented under the New American umbrella, with the techniques and raw materials of non-Western cuisines used to wake up the staid, predictable flavors of familiar Americana.

Not long ago, you could see this playing out on the menus of hip restaurants across the country. At AL's Place in San Francisco, squash tahini was served with burrata, sumac-galangal dressing, pickles, and dukkah; in Los Angeles, there was preserved Meyer lemon and lacto-fermented hot sauce in Sqirl's sorrel pesto rice bowl, and a "Turkish-ish" breakfast of vegetables, a sumac- and Aleppo pepper–dusted egg, and three-day-fermented labneh at Kismet. Over in Nashville, Cafe Roze put a turmeric egg in its hard-boiled BLT and miso ranch in its barley salad. Up in New York, Dimes served a veggie burger with harissa tofu and a dish called huevos Kathmandu that paired green chutney and spiced chickpeas with fried eggs.

But now, as the COVID-19 pandemic has forced most of us to stay home and make the most of our kitchen skills, the global pantry is most visible on the pages and websites of establishment food media. It's *Bon Appétit*'s gluten-free coconut-turmeric pie and kimchi–cream cheese toast; *Food & Wine*'s tofu masala and rosy harissa chicken; the *New York Times*'s brothy chicken soup with hominy and poblano; and *Every Day with Rachael Ray*'s minty matcha smoothie and Korean barbecue burgers. You can see it all over social media and particularly Instagram, where its most viral example is #thestew, Roman's 2018 recipe for a chickpea–coconut milk stew whose broth is made golden with turmeric. And you can see it on *Bon Appétit*'s extremely popular YouTube channel, where its test kitchen stars make everything from saffron brittle to "dahi toast" to slow-roast gochujang chicken to spicy chicken katsu sandwiches (though it bears noting that the first two of those recipes were created by people of color).

As the culinary has become a marker of contemporary culture,

occupying much of the space once monopolized by music or fashion, food media and social media have fused to create a supercharged form of aspirational desire. Within this mode of desire, however, the idea of using new, hitherto "exotic" ingredients only seems to become aspirational when those ingredients appear on the pages of prominent tastemaking magazines (or, perhaps more relevantly, on Instagram) — or are espoused by white tastemakers. Remember that time in 2018 when the author Stephanie Danler told *T: The New York Times Style Magazine* about her "kitchari cleanse," explaining how the Indian dish of lentils and rice (actually called khichrhi) allowed her to "reset [her] system"? Or the time that haldi doodh took over coffee shop menus, the food media, and Instagram after being rebranded as the turmeric latte?

The question that such representations present for the food world is a difficult one: Who gets to use the global pantry or introduce "new" international ingredients to a Western audience? And behind that is an even more uncomfortable query: Can the aspiration that has become central to the culinary arts ever *not* be white?

Because the aesthetics of food media are indeed white. That white aesthetic is not, strictly speaking, the abundant natural light, ceramic plates, strategically scattered handfuls of fresh herbs, pastel dining rooms, artisan knives, or even the butcher diagram tattoos that the food media so loves to fetishize. It is more accurate to say that the way we define what is contemporary and fashionable in food is tied to whiteness as a cultural norm—and to its ability to incorporate other cultures without actually becoming them.

Only whiteness can deracinate and subsume the world of culinary influences into itself and yet remain unnamed. It's a complicated little dance of power and desire: The mainstream is white, so what is presented in the mainstream becomes defined as white, and—ta-da—what you see in viral YouTube videos somehow ends up reinforcing a white norm, even though the historical roots of a dish or an ingredient might be the Levant or East Asia. You might say whiteness works by positing itself as a default. You might also say that this sucks.

You cannot have influence without authority. It's why well-known (usually white) chefs and cookbook authors have historically been so effective in popularizing global ingredients among the North American mainstream. Think, for example, of Rick Bayless, the

Chicago chef whose Mexican restaurants introduced many Midwesterners to contemporary regional Mexican cuisine, or Andy Ricker, the Portland, Oregon, chef whose Pok Pok restaurants spread the gospel of Northern Thai cooking through the Pacific Northwest and beyond. Then there's Yotam Ottolenghi, the Israeli chef and cookbook author whose London-based restaurants and cookbooks were so effective in communicating the joys of Middle Eastern ingredients like Aleppo pepper and tahini that his influence earned its own moniker, the Ottolenghi Effect.

Each of these chefs became successful at a time before social media and the notion of viral stardom had become as all-encompassing as they are today. And, aside from some extremely boneheaded comments Bayless made regarding race and appropriation, their notoriety hinged far less on their personalities than the seductive properties of their food—and how readily their work was gobbled up by the establishment and, by extension, the white mainstream.

In today's food media landscape, there are few more powerful authorities in the Anglo–North American food world than *Bon Appétit*. *BA*'s YouTube channel has become so viral that it has spawned memes, to say nothing of a fan account just for star Claire Saffitz's hair (and, hey: understandable). It has almost six million subscribers, and its videos have collectively surpassed a billion views.

Bon Appétit's on-camera staff is predominantly white, and the aesthetic and culinary mode of the channel feels similar to a lot of contemporary food media: attractive, mostly millennial people wearing bespoke aprons make vibrant, casually elegant, well-lit food that balances approachability with technique and/or fancy ingredients.

It was an aesthetic developed on the glossy pages of the Condé Nast magazine. When editor Adam Rapoport came over to *BA* from *GQ* in 2010, he was tasked with reinventing the publication one year after *Gourmet* folded. It was neatly symbolic: As one bastion of high-end food disappeared, another announced itself as the wave of the future. Rapoport imported a particular style to *BA* from his previous gig: cool but unfussy, effortless but only superficially so. It's a mix that has occasionally gotten the magazine into trouble—see, for example, its website's (since deleted) 2016 "Pho Is the New Ramen" video, in which a white chef told viewers exactly how they should eat the Vietnamese dish. Today, it allows

BA to teach its readers how to reverse-sear steak or carve $1,500 legs of ham, but also make mac and cheese or the perfect vodka soda. The foods it chooses to cast in the spotlight illustrate the way in which authority grants legitimacy. If *BA* is using sumac on eggs, or dashi powder in porridge, it means it's time for you to use those things as well.

But if desire, expertise, and charm work magic in food media, then perhaps it's no coincidence that the globalization of the pantry has found its viral apotheosis in Alison Roman. An erstwhile pastry chef who worked in the *Bon Appétit* test kitchen before going on to become a *New York Times* columnist and the author of two best-selling cookbooks, Roman's story is one of years of hard work, viral-recipe creation, and social media savvy—at least until her recent self-own.

It remains to be seen if Roman's comments about Kondo and Teigen coalesce into a broader or more permanent rejection (yesterday, the *New York Times* confirmed to the *Daily Beast* that her column is on temporary leave, though it declined to provide a reason why). Regardless, the lessons of Roman's success are lasting. For one, it is impossible to talk about Roman's influence without talking about social media, and her masterful use of it.

With 566,000 Instagram followers and legions of fans who make and then photograph her approachable, well-tested recipes —which she then reposts in her own Instagram stories—Roman is successful in part because of her understanding that social media has transformed cooking into a social experience, one that particularly resonates with millennials. It points to how aspirational desire—and the brands that tap into it, whether personal or corporate—can popularize things within that space. *Oh, this is one of Alison's recipes? I want to make it too.*

Like the staff of *BA*, Roman's appeal doesn't lie just in what she does, but who she is and what she represents to her audience. She is self-deprecatingly funny, unapologetically opinionated, and, with her signature orangey-red nail polish and bold lipstick, she projects effortless cool. As Michele Moses put it in *The New Yorker,* "Roman, with her crackling chicken skin and red lips and nails, is libidinous and a little bit mean." Even Roman's kitchen, which features prominently enough in her videos to warrant its own treatment, is undeniably appealing, and its organized clutter of Le

Creuset pots and hanging plants may as well have its own Pinterest page.

Roman's loosely white style *is* mainstream, contemporary food culture right now: Looking through Roman's cookbooks, *Dining In* and *Nothing Fancy,* I noticed how every second page of beautifully shot recipes seemed to feature some "mainstream" American ingredient made new with yuzu kosho or turmeric or chile oil. But even as I found myself poring over the recipes, something felt off. It was the same thing that made the fame of #thestew, Roman's now-viral recipe for chickpeas in coconut milk and turmeric, feel a bit weird but also vaguely familiar to me: I know these ingredients; what *are* white people so excited about?

Is #thestew really just a curry? (Roman has insisted it's not, but others beg to differ.) And are all curries just stews? It's precisely the ambiguity of what separates one from the other that makes neat assertions of cultural appropriation unhelpful but also lets the issue linger. Less important than ascribing a strict lineage, or, worse, the retrogressive idea of cultural ownership, is the question of whether, say, a person of color could have also made a stew featuring chickpeas and turmeric go viral. Aren't both the perceived novelty and the recipe's virality tied to the whiteness of its creator?

For her part, Roman feels the success of that recipe was less about her than what preceded it. Talking over the phone while on the road for her book tour several months ago, she suggested her viral success wasn't unique. "I think if it were Padma Lakshmi or Nigella Lawson or any other person who already has a platform, it could absolutely go viral," Roman told me. "I think the only reason the stew went viral is because the cookies did."

Perhaps that's true, but it does seem worth asking: If a South Asian or Middle Eastern person put forth that mix of ingredients, could it have merely been #thestew, with no other descriptors attached, or would whiteness have forced it to have a name? While it wasn't Roman who gave #thestew its label, having a thing that draws on a variety of influences, but takes on such a generic, rootless—and yet definitive—name is precisely how whiteness works: positing itself as the norm from which all other things are deviations.

"The sad thing about my cultural background is that I don't really have one," Roman told me with a chuckle. It's a line she had

used before, one that evokes the same self-deprecation she employs in her videos. Peering in from the outside, one of the things that seems, well, sort of fun about being white is that way in which things can just *be:* "Ethnic" fashion is quirky or inventive, spirituality can be a generic mix, and cuisine can simply be food. There's a sense, too, that the collective output of *Bon Appétit* takes a similarly obfuscated view: it's just food, man. I mean, imagine the freedom.

When we spoke, Roman seemed aware of this reality, if only partly. "I absolutely feel whiteness is a factor [in my success] because white privilege is everywhere. That's not lost on me," she said. "But I don't think that has to exist separately from the hard work I've put in to create a career for myself and a palate and flavor profile."

It's a comment that reads differently now, and the lengthy apology Roman issued for her comments about Teigen and Kondo suggests that she is more aware of the complex relationship between her privilege and her prominence. Still, I don't think there is much to the idea that Roman's success is somehow unearned, or even that we aren't better off for it. Nor do I think that *Bon Appétit* comes close to the more egregious examples of appropriation and erasure; to the contrary, it increasingly seems to be doing more to educate its audience. *Bon Appétit* is also hardly the only powerful food media authority to grapple (or not) with whom it chooses to cast as its ambassadors of the global pantry: scrolling through the *New York Times*'s Cooking section's 15 of Our Best Vietnamese Recipes and Mexican at Home recipes, for example, it is impossible not to notice that every single byline is that of an (ostensibly) white writer. And just last week, Momofuku Milk Bar owner Christina Tosi posted a recipe on Instagram for "flaky bread" that, as some commenters quickly pointed out, looked an awful lot like paratha, an Indian flatbread.

But to recognize white privilege is one thing; to actively combat it or resist taking advantage of it is something else altogether. That balance between competing and contradictory ideas is a useful way to think about food media in 2020. It doesn't help to say that certain people own ingredients, or have dominion over certain types or presentations or techniques. But the way that excitement over particular trends and recipes circulates publicly, whether on Instagram or in *Bon Appétit,* can reinforce whiteness as a norm, just as divorcing history from food erases the contributions and lives

of people of color from Western narratives. When whiteness is allowed to function as if it weren't that, it hurts us all.

During our interview, Roman pointed out that many home kitchens, particularly in places like the United States, the United Kingdom, and Australia, now feature such previously so-called exotic ingredients as anchovies, soy sauce, and Aleppo pepper. "The modern way we cook now integrates so many different ingredients that come from so many different places, and I think that's fucking awesome," she said.

That seems quite correct, and the last thing anyone should argue is that people shouldn't use an ingredient in their own home for some abstract fear of "theft." Instead, the question here is much less about what we do in private than what public representation does and means: if or why it matters when a white person popularizes ghee, or Nashville hot chicken becomes a big thing but the work of African American cooks and chefs is still ignored. In the circuits of culture, there are routes to legitimacy and fame, and the problem we have in the food world is that the most reliable path seems to center whiteness again and again.

That's not to say things aren't changing. It felt symbolic that last year's *BA* Thanksgiving extravaganza featured Rick Martinez's self-described "Mexican-ish" take on stuffing. Fan favorite Andy Baraghani now draws on his Iranian heritage in some dishes, particularly after coming to terms with how he suppressed both his ethnic identity and sexuality. And *BA*'s more recent hires include Sohla El-Waylly and Priya Krishna, the latter of whom used her profile at *BA* to augment the launch of her book *Indian-ish*, a collection of, um, Indian-ish recipes that to my mind is pleasingly inauthentic. In fighting to get their recipes featured, all of these cooks from nonwhite backgrounds are doing the hard work of representation.

Yet Krishna herself believes there is still a long way to go. "I have been told so many times that my Indian food isn't click-y, that it won't get page views," she says in an email, "and then I see white cooks and chefs making dishes that are rooted in Indian techniques and flavors, calling it something different, and getting a lot of attention."

Her experience speaks to the assumption that food media's readership is always white, as if the audience is unfamiliar with or

intimidated by what, to many of them—to us—are in fact quite ordinary things. "I love that people's pantries are getting more global," says Krishna, "but I do hope that when people cook with them, they take the time to educate themselves about the origin of these ingredients, rather than treating them as ingredients in a vacuum, divorced of their context."

The idea that we need to pay attention to where things come from is certainly true, but it's a mantra that can take you only so far: If cultural forces like *BA* or Roman are necessary to popularize new-to-white-people ingredients, then only part of that dynamic changes. In the attention economy, those who garner attention will always have more sway, and even in 2020, the collective unconscious wants what it wants.

What is it that actually captures attention, then? At least one thing is the subconscious desire to emulate *BA*'s authority or Roman's cool. In aspiration, desire matters. But that leaves me with another question, one that stalks my thoughts a lot of the time: What might nonwhite aspiration look like?

Thankfully, we already have one answer: Samin Nosrat. Her warmth and seemingly limitless charm, coupled with her encyclopedic knowledge of food, has endeared her to many, and her book *Salt, Fat, Acid, Heat* is a No. 1 *New York Times* best seller that became a Netflix series. Nosrat jumps between cultural influences frequently, particularly her own Persian heritage, and her generous, open approach to both food and people has done much to expand the conversation. As Jenny G. Zhang noted on *Eater*, the image of Nosrat eating with gusto throughout the Netflix series changed the rules for who gets to eat on TV.

Yet Nosrat's success isn't only about who she is inherently, but her ability to bridge worlds, to speak about and make comprehensible to the mainstream the assumed difference of minorities and the places and cultures they come from. To paraphrase postcolonial theorist Gayatri Spivak, it's indicative of the way in which minorities must contort themselves to ever have any power: they have to manifest it in ways recognizable to those who hold it.

The only way that changes is representation. "As long as staffs of food websites and publications are mostly white, and as long as the leadership of food websites and publications is mostly white," Krishna says, "everything other than white food will always be seen

as the other, as a museum artifact versus someone's lived experience."

Even then, representation has its limits. It's easy for those in the mainstream to cherry-pick the aspects of whatever culture they happen to like that week. Actual change, then, comes up against a difficult paradox: we need to pay attention to where things come from, to focus on their difference, but in order to overcome both fetishization and exploitation, the foreign needs to become domestic.

Rather than simply having people who look like us on our screens or pages, our definition of what is shared needs to change. The polyglot culinary vocabulary that Roman and Krishna evoke must represent a genuine expansion of how we understand food and flavor and, sometimes, culture too. More simply, real change only happens when the thing that white supremacists fear becomes true: that the mainstream increasingly *becomes* rather than simply appropriates the "ethnic." But to speak of a mainstream North American culture that isn't neatly "white" in both its logic and its aesthetics is to envision something that doesn't yet exist, and that we don't know how to articulate.

In the meantime, I find myself searching for food media that reflects me. Yes, as a North American urbanite with a global pantry and a *New York Times* subscription, Roman's work certainly fits the bill sometimes. But that quest has also belatedly led me to Ranveer Brar. An established chef with experience in both the United States and India, he runs a YouTube channel focusing broadly on Indian cuisine, but mostly food from Brar's own Punjabi heritage, which I share. A tall, handsome man with a wry presence in front of the camera, Brar likely has his share of fans who are drawn to him by desire, subconscious or otherwise.

But his content is also closed off to people who don't speak Hindi, and reaffirms my lingering suspicion that some cultural difference is insurmountable: that ideals of kitchens and food and life in Brooklyn and Toronto and New Delhi are different, regardless of how the twenty-first century has both shrunk and intertwined the world. And it seems these divides will remain until cooks and chefs of color finally push their way into the mainstream. It's almost as if we're waiting for *something* to catch up—that the cuisines and ingredients we've become so familiar with now have to sort of

seep into our bones, become a part of us, have stories and myth accrete in layers over time.

Aspiration is about wanting, and what I want from food media isn't a bone thrown in my direction, but simply *more:* more representation, more diversity, more sense that the mainstream isn't just accommodating me, but instead making room for me. What I want as we head into the 2020s is — *God* — isn't it time yet? I just want more.

The Queer Legacy of Elka Gilmore

FROM *Eater*

ELKA GILMORE'S CAREER began with a lie.

The chef was just eleven when she hustled her way to a dish-washing gig at a French restaurant in Austin, Texas. Pretending to be far older, she fooled her bosses, even though she had to stand on a milk crate to reach the dishes. Within three months, she was working the line, balancing the job with school.

It was the early 1970s, and Gilmore was trying to save enough money to flee from home. She ran away at sixteen to live with her grandmother in Madison, Wisconsin. A kitchen prodigy, she bounced from prep cook to chef at a restaurant called L'Etoile after the head chef quit, staying at the restaurant until she was eighteen. She was peripatetic over the next two decades, working in Boston, New York, Cotignac in France, and Los Angeles.

It was in San Francisco, however, where Gilmore became a star in no uncertain terms. She made her biggest splash with Elka, a Franco-Japanese restaurant she opened with Traci Des Jardins in 1991 in Japantown. Elka was a dazzling showcase for both women's artistry, with dishes like hunks of ahi tuna with miso eggplant smeared with tomato-ginger jam. She followed her namesake restaurant with the short-lived Liberté and Oodles before receding from the limelight in the aughts.

Gilmore, who died in San Francisco last July at fifty-nine after a flurry of health problems, became one of Bay Area dining's most recognizable names in the 1990s. She found success while being open about her queerness and championing fellow queer, female culinary voices. Gilmore had been out since she was twelve, when

she had her first lesbian relationship. "I'm a proponent of the concept that it's tremendously helpful to the world for gay people to be out," she told the journalist John G. Watson of *Out* in April 1995. "I've lived my life that way for the past 22 years or so, a significant part of my life."

With her restaurant Elka, she assembled an indisputably skilled cadre of queer female chefs, with Des Jardins as her chef de cuisine and Elizabeth Falkner as her pastry chef. Both Des Jardins and Falkner went on to become celebrities in their own right— Des Jardins with San Francisco's Jardinière, Falkner with the city's Citizen Cake and Orson.

Gilmore recognized raw talent. With careful intention, she helped genius thrive. She mentored younger queer chefs, encouraging them to push boundaries with their cooking. This private work had public impact. To observers of Bay Area dining, it seemed as if a queer culinary oasis sprouted overnight under Gilmore's watch.

"That team that she put together—it seemed to be the birth of a faction, and the faction was really sharp, really talented lesbian chefs," Maria Binchet, a veteran food writer who reviewed the restaurant for *Gourmet,* says of Gilmore. "All of a sudden, there was this new flank that was gaining momentum, independent of the typically male-dominated chef's world."

The Bay Area was no stranger to queer chefs prior to Gilmore's arrival, though visibility skewed disproportionately toward men. Look at Jeremiah Tower, the gay man who built an image oozing with sensuality as he rose to prominence at Chez Panisse in the 1970s and cemented his celebrity with the restaurant Stars the decade after. The chef Gary Danko, too, made a name for himself as the chef of the Dining Room at the Ritz-Carlton in San Francisco. Far fewer people know of Gilmore, though. Tower and Danko, after all, are men, which guarantees certain privileges—say, a surer shot at longevity in American cultural memory.

The pastry chef Dana Farkas moved to the Bay Area with Gilmore after working with her in Los Angeles and served as the pastry chef at Elka before Falkner. "For sure, Elka was completely confident in her queerness, I will say very proud," Farkas says. She notes that, apart from Gilmore, the high-profile female chefs in the Bay Area of that era included names like Joyce Goldstein, Nancy Oakes, Cindy Pawlcyn, Judy Rodgers, Barbara Tropp, and

Alice Waters. Meanwhile, openly queer female chefs like Amaryll Schwertner and Lori Regis of San Francisco's Sol Y Luna tended to generate less press. Gilmore's national fame set her apart.

"I think Elka was a pioneer in many ways," Farkas says.

In 1981, before she came to California, Gilmore worked for six months as an apprentice at Lou Callen Inn, a restaurant in the south of France. There, a "bully" executive chef made her fearful about acceptance. "Then the dining room staff came in," she later told *Out*, "and they turned out to be all gay women—it was just too wild." She'd found a queer sanctuary.

Conversations with nearly a dozen of Gilmore's former coworkers reveal that Gilmore fostered a similarly welcoming environment in her own kitchen at Elka, situated in Japantown's Miyako Hotel (now Hotel Kabuki), which, at the time, was owned by the Kintetsu Enterprise Company of America, a subsidiary of the Japanese corporation Kintetsu Group Holdings. A handful of Gilmore's coworkers there mention a roughly even split between men and women at the restaurant, a rarity for the era. During her time in the industry, Gilmore became a fierce advocate for women in the kitchen, and a founding member of the nonprofit organization Women Chefs & Restaurateurs.

Gilmore's path to renown, however, was riddled with complications. When Farkas and Gilmore moved to the Bay Area in 1990, both went out of their way to find fellow lesbian chefs. San Francisco, after all, was a queer haven. They had some trouble, though. "There was not a lot of marketing being done promoting queer women in kitchens," Farkas says of that era.

Still, Gilmore had no shame about her queer identity. She fought for attention. "Elka was not afraid to say the words, to have that conversation or to just be okay with letting people figure it out, and that was usually sooner than later," Farkas remembers. This lack of apology could turn powerful people against her. "I witnessed several owners of businesses flinch once they figured out who Elka was as an out gay woman," Farkas says. "Attitudes suddenly changed, generally not for the good or in her favor."

Gilmore didn't let such setbacks deter her, though. She kept searching for a stage where her talents could shine without filter. Gilmore had learned how to survive trying situations early on. Her childhood wasn't easy, Farkas notes. "Elka created a family envi-

ronment in her kitchens, I believe due to a lack of her own personal family," says Farkas.

Traci Des Jardins first learned of Gilmore back in 1983, when both women were working in Los Angeles. In those years, Gilmore had already established herself as "someone to kind of look up to," in Des Jardins's words. It wasn't until they both moved to the Bay Area, though, that Gilmore and Des Jardins partnered for Elka.

Des Jardins was all but ready to take a sabbatical from the restaurant industry by 1991, having helped open Aqua in San Francisco. She'd worked almost exclusively for men throughout her time in the industry. "I was honestly pretty burnt out on cooking and the environments I had experienced," Des Jardins says. Gilmore, however, persuaded Des Jardins to link up with her for Elka.

"It was a refreshing sort of change for me to be around somebody who really had a lot of fun in the kitchen," Des Jardins says. Elka represented a departure for Des Jardins, who had been in "super-serious French kitchens" up until that point. By comparison, the kitchen at Elka was "not quite so serious and regimented."

National recognition came quickly for the restaurant: Elka found a spot on *Esquire*'s list of Best New Restaurants in 1992. Gilmore gave Des Jardins the latitude to focus solely on cooking, so Des Jardins had no hand in the administrative tasks that were part of Gilmore's job. Watching from a distance, Des Jardins would marvel at how deftly Gilmore navigated the thorny politics of "a traditional Japanese corporation" as a queer woman. "She was always just 100 percent herself, which was admirable," Des Jardins observes. "She was very out, and never really made any excuses."

The restaurant's boldness attracted Elizabeth Falkner, who was working in pastry at Masa's when Elka opened. Gilmore and Des Jardins gave Falkner carte blanche to retool the dessert menu. Such freedom resulted in fanciful desserts like "tiramisushi," with rolls of cocoa roulade sponge cake jammed with marsala mascarpone filling. Gilmore nudged Falkner in more inventive directions, letting Falkner's budding creative impulses blossom.

"One time she came up to me and said, 'You know how people make chocolate-covered cherries?'" Falkner recalled. Gilmore wondered why no one made the inverse, cherry-covered chocolate. "I was like, *that is a good question!*" Falkner says. "She could inspire me just by saying stuff like that."

Falkner would eventually follow Des Jardins to Rubicon in

1994, while Gilmore continued with her namesake restaurant and opened another, Liberté, that year. Gilmore's efforts at Elka earned her a James Beard nomination in 1994. She closed both Elka and Liberté in 1995, though, and moved to New York, coaxed there by the opportunity to be the executive chef of Manhattan's Kokachin. Friends claimed that New York wasn't easy for her. Gilmore returned to San Francisco soon after and opened Oodles, which she called an "Asian bistro" restaurant, in the summer of 1998.

The restaurant flamed out after eighteen months. Reports from 2000 suggest she was named as a suspect in a burglary that effectively shut down Oodles. (Records later in the decade indicate that she was arrested for burglary, fraud, and identity theft.) She withdrew from the public eye in the years after, though she didn't disconnect from food entirely. A news story in 2011 specified that she worked as an instructor for Oakland's Kitchen of Champions, teaching cooking to lower-income individuals, many of whom were formerly incarcerated.

Like others who were once in Gilmore's orbit, Falkner fell out of touch with her in this period. *Whatever happened to Elka?* became a common refrain in the circles that Falkner ran in. But she encountered Gilmore by chance on a flight to Los Angeles in the late aughts, when Falkner was filming for *Top Chef Masters*. Falkner was sitting in first class, Gilmore in the back. After most passengers had deplaned, Falkner walked back to the plane and chatted with Gilmore.

"I want you to know that I have talked about you many, many years with different cooks that I've had about what you inspired me with the chocolate-covered cherries and cherry-covered chocolate," Falkner remembers telling Gilmore. "I want you to know that I actually repeat that story to people all the time."

A good number of Gilmore's friends and former coworkers say her sexuality wasn't germane to her actual work. "I knew she was gay, but it didn't seem to have anything to do with much of anything, as far as I could see," Jerry Di Vecchio, the former food editor of *Sunset* and longtime friend of Gilmore, says.

Downplaying Gilmore's queerness, however, ignores the scope of her influence. Thanks to the openness of figures like Gilmore, San Francisco became "the place where you could be out and respected, free to cook beyond some cramped, invisible bistro in the

gayborhood, unconfined by pink ghettoes and fear," as the writer John Birdsall observed in a 2015 essay for the queer food journal *Jarry*.

Her sexuality was an accepted reality, not a professional liability. This may not seem particularly novel for a city like San Francisco, but her national visibility meant that younger chefs far outside the Bay Area could look to her as a model of queer female success. The rest of America wasn't like San Francisco, after all. In other parts of the country, a queer woman's sexuality could be an impediment in the kitchen. This was a truth Gilmore knew herself.

The chef Preeti Mistry, who moved to the Bay Area from Michigan in 1996, is one of many queer chefs who admired Gilmore from afar, long before Mistry entered the industry. "I think that you're looking at a situation where it's like, well, yeah, why is it that you haven't heard about Elka Gilmore?" Mistry says. "How is it that Jeremiah Tower hasn't, until recently, had a restaurant in twenty years, but everybody knows his name?"

Mistry never even met Gilmore. To Mistry, though, Gilmore's prominence has created an ecosystem where queer, female-identifying chefs no longer have to fight quite as hard for the basic courtesy of acknowledgment from the food establishment. "I can't deny that, even though I never met her, or what have you, or that her career was eclipsed in some way in terms of the public, that doesn't form a foundation or a basis for how the media and the dining community react to up-and-coming queer chefs and women chefs," Mistry says.

Gilmore's queerness mattered—and still matters today—precisely because her work gave permission to other chefs who followed. As more time elapses since her death, history may remember her as an advocate for women in the kitchen who possessed a startlingly distinct culinary vision. Yet any tribute to Gilmore's work must acknowledge her queerness, too, a truth she lived with utter conviction.

DAYNA EVANS

Who Will Save the Food Timeline?

FROM *Eater*

IN THE LONG timeline of human civilization, here's roughly how things shook out: First, there was fire, water, ice, and salt. Then we started cooking up and chowing down on oysters, scallops, horsemeat, mushrooms, insects, and frogs, in that general chronological order. Fatty almonds and sweet cherries found their way into our diet before walnuts and apples did, but it would be a couple thousand years until we figured out how to make ice cream or a truly good apple pie. Challah (first century), hot dogs (fifteenth century), Fig Newtons (1891), and Meyer lemons (1908) landed in our kitchens long before Red Bull (1984), but they all arrived late to the marshmallow party—we'd been eating one version or another of those fluffy guys since 2000 BC.

This is, more or less, the history of human eating habits for 20,000 years, and right now, you can find it all catalogued on the Food Timeline, an archival trove of food history hiding in plain sight on a website so lo-fi you'd be forgiven for thinking it was a GeoCities fanpage. When you look past the Times Roman font and taupe background, the Food Timeline happens to be the single most comprehensive inventory of food knowledge on the internet, with thousands upon thousands of pages of primary sources, cross-checked research, and obsessively detailed food history presented in chronological order. Every entry on the Food Timeline, which begins with "water" in pre-17,000 BC and ends with "test tube burgers" in 2013, is sourced from "old cook books, newspapers, magazines, National Historic Parks, government agencies, universities, cultural organizations, culinary historians, and company/

restaurant web sites." There is history, context, and commentary on everything from Taylor Pork Roll to Scottish tablet to "cowboy cooking."

A couple of years ago, I landed on the humble authority of the Food Timeline while doing research on bread soup, a kind of austerity cuisine found in countless cultures. The entry for soup alone spans more than 70,000 words (*The Great Gatsby* doesn't break 50,000), with excerpts from sources like Maguelonne Toussaint-Samat's *A History of Food,* John Ayto's *An A–Z of Food and Drink,* and D. Eleanor Scully and Terence Scully's *Early French Cookery.* Before long, I fell into the emotional condition known as an internet K-hole, following link after link after link for hours on end. From olla podrida to hodge podge to cassava to taro to Chex Mix to johnnycakes, the Food Timeline covered everything. Did you know that mozzarella sticks go as far back as the Middle Ages, but back then they called them "pipefarces"? I bookmarked the site and returned to it time and time again, when I was researching, writing, or just bored and hungry.

Despite the Food Timeline's incredible utility, few people I spoke to had ever heard of it. Those who had always marveled at its breadth. "Oh my god, it's nirvana," *Taste of the Past* podcast host Linda Pelaccio said to herself when she first stumbled onto the Food Timeline. Sandy Oliver, a food historian and fellow fan, was stunned by its completeness and simplicity. "It was one of the most accessible ways of getting into food history—especially if you were a beginner—because it was just so easy to use," she told me. "It didn't have a hyperacademic approach, which would be off-putting."

When Oliver learned that the thousands of pages and countless resources on the Food Timeline were compiled and updated entirely by one woman, she couldn't believe it. *Oh my lord,* she thought. *This is an obsessed person.*

The Food Timeline, in all its comprehensive splendor, was indeed the work of an obsessed person: a New Jersey reference librarian named Lynne Olver. Olver launched the site in 1999, two years before Wikipedia debuted, and maintained it, with little additional help, for more than fifteen years. By 2014, it had reached thirty-five million readers and Olver had personally answered 25,000 questions from fans who were writing history papers or wondering about the origins of family recipes. Olver populated

the pages with well-researched answers to these questions, making a resource so thorough that a full scroll to the bottom of the Food Timeline takes several labored seconds.

For nearly two decades, Olver's work was everyone else's gain. In April of 2015, she passed away after a seven-month struggle with leukemia, a tragedy acknowledged briefly at the bottom of the site. "The Food Timeline was created and maintained solely by Lynne Olver (1958–2015, her obituary), reference librarian with a passion for food history."

In the wake of Olver's death, no one has come forward to take over her complex project, leaving a void in the internet that has yet to be filled—and worse, her noble contribution to a world lacking in accurate information and teeming with fake news is now in danger of being lost forever.

It isn't often that we are tasked with thinking about the history of the food that we eat, unless it shows up in a *Jeopardy!* question or we ask our informal family historians to detail whose mother passed down this or that version of pound cake. But there are plenty of reasons to pay close attention: for curiosity's sake; for deepening an appreciation of and respect for cooks, food, and technique; and for gathering perspective on what came before us. "Very few (if any) foods are invented. Most are contemporary twists on traditional themes," Olver wrote on the Food Timeline. "Today's grilled cheese sandwich is connected to ancient cooks who melted cheese on bread. 1950s meatloaf is connected to ground cooked meat products promoted at the turn of the 20th century, which are, in turn related to ancient Roman minces."

The problem is that these days we're overloaded with bad information that can be accessed instantaneously, with few intermediaries running quality control. "I think it's a little too easy to turn to the web," Oliver, who was also a longtime friend of Olver's, told me as we talked about the legacy of Food Timeline. "What I worry about is that people aren't learning critical thinking skills. Once in a while I run into someone who has never used a primary source —wouldn't know it if it hit them on the head. Libraries are where you'd find that stuff. It's not the same as using a Wikipedia page at all." Or, if not a library, a mammoth resource compiled by a certified reference librarian herself. Whenever a reader would write in asking a question, or when Olver herself would become interested

in the provenance of a certain food, she'd turn to her personal library of thousands of food books, and her litany of professional resources and skills, and write out detailed answers with sources cited on her website.

As Olver emphasized proudly in a 2013 interview on Pelaccio's *Taste of the Past* podcast, when you Google "food history," the Food Timeline appears first in the search results, even though she never "paid search engines for premium placement, solicited reciprocal links, partnered with book vendors, or sold advertising." Over the years, thousands of emails poured in asking Olver for help finding the specific information they were looking for, like the history of a weird cheese or a grandmother's pie recipe.

"One of my favorite groupings of people are those who are looking to recover family recipes," Olver explained to Pelaccio. "I love that! As long as you can give me a little bit of context, then I have some direction." She would often cook the recipes people sent her so she could gain a better understanding of the legacy of certain foods. Occasionally, she would struggle to come up with an answer to readers' questions. "If anybody out there knows the answer to this, please let me know," she began on Pelaccio's podcast. "I've been asked repeatedly over the years for a recipe for 'guildmaster sauce.' It is mentioned on some of the old railroad menus and on fancy dining car menus, but we are not coming up with a recipe or other references." She never got the answer.

"One of the reasons she wanted people to learn about food was for the simple basic fundamental fact that it kept people alive," Sara Weissman, a fellow reference librarian at the Morris County Public Library and occasional Food Timeline collaborator, told me. "It was that simple. There was no pretension about it." Olver found food to be a universal subject of interest—everyone had something to share and everyone had something to learn.

"Yesterday I took the entire day off from work because I wanted to research seitan wheat meat," Olver told Pelaccio. "My whole site is really driven by my readers. What is it that *they* want to know?"

The Olvers' former family home is a modest colonial that sits on a shady suburban street in Randolph, New Jersey, about ten minutes from the Morris County Public Library, where Lynne worked for more than twenty-five years. It is fastidiously clean and welcoming, and Olver's library was still the focal point of the house when

I visited a little more than a year ago. As she amassed primary sources to build out the Food Timeline, the sitting room filled up with bookshelves to house her more than 2,300 books—some dating to the seventeenth century—as well as thousands of brochures and vintage magazines, and a disarrayed collection of other food ephemera, like plastic cups from Pat's and Geno's and a tin of Spam. "One of ten top iconic American manufactured foods, SPAM holds a special place on our national table & culinary folklore," Olver wrote on the timeline.

Despite Olver's intense fondness for it as an object of inquiry, Spam did not hold a special place on her palate; she never tried it. A picky eater, she detested lima beans, pistachio ice cream, calamari, slimy textures, and anything that even edged on raw. When she was in high school in the early '70s, her favorite dish to make was something she called "peas with cheese," which is as simple as it sounds. "She would take frozen peas and she'd melt cheese on it, mostly Swiss," then cover the messy pile in Worcestershire sauce, Olver's sister, Janice Martin, recalled. "We called Worcestershire sauce 'life's blood.' It was coursing through our veins." (Sadly, the timeline does not include an entry for peas with cheese.)

Making peas with cheese as a teenager was the beginning of what would become a lifelong interest in food for Olver. Libraries also captured her attention early on: at sixteen, she took her first job as a clerk in the Bryant Library in Roslyn, New York, shelving books in the children's department. There, she was mentored by two older librarians, whom she loved. "She was an introvert," Olver's sister told me. "When it came to research, she was fascinated by ferreting out information that nobody else could find." In 1980, she graduated with a degree in library science from Albany State University, where she also worked as a short-order cook, making sandwiches for students and faculty at a university canteen.

Olver and her future husband, Gordon, met at Albany State and married the year after Olver graduated, in 1981, after which they worked in Manhattan (Lynne at a law library, Gordon in reinsurance), then Connecticut. They eventually had two children—Sarah and Jason—and settled in New Jersey in 1991, where Olver found a job as a reference librarian at the Morris County Public Library, eventually becoming the head of reference, and finally director of the library.

It was during Olver's time as a reference librarian that the seed

was planted for the Food Timeline. It began as an assignment to explain the origins of Thanksgiving dinner to children, to be published on an early incarnation of the library's website. Around the same time, Olver was asked to write a monthly print newsletter to share library news, which she named *Eureka!* One section of the newsletter was devoted to "Hot Topics," as Olver and her colleague Sharon Javer wrote in the first dispatch. "Each month, this lead feature will focus on a particular theme: holidays, New Jersey events sources, census data, and so on. Included in this sizzling section will be answers to arduous questions, practical pointers and many marvelous morsels of information."

Eureka!, in a sign of things to come, began to take over her life. "I remember one time saying to her, 'How come we're buying all this colored paper?'" Gordon, her husband, told me. "The library wouldn't pay for the paper, so she was buying it on her own. When the library realized it was taking so much of her time, they asked her to stop. Meanwhile, she had put so much time and effort into it that she said to them, 'Just pass it over to me, I'll take it.'"

When the family got a Gateway computer in the late '90s, Olver began teaching herself HTML, and by 1999, she was combining her interest in the Thanksgiving dinner project and the *Eureka!* answers column into a hybrid website she called the Food Timeline, where she could focus on providing well-researched food history on her own time. An archived version of the 1999 Food Timeline still exists and looks—unsurprisingly—more or less the same as the one now. "We still hand code html & today's readers comment the site is 'ugly,'" Olver wrote under the site's "Market Strategy." "We acknowledge: what was cutting edge in 1999 is now stale. Conversley? [*sic*] FT looks so old it's become vintage."

Olver wrote everything on the Food Timeline with a royal "we," including her responses to readers' emails, despite the fact the project was largely hers, with an occasional assist from others. "'I don't want anyone to know that it's just me,'" Sarah recalled her mom saying. "She wanted people to believe that it was a network of volunteers," because she felt that it lent the site more credibility.

While Olver worked at the county library by day, by night she was creating an online resource for anyone who wanted to know more about Johnny Appleseed or chuck wagon stew or the origins of Sauce Robert. By the website's first anniversary, Olver was already spending upwards of thirty hours a week on the Food Time-

line, compiling and posting all the information she was digging up and answering readers' questions about the origins of their grandmothers' crumble recipes. "If you came in the house and you wanted to know where she was, and she wasn't cooking, she was in the office on the computer," Gordon recalled.

Eventually, even the cooking fell behind. Olver's children came to expect burnt grilled cheese sandwiches at meals, Sarah said. "She would be like, 'I'll leave these [on the stove] and go do my work,' and then she would forget because she was so into what she was doing."

Over time, the audience for the site expanded, and Olver's subtle form of fame grew with it. She was named a winner of the New York Times Librarian Award in 2002, and, in 2004, *Saveur* put the Food Timeline on its Saveur 100 list of the best food finds that year. In the mid-2010s, she was asked to contribute to *The Oxford Encyclopedia of Food and Drink in America* and consult for *America's Test Kitchen*.

Sarah and Jason recalled taking their mother to a cooking class at the Institute of Culinary Education in Manhattan during that time period. "She was so excited about the teacher of this class because she had heard of her through her research," Sarah told me. "When we got there, the teacher was like, 'I'm looking at my roster of students and I see that Lynne Olver is here. Where is Lynne Olver?' Mom kind of timidly raised her hand, and this chef was like, 'I've been dying to meet you!'" The chef who left Olver starstruck was just as starstruck to meet Olver.

For years, Olver lived something of a double life. As the director of a mid-size suburban library, she was known to hand out PayDay candy bars to her staff on pay day and shovel snow from the building walkway during snowstorms, while as the founder of Food Timeline, she brought her computer on vacation, dutifully responding to readers' food history questions within the promised forty-eight-hour window. "I think she started on the internet as a way to reach a lot of people," her sister said. "A lot of people who wouldn't go into the library."

The night before her wedding, in September 2014, Olver's daughter, Sarah, noticed that her mom wasn't acting like herself. While the family was sitting all together in the living room, Olver got up to go to the bathroom; minutes later, she was in the throes of a seizure. Sarah called 911, and Olver was taken to the hospital.

The family stayed with her until doctors sent them home in the early hours of Sarah's wedding day. The wedding had to go on, though Olver was too sick to attend. Doctors diagnosed her with leukemia the next day.

Olver had known for a while that she was sick, but didn't want to ruin the wedding, so she had put off telling anyone. "She'd be like, 'I'm dying, but let me put everyone else first,'" Sarah said. Olver was kept in the hospital for two months, but fought hard to be home for Thanksgiving. "It was my first time cooking Thanksgiving dinner because she wasn't feeling up to cooking—and I ruined it," Sarah said. "The turkey shrunk off the bone. That was one of the only things that made her laugh in a really long time."

When she was diagnosed with leukemia, Olver used the Food Timeline's Twitter account to grumble about the food in the ICU at Morristown Medical Center, where she stayed until she was transferred to specialists in Hackensack two months later. "It was a chicken cutlet with some kind of sauce on it," Gordon recalled; the post has since been taken down by the family. "She said, 'This sauce, I don't know what it is, I'm not eating it. It doesn't look very good. It's not a natural color.'"

Following her stay at the hospital in Hackensack, Olver returned home to wait for a bone marrow transplant. "She had to use a walker because balance was a problem, but very shortly after getting back from the hospital, she was walking around and doing all of her Food Timeline stuff again," Gordon explained. She was responding to emails, diving back into her research. "On her birthday, March 10, she said, 'I had a glorious day.'"

The reason? "Someone had written in with a question that she liked."

A little over a month later, Lynne died of leukemia, only one year short of her retirement from the library. She had been planning to spend her retirement working on it full time: earlier that year, she had renewed the Food Timeline domain for ten more years.

A year after Olver's death, her family began to discuss what would happen to the Food Timeline and who could take it over. "What we know is that we couldn't do it justice ourselves," Sarah said.

To anyone willing and able to maintain Olver's vision of an ad-free, simply designed, easy-to-access resource on food history, the

family members say that the website and her library are theirs, for free. A couple of people have put forward their names, but the family felt that their hearts weren't in the right place. "One woman had shown us what she had done with her website and it was just full of banner advertisements," Gordon said.

"It has to uphold her vision," Sarah added.

Olver's book collection—if a price were to be put on it—would be worth tens of thousands of dollars, Gordon estimates. So far, there have been no takers for either the books or the task of keeping the site going.

"The Culinary Institute of America initially expressed interest," Gordon said. "But three months later, they came back and said, 'We don't really have the ability to take that volume of texts *and* dedicate [the task of updating the site] to a specific person. I said they were missing the point; I wasn't looking to give them the books unless they wanted the website, too."

The Food Timeline was—and still is—a great democratizing force. "I think Lynne liked that the internet was *for* everybody and *by* everybody. Knowledge is power, but sharing knowledge is the best," Lynne's sister, Janice, told me. "If you hold the knowledge and you can help everybody get it, that's where it's at." Lynne Olver, an award-winning reference librarian, wanted everybody to know exactly what she knew.

"I would second anybody who says that they want Food Timeline to be brought up to date, who know how to keep that valuable digitized information where people can get their hands or their minds on it," Sandy Oliver told me. "I'd hate to think Lynne had spent all those hours doing all that work and have it just slide into oblivion. I'd love to see it continue in whatever useful form it can."

BETH LANDMAN

You'll Probably Never Get into This Restaurant

FROM *Eater*

AT THE FALL pre-opening party for Tavern by WS, a restaurant partnership at Hudson Yards between the magazine *Wine Spectator* and the mega-complex's developer, Related, a crowd of invitees mingled in a spacious room with double-height ceilings and murals, sipping Oregon pinot noir and French Chablis. As they nibbled on mini-bowls of pork and beans, a few observant guests noticed that trays of foie gras were en route to a different gathering upstairs.

Above the tavern is a more intimate and inviting group of dining rooms intended to give visitors the sense of walking into somebody's country estate. Seats are fine leather rather than upholstered wood, and an amber aura highlights an open kitchen, two fireplaces, and a chic lounge bar that will play host to special dinners planned with chefs like Thomas Keller, whose restaurants TAK Room and Per Se happen to make him a tenant of Related Companies and its billionaire mogul chairman, Stephen Ross.

Sound exciting? Unfortunately, you most likely won't be able to go. While Tavern by WS is open to the public, the space above it—called simply WS New York—is reserved for members willing to pay a $15,000 initiation fee, plus $7,500 in annual dues. A brochure for WS New York lures people to join for an "insider perspective on rarified worlds." As one of the club's managers was heard explaining at the party, "Think Soho House, but ten years older, so ten years richer and more exclusive."

WS New York isn't the only place in New York where most peo-

ple will have trouble scoring a seat. Private restaurants, or those where it's nearly impossible to get a reservation, are on the rise throughout the city.

Just last month, celebrity hot-spot restaurateur Omar Hernandez opened a new members-only restaurant on the Lower East Side, with chef Flynn McGarry consulting on the menu. There are also places like Fleming by Le Bilboquet and the Polo Bar, where billionaire owners Ronald Perelman and Ralph Lauren, respectively, curate the crowds, reportedly going as far as making staffers Google every single potential diner. Even harder to infiltrate are the increasing number of enviable dining rooms at high-end condominiums—like 432 Park Avenue, where esteemed chef Shaun Hergatt oversees the kitchen, or 220 Central Park South, which will house the next New York restaurant from uber-chef Jean-Georges Vongerichten. There, all fifty-four seats will be off limits to anyone who's not a resident (or guest of one) at the building, where a penthouse sold for $238 million.

In fact, exclusive restaurants with high-end chefs are becoming the latest in-demand amenity of luxury condos, according to Stacey Kanbar and Julie Kopel from the Kanbar Kopel Team at real estate firm Compass, who say they've noticed an uptick in the trend among clients looking at new upscale buildings.

"They provide privacy and serve as a convenient place to host personal and professional meetings," Kanbar says. "It's something we didn't see often just a year ago, but now, for some high-profile clients, dining with discretion has become a must-have feature in a new home."

Private dining rooms have become important points of distinction and selling tools for the properties in part because the luxury real estate market in New York is suffering a glut of unsold spaces, says Stephen Zagor, a consultant who teaches restaurant and food entrepreneurship at Columbia Business School and New York University. A recent report found that more than 25 percent of new condos in Manhattan hadn't been sold as of September 2019, including some 40 percent of Billionaires' Row.

"Developers are looking for anything that can distinguish a building by adding a layer of exclusivity," Zagor says. "If a couple were shopping for an ideal $10 million apartment, and they were told about this private restaurant in one, they would high-five each other at the thought of ordering their room service from Jean-

Georges. Of course, we know he won't exactly be sitting there wait-
ing for them to come down for dinner."

Exclusive dining is not a new concept in New York. Iconic Rao's
famously has a timeshare system, with customers owning a table's
scheduled slot; anyone who wants to dine at the famed East Har-
lem Italian restaurant has to be invited. The more than ten-year-
old Japanese restaurant Bohemian in Noho has an unlisted num-
ber and only accepts reservations for those referred by regular
patrons. Membership establishments, including university clubs,
have been around for years—with fees as diverse as more than
$2,100 annually plus a $550 application fee for Soho House to an
initiation of $30,000 plus an annual membership of $12,000 for
the Core Club.

In London, dining clubs are a major and accepted part of the
social fabric. Robin Birley—a London club owner and the son
of Mark Birley, who founded Annabel's, arguably London's best-
known club—must have gotten wind of the New York trend, as he
plans to open a private dining club called Oswald's later this year
on the Upper East Side.

The appeal for the restaurateurs, experts say, is that they better
set the mood if they have full control over not only the space but
who's dining there. "A lot of these places have the country-club
mentality, which is a totally different mindset from most restau-
rants," says Steve Hanson, who owned more than thirty restaurants
in New York before selling his company BR Guest in 2007 for
$150 million. "The premise is 'Okay, let's make everybody happy,'
instead of 'Okay, let's make money,' so the benefits are passed to
the consumer—they just want the customer to have a great expe-
rience."

Lumaca chef John DeLucie, who opened the exclusive Waverly
Inn with then–*Vanity Fair* editor in chief Graydon Carter but is no
longer there, says that knowing who's coming in makes it easier
for the restaurant on the service side. He's visited Annabel's and
understands how it's easier to execute personalized hospitality in
these contexts, he says. "When you have a more limited number
of guests and you know who they are, you can really deliver on the
promise of making people feel special," he says. "In places with
memberships you are paying for the privilege of being with peo-
ple who can afford it, and you are buying a more pampered exis-
tence."

And for some of the restaurateurs, it's just as much of a brand-ing play as it is a place to get food. At the Polo Bar, designer Ralph Lauren can theoretically make everything he does more "visceral," Black Tap restaurateur Chris Barish argues.

"It's a brand extension for a lot of these owners, for Hudson Yards, *Wine Spectator,* and Polo," Hanson says, "and neither Ralph Lauren nor Ron Perelman are looking to make a living from their restaurants."

For diners, entrance to exclusive restaurants can ease some of the more daunting aspects of New York dining—like difficulty making reservations, long waits after arrival, or rooms so loud that conversation isn't audible. Some people welcome the civility and level of service at exclusive dining rooms, particularly when look-ing to impress a business or romantic interest.

An art-world insider, who has become a regular at Bohemian and asked to remain anonymous to respect the privacy policy, feels the thirty-seat boîte is like a retreat from the normal New York dining scene. He likes that the menu is small but reliable, with meat from the next-door Japanese butcher, and he enjoys that the restaurant sometimes hosts events or live music. "Going feels like eating with a big family," he says.

There are other cultural perks too. He likes that the space used to be artist Jean-Michel Basquiat's studio, and that diners might be seated with people like Sofia Coppola or Rami Malek. Bohemian also has a private vacation house in the Caribbean that its regulars can visit.

And perhaps most importantly, there's value to being an insider and having access in New York; a recommendation to Bohemian or an invitation to dinner at another exclusive spot has social currency. Gaining entrance brings the ability to network—and it doesn't hurt if that community is solvent and influential. Ross, for instance, is not only a landlord but also the owner of the Miami Dolphins and Equinox and a major investor in the Momofuku restaurants, while Perelman has stakes in everything from Revlon to pharmaceutical company SIGA Technologies.

"There is a seductiveness to private dining; people who have re-sources would like to spend more time together with people who have resources," says Zagor. "At WS, you get to be a part of Steve Ross's club, which is being curated by one of the most well-known, successful people in the country. If you want to show yourself off,

this is a great place to do it, although in January, when no one is crawling across the Vessel, it might be slightly less appealing. Like the characters in *Downton Abbey*, these people are trying to maintain their lifestyle."

DeLucie refers to these spots as enclaves of "aspirational dining," for those who want a sense of belonging to an elite crowd. Waverly didn't have a public number, and all requests went through Carter's office. "I'm a member of Soho House and I like going there because I feel there are other creative, like-minded people," he says. "And when you go to Bohemian, even if you are not very in the know, you feel like you are part of something cool."

Plus, tons of restaurants in New York have good food—the social element matters more than ever as an added bonus in a competitive field, says John Meadow, who's president of LDV Hospitality (Scarpetta, American Cut) and has been approached to do private restaurants. "Like all trends in New York, the chef-driven esoteric food-porn craze is slowing down, and the pendulum shift is back toward the restaurant experience as an opportunity for community-centric connectivity," Meadow says.

Despite understanding the appeal, many industry experts have reservations about the concept, from the demographics of the crowds that exclusive restaurants draw to whether or not they're sustainable as businesses. "It's a weird nondemocratic idea I'm not sure I love," says DeLucie. "If you like more diversity, maybe it's not exactly what you are looking for."

And an exclusive restaurant inherently means fewer customers. At Fleming, employees reportedly research every person who tries to make a reservation and will reject people "even if it means we're slow." (A staffer told the *New York Post* that diners are only accepted there if they're "rich.") If an owner is not a real estate developer or someone with extremely deep pockets, like Ross, Perelman, or Lauren, that financial model doesn't always work.

Zagor points to "a long history of casualties" in the world of exclusive restaurants, like when the 21 Club tried to make its upstairs a members-only situation. "Many of those out there now are challenged to make money," he says. "When you have a restricted membership, you don't necessarily have the number of bodies to cover the cost."

New York Post restaurant critic and longtime real estate reporter Steve Cuozzo says that "highly specialized" places like the mem-

bers-only cigar bar the Grand Havana Room or the new *Wine Spectator* club might work. Generally, though, he's dubious.

"Private dining rooms in fancy apartment towers can rely on rich residents to keep them afloat," Cuozzo says, "but free-standing clubs that exist mainly to let members think they're special usually fall flat on their faces."

The Chef Restoring Appalachia's World-Class Food Culture

FROM *Atlas Obscura*

THE LATE-AUGUST SUN blazes overhead as Travis Milton enters the gated two-acre vegetable garden just steps from Taste, his new brews-and-bistro-style pub. Some 200 yards away, an accompanying fine dining spot, Hickory, is being built. He walks along a row of heavy, two-foot-long Candy Roaster winter squashes that, when sliced, reveal delicate pink-orange flesh. Elsewhere, ears of Bloody Butcher corn as red as a mountain sunset grow alongside Cherokee White Eagle Corn, which contrast, in turn, with licorice-colored Black Nebula carrots.

The experience feels like touring a high-end botanical garden, but Milton describes it as more of a living-history museum, one that re-creates gardens like his great-grandparents', before it was strip-mined for coal. Most of the more than 100 rare and obscure varieties, he says, were standardized a century ago by homesteaders in Appalachian coal country. All were once regional staples —Milton collected many of the seeds from mountain-country old-timers.

"The diversity of fruits, vegetables, and livestock being cultivated on homesteads in this region was simply astonishing," says Milton. It was amplified by a tradition of foraging American chestnuts, dandelion leaves, and other wild foods. "If you could've brought everything together on one property, you would've had one of the largest and most unique region-specific collections of ingredients in the world."

This, of course, is what Milton is creating now: a farm, garden,

drink venue, and restaurant that restore and showcase Appalachia's world-class food culture. To do it, he's partnered with Kevin Nicewonder, the scion of one of Appalachia's oldest and wealthiest coal families. Taste and the farm are now open, and are meant to preview the 28-room Nicewonder Inn and 130-seat Hickory, which will open around June 2020.

With the coal industry disappearing and leaving a gulf of economic disparity, says Nicewonder, "We have to define what this region is going to be moving forward." He sees the project with Milton as a way to set the bar for future development. "Here, the idea is to tell the story of the land through its food, but with an eye toward healing old wounds." Rather than doomed efforts to bring back coal, he wants to pursue projects "that will bring positive and sustainable results."

Milton is from coal country. But to become successful—a star chef, in his case—he left, even shedding his accent. Countless Appalachians have done the same, creating a kind of diaspora, a brain drain. Milton and Nicewonder hope to reverse that, to redefine a region known for poverty, branded as hick, and defined by its dying coal industry as a thriving culinary destination. In truth, though, Milton says, it's not so much a redefinition as a return to a past that went unappreciated and is almost lost.

"We want to build a beacon that tells people that left the region, or those that're thinking about leaving: 'Things are changing. You can put your talents to work here,'" Milton says.

With his great-grandparents' seeds, and a culture that was nearly strip-mined out of existence, he wants to sow a new future for Appalachia.

Milton was born some twenty miles from the site of Hickory and Taste, in the 2,000-person town of Castlewood. His parents couldn't afford childcare, so he spent days with grandparents and great-grandparents. His mom's side ran a diner; his dad's, a cattle farm. Both kept home gardens and orchards.

"My first memories are being in the kitchen of my grandparents' restaurant," says Milton. "It's my grandma teaching me to make scratch biscuits, peel potatoes, mix egg batter." He also rounded up Hereford cattle, shucked green beans on front porches, canned tomatoes, baked vinegar pies, pickled peaches, pruned apple trees, foraged for berries, made preserves, and tended gardens.

"To me, this was just normal stuff," says Milton. "Everybody's grandparents kept gardens."

But when Milton's parents moved to Richmond, the contrast was glaring. His mountain drawl was a lightning rod for cruelty. He was labeled a bumpkin and teased relentlessly.

"It was like I'd been uprooted and thrown into this hostile, alien place," says Milton. "To survive, I rewrote who I was."

He changed the way he dressed and stopped listening to Bill Monroe in favor of David Bowie. He practiced reading aloud to subdue his accent. He took up literature and became a high school English teacher. But after a year, he took a job as a cook in an upscale Italian restaurant.

"That first night, a light went on," says Milton. "I said to myself, 'Okay, so this is what I'm supposed to be doing.'"

Milton rose fast. Within a year he'd been promoted to sous and soon to head chef. The position led to better posts, and he used vacations to apprentice at top restaurants and become a certified butcher and sommelier.

By the late 2000s, though, Milton's thoughts increasingly returned to Castlewood.

"The more I learned about the restaurant business, the more I appreciated the food culture I'd grown up in," he says. "My great-grandparents were always tinkering with vegetables and fruit trees, trying to create new varieties that would bring different tastes and textures. I started dreaming of a restaurant that would capture and celebrate that lifestyle, allow me to explore where it came from."

His idea was not well received by other chefs.

"I'd say 'Appalachian Cuisine,' and they'd hit me with a shit-eating sneer," says Milton. He tells this story in the garden, pausing along a row of trellised vines hung with what appear to be glossy, oversized green beans. "They'd start cracking jokes about toothless rednecks frying up possums and squirrels, or trailer-park trash eating Spam out the can."

The beans behind him, Milton explains, are known as Greasy Grits. Hybridized in Appalachian gardens more than 120 years ago, they were prized for making a dried staple known as leather-britches. Rehydrated and served in their pods, they bring an unrivaled silky texture punctuated by a sweet and nutty pop.

In 2010, at a New York restaurant, Milton was part of a group

planning dishes that would "tell about who we are." He wondered aloud about sourcing greasies for leather-britches.

The following afternoon, the head chef slapped a copy of *White Trash Cooking* onto Milton's station. "He got in my face," says Milton, "and started barking, 'If this is what you wanna do in my kitchen then you can get the fuck out!'"

Having *White Trash Cooking* slammed in his face was a turning point. To overcome the stereotypes, Milton realized, he'd need to be able to tell the story of Appalachian food, and give people a taste. But writing on the region's cuisine was mostly scholarly, focused on single mothers dressing up Spam in a sugary sauce and other relatively recent ways that plucky Appalachian cooks had responded to the poverty that is, for many, coal's legacy in Appalachia. And while a few chefs served Appalachian-inspired entrées or appetizers, nobody was doing a full-blown cuisine.

So, in 2010, Milton hit the books. Late at night after shifts, he read online articles, obscure cookbooks, and histories. They led him to chefs, food writers, farmers, seed purveyors, food-studies professors, and heads of preservation organizations. He wrote emails, made phone calls, paid visits.

Above all, Milton learned that Appalachia was the New World's first true culinary melting pot. In the 1700s, Germans and Scotch Irish arrived in what for them was a wild frontier, followed by numbers of English, enslaved people, and freedmen. Settling in small groups for safety and sustenance, mostly in valleys, meadows, and hollows, they found areas inhabited by Indigenous groups such as the Cherokee.

The region's isolation, challenging terrain, short growing seasons, and hard winters broke down traditional social barriers, and forced newcomers from different backgrounds to work together to survive. Subsequently, they adopted each other's foodways. Though many were infringing on Cherokee lands—and sometimes used violence to secure them, with the US government eventually warring with and forcibly removing the Cherokee—the tendency is most apparent in how the region embraced Native American food.

Appalachian terrain is extremely varied. Small valleys give way to steep slopes and peaks as high as 6,000 feet—many topped with balds and meadows. Europeans typically cultivated single crops in large flatland plots.

"But that method was useless in Appalachia," says food writer and historian Ronni Lundy, whose 2016 book, *Victuals: An Appalachian Journey*, offers an experiential history of the region's cuisine. Though Europeans throughout the Americas learned from Indigenous groups, here the effect was amplified.

Lundy says Appalachian settlers adopted Cherokee methods almost wholesale. They hunted wild game, including bison, deer, turtles, and possum. They seasoned meals with herbs such as wild ginger, sumac, and spicebush, and foraged for wild greens, nuts, and berries. Wherever possible, they planted small gardens of beans, corn, and squash using the Three Sisters method.

Lundy calls the Native Americans' famous three-crop system "deceptively diverse." Though statistics are fuzzy, Cherokee gardens are known to have contained dozens of locally adapted varieties of beans. Ditto for corn, pumpkins, tomatoes, and squash. In *Victuals*, Lundy points to archaeological finds of crops such as goosefoot (a relative of quinoa) as well.

Europeans added their own crops and traditions to the medley. "You had all these incredible ingredients and culinary traditions coming together in one place and combining in new and exciting ways," says Lundy. Which is why Milton, as a youth in his great-grandparents' gardens, walked among both beans and squashes from the Americas and Old World fruits and vegetables, picking them to prepare dishes, such as a speckled butter bean cassoulet with rabbit confit, that, in terms of ingredients and cookware, more closely resembled Native pot roasts than its French namesake.

Appalachia's landscape determined its culinary destiny, Milton found, in another important way: the region produced renowned livestock, but a cuisine that did not center around meat.

With its abundant chestnuts, acorns, berries, and alpine sweetgrasses, the mountain wilderness yielded world-class meats (and cheeses) on the cheap. Appalachians let their animals range freely, keeping prized breeds adapted to the landscape. Settlers raised pigs on acorns, berries, and chestnuts, which produced a uniquely flavorful and succulent meat, and helped establish what would become known as the Ham Belt of Tennessee and Kentucky. Meanwhile, says Lundy, German immigrants turned sheep and pigs that roamed at 4,000 feet into delicious sausage. Italians arrived later, bringing their own swine-related techniques and traditions.

"Appalachian livestock and meat products subsequently developed a reputation of superiority and came to be coveted throughout the plantation South," says Lundy.

But because livestock was so valuable and pasture space so limited, vegetables remained the stars in Appalachia's kitchens. "Meats were seen more as a flavoring agent or a compliment," says Milton.

A thriving restaurant scene developed along early nineteenth-century drovers' roads that connected isolated villages and homesteads to Southern market towns. Most kitchens were run by enslaved people or indentured freedmen and women. The cooks introduced Appalachians to Southern foods such as hoppin' John and African vegetables and herbs including red peas, black sesame seeds, and okra.

Though the Civil War decimated the meat trade—and its related restaurants—the Appalachian ethos of self-subsistence continued. While the rest of the United States specialized and industrialized, linked by growing ports and railroad tracks, using their growing incomes to buy mass-produced ingredients and more and more meat, residents of isolated, largely ignored Appalachia held tight to their gardening traditions.

They were incredible at it. Appalachians crossed Old World apples with indigenous crab apples to invent now world-famous takes on English-style hard ciders and brandies. Other hybrids—some orange-hued and big as miniature pumpkins, others purple as eggplants—were developed for baking pies, animal fodder, eating, or crafting apple butter. The region subsequently became home to more than 7,000 unique apple varieties.

And that's just one fruit. Appalachians hybridized varieties of squash, tomatoes, collard greens, you name it.

"These weren't casual gardeners; they weren't buying fancy seeds from catalogues and planting them for fun," says Virginia Tech agricultural extension agent Scott Jerrell. Appalachian gardens were laboratories dedicated to creating new tastes and useful characteristics, like later-maturing squash that grew sweeter with time and kept into the winter. With limited access to sugar, specialty corns were bred to be sweet enough to make delicious cornmeal.

"The approach is very different than [that of most modern] university research programs," says Jerrell. Most of the time "our

primary concern is maximizing yield . . . [and] shortening maturation times, thereby maximizing profitability for farmers. These people? What they cared about most was taste."

People like Milton's great-grandfather took pride in creating specialty varieties of vegetables, herbs, and fruits. A plate of multicolored fingerling potatoes topped with blue, purple, yellow, bright and dark-green rehydrated leather-britches, a sprinkling of equally variegated beans, chopped black garlic, and a bright-scarlet dusting of smoked paprika brought fantastic flavors and bragging rights. Many varieties in Milton's garden have names like Bertie's Best Greasy Beans.

But the arrival of the coal industry in the late 1800s and early 1900s led to the demise of Appalachia's foodways.

Lured by the money economy, men took jobs in coal mines, moving with their families to mining camps and towns. Though their families kept home gardens to avoid overpriced goods from commissaries, it was a big step away from subsistence. Over time, higher wages combined with better roads and made buying from grocers more attractive. The gardens began to vanish.

Though Milton's maternal great-grandfather turned to agriculture to make money, he didn't escape the impact of coal. He ran a commercial orchard in Wise County, Virginia, with his brothers from 1911 to 1950. Economic hardships led the family to sell the property to a coal company around 1950, and, like thousands of others, it was eventually strip-mined.

For Milton, visiting the site is a source of painful inspiration.

"It looks like a bombed-out battlefield; it's impossible to imagine somebody ever grew food there," he says. "When people talk about bringing back coal, they don't understand the costs. But I can look at the pictures and see the before-and-after. [Coal] took this amazing orchard and turned it into a barren wasteland."

But the loss had more than just personal significance. The event coincided with a perilous shift in Appalachian foodways: the region's amazing culinary history was being buried by historical shifts.

"The rise of big agriculture and the supermarket economy of the 1950s paired with the collapse of the coal industry to fuel a diaspora," says Milton. The former had divested younger generations of their capacity to live off the land. Faced with poverty,

young families fled to cities looking for work. "The older Appalachian foodways came under pressure."

As the Depression-era generation began to pass, no one was there to take them up. The foodways were in danger of being lost entirely.

In 2011, Milton assumed the mantle at Richmond's hip New Southern eatery, Comfort, and made a name for himself with a menu that incorporated traditional Appalachian ingredients.

The farm-to-table revolution was exploding, and interest in Southern cuisine was high. Milton parlayed the attention to feature foods he'd grown up with in southwest Virginia.

"But Comfort had a strong customer base, so I had to keep it pretty low-key," he says. Patrons expected traditional staples such as fried green tomatoes and chicken and dumplings. "The idea was to challenge eaters, but do it gently."

For example, a stack of fried green tomatoes might bring a medley of mountain heirlooms breaded with Bloody Butcher cornbread instead of flour and a topping of strawberry-rhubarb relish. A collard greens dish might include heritage varieties such as Champion and Alabama Blue, and be paired with leather-britches made from Pink Tip Greasy Beans, cubes of grilled Candy Roaster Melon Squash, and bacon crumbles from a West Virginia Tamworth pig.

The response was cultlike. Area food critics crowned Milton one of the city's top chefs.

In 2015 he shocked the culinary world by accepting an offer to develop Comfort-esque eateries at two new boutique hotels in the heart of southwest Virginia coal country. The collaboration led to an eponymous restaurant in the hip and offbeat Western Front Hotel in the 1,000-person town of St. Paul, which was devastated by the near-total loss of regional coal jobs in the early 2000s. Situated deep in the Blue Ridge Mountains on the Clinch River, the hotel and eatery is at the center of the town's effort to overhaul its economy around outdoor tourism.

For Milton, the move was all about location—it wasn't enough to be sprinkling Appalachian touches on the menu of a restaurant in the state capital. "Travis understands that you can't extract the cuisine from the culture," said John Fleer, chef-owner of Rhubarb

in Asheville, North Carolina, to the *Washington Post* in 2016. Revitalizing Appalachian cuisine required relocating to the region.

But the projects had other goals too. They marked the first step of Milton's plan to bring culinary-based economic development to a region decimated by the loss of coal jobs.

"Restaurants hire and train workers and, if they source local, support area farmers and food artisans," says Milton. Visitors bring dollars that drive tourism-related businesses—including pick-your-own berry farms, ATV tour companies, fly-fishing and canoe outfitters, farmers markets, breweries, cideries, distilleries, and additional restaurants.

"There are so many talented people out there that, like me, grew up here, miss this place, and would love to find a way to come back," says Milton. Hiring for sous-chefs at Western Front brought about 150 résumés; 75 percent came from Appalachian expats living in cities such as New York and San Francisco. "My hope is that these projects will convince some of them to bring their [real and creative capital] back to Appalachia."

Nearly seventy years after his great-grandparents' garden and orchard was strip-mined, Milton decided to partner with Kevin Nicewonder, the coal-family scion, to do that in an even bigger way.

Milton calls his project with Nicewonder the spearpoint of a crusade to spread awareness about and revitalize Appalachia's endangered historic foodways. In addition to the garden and two restaurants, heritage-breed sheep, cows, pigs, chickens, and turkeys will roam forest-lined pastures throughout the 800-acre property. He plans to add berries, fruit, and nut trees as well.

"Kevin has provided the space and resources I need to create a flagship venue that goes well beyond the scope of a traditional restaurant," says Milton, drawing comparisons to Tennessee's famous culinary destination Blackberry Farm. "We want to teach eaters about [Appalachia's] history and story, and let them experience it through taste."

Milton calls the symbolism of the partnership with Nicewonder fundamental.

"The coal fields drove the region's economy for a long, long time," says Milton. But the environmental and social costs were disastrously high. "To me, this is a demonstrative effort to heal and move forward. I'm not calling it reparations, because it's not. But

it is a statement. This project is saying, 'Look, that was the old way. And this is the new way, this is the future.'"

Again, Milton likens the project to a beacon for the region. He sees Taste, Hickory, the garden, and farm as a training ground for high-end waitstaff, mixologists, chefs, and small-scale farmers who will go on to work at and with other Appalachian-themed restaurants—or even better, open businesses of their own.

"This isn't easy work," says Milton. Training waitstaff to explain the cultural heritage of hundreds of obscure vegetables is challenging in a region where poverty rates hover around 25 percent. "But I love this place and I'm passionate about it," Milton asserts. "I dream of a future where young people are coming back to take over their grandparents' farms and plant apple trees on strip-mined mountaintops. And we're starting to see that happen."

Because with each addition, says Milton, the beacon shines a little brighter.

Waterworld

FROM *Afar*

ON DECEMBER 9, 1971, Bruce Lee sat down with Canadian journalist Pierre Berton for the martial artist's first and only English-language interview. The conversation lasted nearly thirty minutes and covered myriad topics: the differences in Eastern and Western media; being an Asian man in Hollywood; Lee's new-at-the-time martial arts school, set up for instruction in judo, karate, Chinese boxing. The footage was lost soon after the filming finished and would not be found until 1994, twenty-one years after Lee's death.

When it did finally air, the interview made an immediate splash, almost as if a charismatic Lee had been summoned from the past to provide sage wisdom to baby boomers, all grown up. Of everything Lee said in those thirty minutes, what's remembered most in popular culture is his fifteen seconds about water, the words appearing today on everything from T-shirts to protest signs in his native Hong Kong.

"Empty your mind, be formless, shapeless — like water," said Lee, musing on resilience while riffing off lines he'd spoken during his short-lived role on the TV series *Longstreet*. "Now, you put water in a cup, it becomes the cup; you put water into a bottle it becomes the bottle; you put it in a teapot it becomes the teapot. Water can flow or it can crash. Be water, my friend."

Nearly fifty years since Lee first uttered those words, there's another man in Hollywood talking about water and the ways we can learn from it. The ways we should — must! — pay attention to it. Sure, how these men discuss one of Earth's most precious nat-

ural resources is more different than alike, and yes, one man is known for a hand in the shape of a fist while the other has his around a glass. But like Lee, that man wasn't raised in the United States. Like Lee, that man has sometimes been the subject of jokes. And unfortunately for him, the jokes come easily when they hear that he, Martin Riese, is America's first water sommelier, curating menus and tastings around what he calls "the most important beverage on the planet."

Still, perhaps most importantly, like Lee, Riese is taking cues from the element he considers most beloved, going with the flow and flowing where he's able, taking opportunities as they come, and sharing why we should care about water with anyone who cares to listen.

"Water is not just water," he says to me one sunny October afternoon, shining bright from Los Angeles via laptop with the urgency of a theater attendant walking you to your seat just before the lights dim and the show starts. *Okay,* I think. Off we go. Down into waterworld.

Still or Sparkling? (Or Deionized, Artesian, Glacier . . .)

Martin Riese grew up in the village of Aventoft, population 460, the northernmost point of contiguous German territory. The town is twelve miles inland from the North Sea, separated from Denmark in the north by the Vidå River and Ruttebüller Lake. Everywhere Riese turned, *whoosh,* there was water: the sight of it, the smell of it. Listen hard enough, even the trickle, gurgle, and slap of it. "I was always surrounded by water, throughout my whole childhood," says Riese, a trim, tan, bespectacled man in his mid-forties. "I think that's also why I love water so much."

Starting when Riese was four years old, on vacations—to the Danish North Sea, Spain, France, Austria, Switzerland, southern and East Germany—his parents noticed something curious: one of the first things he'd do in any new destination was stumble to the sink, turn on the tap, fill a glass, and drink. Riese was fascinated by the idea that water tastes different in different places but didn't have the faculties to describe why, nor could he understand. Considering the many other worse things he could be doing, his mother and father let him be.

Riese's interest in water continued, but his passion had no sense of direction; it was a meandering stream instead of a rushing river. And so after high school he became a DJ, organizing parties and spinning aggressive, progressive trance music that clocked in at 160 beats per minute. Eventually, Riese grew tired of the late nights and loud music, but realized he liked the hospitality element of it all: he was helping people enjoy themselves, like a courier to only good times. Figuring that food and drink were some of life's greatest pleasures, he went to school for a degree in restaurant management.

In 2005, after apprenticing around Germany, Riese was the deputy maître d' at the Michelin-starred First Floor restaurant in the Hotel Palace Berlin. His return to water began here, sort of, via an unhappy guest, who approached Riese to complain. *You have more than 1,000 wines on the menu, yet you're just serving one type of water,* Riese remembers him saying. *And I don't like the taste.*

After the guest left, Riese couldn't shake the fact that he saw annoying truth in what the man said. It was niggling, the idea. That in the restaurant industry, where it was all about options, why then was there only one question about water: still or sparkling? Riese got to work: researching, reading, sipping, swilling. In 2006, he curated a water menu for the restaurant, with more than thirty-five different mineral waters from around the world. The clientele was receptive, and Riese's profile around the city began to grow: When a delegation from Saudi Arabia visited Berlin's City Hall for a meal with the mayor, Klaus Wowereit, it was Riese who was tapped to select the accompanying water. According to the German magazine *Der Spiegel,* Wowereit was so thrilled with the pairings—so delighted that such an offering was available in the German capital —that after tasting some of the water he flung his arms out and cried, "Ah! Berlin!"

By 2009, Riese had coauthored a book on water with Rose Marie Donhauser, a Berlin-based food critic and writer. Titled *Die Welt des Wassers* (The World of Water), it charts the differences between mineral, medicinal, and table waters; traces water-related myths and legends; and champions the health benefits of water. A year later, in 2010, Riese received the status of a Mineral Water Sommelier from the German Mineral Water Trade Association after training for two weeks in the "theory of waters," "sensations of waters," "marketing and consulting in beverage trade," and "marketing

and consulting in catering and gastronomy." Today, the association has nearly 200 members in more than 25 countries.

That Riese first found footing as a water sommelier in Germany is of little surprise. In the European Union, Germany is second only to Italy in the amount of bottled water consumed, with 46.2 gallons per capita. Mineral water—created as rainwater flows through the earth, acquiring minerals along the way—is the object of particular German pride and passion for its association with healing properties. (Experts say there are around 3,000 brands of bottled mineral water around the world, from natural sources like mountain springs and icebergs.) Across the continent, Germany has the largest market of different mineral water brands, with the mineral content of each water determined by each respective region. It is highly regulated, with EU law stipulating that anything calling itself "mineral water" must be minimally treated.

Because of its size and population, the United States has the biggest consumer market for bottled water worldwide. Despite being a "major culprit" in ocean pollution and a "symbol of human environmental desecration," according to *National Geographic,* plastic bottles are part and parcel of the bottled water industry—and that industry is booming: Since 2010, bottled water has steadily increased in sales volume year after year, and in 2016, bottled water outsold soda for the first time. It has done so every year since. Americans consumed 14.4 billion gallons of bottled water in 2019, up 3.6 percent from 2018. Bottled water's retail dollar sales also jumped last year, notching $34.6 billion, and interest in imported bottled water is also rising steadily. In a 2019 poll, 84 percent of Americans had a "very positive" or "somewhat positive" opinion of bottled water, according to the International Bottled Water Association (IBWA), which is headquartered in Alexandria, Virginia, and bills itself as the "authoritative source of information about all types of bottled waters."

When it comes to water, Germany still outdrinks the United States: Bottled water consumption per capita in the United States is 43.7 gallons, with just 26 percent of Americans buying name-brand bottled water and another 23 percent opting for store-brand bottles. Under FDA guidelines, bottled water can be labeled as "artesian water," "groundwater," "distilled water," "deionized water," "reverse osmosis," "mineral water," "purified water," "sparkling water," "spring water," and "sterile water"; the agency also requires

these terms be included on the product label to "enable consumers to easily determine the type of water they are purchasing," says Joe Doss, president of the IBWA. But does anyone actually *know* what they're buying? After all, 63 percent of the non-sparkling domestic bottled water that Americans purchase is treated water from municipal sources like wells, lakes, rivers, or reservoirs—the same original source as tap water. (Somewhat ironically, American consumers cite taste, quality, and safety as their top reasons for choosing bottled water over other packaged beverages.)

Though Doss acknowledges the common point of origin for tap water and several bottled waters, he is adamant that the end product is different. "The chemical and physical quality of this [bottled] water is not the same as water that comes out of the tap," he says, adding that "on a gallon-for-gallon basis, bottled water is required by law to be tested for safety at least 30 times more often than tap water."

Regardless, it's here that Riese needles back at critics who knife him for his work—those who say that advocating for such choice around water is a joke. What a luxury. What a waste of time. *What . . . bullshit?* But Riese, who in 2011 came to the United States on an O-1 visa—reserved for people with "extraordinary ability" or a "level of expertise indicating that the person is one of the small percentage who has risen to the very top of the field of endeavor"—doesn't fold. *Americans are already drinking bottled water,* he'll counter. *But if the bottled water they are drinking is mostly originating from municipal sources, why not help them pivot away from that, whether that means they go back to the tap or turn to natural waters? Why not raise awareness about companies that have built-in programs for social impact and giving back? Why not help consumers discover and drink the best waters, both for themselves and for the Earth?*

This is a familiar refrain in the small but passionate fine water community—an unofficial designation for water lovers of the world—where there is an immense gulf between "commodity" waters (which originate from municipal sources and don't "need" to be bottled) and natural ones (which do, sourced as they are from far-flung locales). Water, they argue, should be thought of like food or wine: How has it been fiddled with? What's been removed, and has anything been added? Is it sourced responsibly?

Think, Riese says, of a carrot.

"Where should your carrot come from? From a farm, or from

a grocery store in a plastic bag? From a farmer, ideally," he says. "Now where should your water come from? In a remote area relatively untouched by Mother Nature, or an urban factory in the middle of a major city?"

He waits, leaning forward to open a palm to me, and nods, eyebrows raised. *Exactly.*

Bottled water has the smallest water and energy use footprint of any packaged beverage: On average, it takes about 1.4 liters of water to make one liter of bottled water, compared to just one glass of wine, which can require more than 100 liters of water. Bottled water also accounts for less than 0.01 percent of all the water used in the United States each year. But Riese, who says he is "not against tap water whatsoever," is advocating for more transparency, whatever the water.

"Where there's enough water, and it hasn't been stolen, it needs to be sustainably sourced. That's very, very important to me," he says. "And I have a strong belief that eventually, the American consumer will say, 'I want to know where my water is coming from.'"

"A Watery Flavor"

In 2013, after two years of traveling around the world and tasting water, Riese unveiled a signature water program at Ray's and Stark Bar at the Los Angeles County Museum of Art, replete with a twenty-item menu. Waters began at $8 (Waiākea volcanic water) and ranged all the way to $20 per 0.75 liter bottle (Berg, from western Greenland). Riese made a late-night appearance on *Conan* to promote the menu, and brought along several of the waters he offered at the restaurant. O'Brien was skeptical, and to put it politely, *scandalized* that anyone would—and should—pay more for water.

"This tastes like what you drink when you're dying on a raft," he said after sampling Vichy Catalan, a naturally sparkling well water from Spain that has 1 gram of sodium per liter. (A Big Mac, for comparison, has 1.01 grams of sodium per sandwich.) No matter: water sales at Ray's and Stark Bar jumped 500 percent that first year. A year later, in 2014, Riese introduced a similar menu at Patina Restaurant in the Walt Disney Concert Hall, along with a two-hour, $50 water tasting. Other media appearances followed:

in 2015, he opened a $100,000 bottle of Beverly Hills 9OH2O water with rapper 2 Chainz and producer and DJ Diplo for *GQ* magazine's Most Expensivest Shit series, and in 2017, he visited the set of *Bill Nye Saves the World* as a guest on the episode, "Surviving in a World Without Water." Since November 2018, Riese has been the water sommelier at luxury boutique hotel Petit Ermitage in West Hollywood, where he offers West Hollywood tap water on his menu for $0, alongside listings for other waters like Hallstein (Austria, $25), Vellamo (Finland, $13), Gerolsteiner (Germany, $12), Antipodes (New Zealand, $14), and a quote from Leonardo da Vinci: "Water is sometimes sharp and sometimes strong, sometimes acid and sometimes bitter, sometimes sweet and sometimes thick or thin, sometimes it is seen bringing hurt or pestilence, sometimes health giving, sometimes poisonous. It suffers change into as many natures as are the different places through which it passes."

Most recently, Riese appeared on *Down to Earth*, a Netflix travelogue that debuted in July 2020 and follows actor-host Zac Efron around the world as he explores sustainability and wellness. In the show's second episode, Efron and actor Anna Kendrick sit for a water tasting with Riese in Los Angeles. "It annoys me that this is so good. Because I don't know how to describe it, but it tastes so strong," Kendrick says after sipping Three Bays water from Australia, which Riese describes as "heavy" and reminiscent of olive oil. "Water has a flavor, for sure," Efron agrees. "It's a watery flavor."

Riese delights in this challenge of converting skeptics into believers—of dismantling the idea that water has no flavor but that of water. *There. Is. No. Such. Thing. As. One. Flavor,* he will say, tapping the table for emphasis, major of his own drumline. But he is also sympathetic to the untrained palate, acknowledging that unlike "normal," where we can often rely on a combination of sight, smell, and taste to form our impressions of a bite or a sip, water on its own leaves you little to work with. If water is discolored or has an odor, ultimately, you should ideally not be drinking it in the first place. So how to actually describe its taste?

Water contains zero calories, zero carbs, zero grams of protein, and zero fat. It has no organic nutrients, but it can have trace minerals. Spend time with those in the fine water industry, and it will likely be mere minutes before you hear about total dissolved solids (TDS) levels, which represent the total concentration

of substances in water and can affect the flavor. Typically, these substances include calcium, magnesium, sodium, and potassium cations and carbonate, hydrogencarbonate, chloride, sulfate, and nitrate anions. Much like terroir with wine, water can draw out these substances (and, some argue, its *taste*) from its surrounds. Generally, the higher the TDS level, the "harder" and "harsher" the water is considered.

In 2003, a panel of testers came together for the World Health Organization to determine what they deemed "Guidelines for Drinking-Water Quality." Any water with less than 300 milligrams of TDS per liter is considered "excellent," while anything greater than 1,200 TDS per liter was deemed "unacceptable." FIJI Water, sourced from an ancient aquifer and known for its smooth taste, thanks to its 93 mg/l of silica, has a TDS of 222 mg. Hildon, which has a Royal Warrant for supplying water to Queen Elizabeth II and Buckingham Palace, has a TDS of 312 mg/l. On and on it goes, all the way up to Roi, which originates in Rogaška Slatina, Slovenia, holds the world's title for the most magnesium-rich water, and has a dizzying TDS of 7,481 mg/l. (It tastes astoundingly metallic—almost as if you swallowed a filling.) Pairing water with your meal, instead of wine? Anything with a TDS of 800 can be treated like a red, while lower-TDS waters are more like whites.

A large component of water tasting comes down to the mouth-feel of the carbonation, which accounts for 75 percent of the flavor: Are there bubbles? If so, how many? How big are they? Tasters also consider the density of the minerals in the water (20 percent of the flavor), and the pH balance (5 percent): Acidic waters have a pH of 6.7 or less, and can taste slightly sour, like the inside of an orange peel. More alkaline waters—with a pH of greater than 7.8 —smack sweeter. Zaros, sourced from below the Psiloritis Mountain in Crete, Greece, is an example of an award-winning alkaline water, with a pH of 7.9. Dasani, Aquafina, San Pellegrino, Perrier, and filtered tap water are acidic, with pHs of around 4. "The concept of pure water doesn't exist," says Riese.

Beamed through screens and circulated in click-worthy social media bites, Riese's enthusiasm can seem like an act. But in conversation, he is painstakingly, actually earnest. Even if his credibility is sometimes beset by his own Dad-like cheers ("Water should never be a dry topic!"), Riese is genuinely thrilled about the idea that water is a vessel we can use to travel around the world. That

it—so fundamental as a base in our foods and beverages—can change the way those foods and beverages taste, whether as ingredient or accompaniment. When I report that a mineral water registers salty and may pair well with a fatty steak, he leans forward in excitement. "Yes, exactly!" he cries. Another time, when I muse out loud that I am interested in mixing different waters in my oatmeal to see how it affects the flavor profile, he is overjoyed. "Do it!" he crows.

Riese has only once met a water he didn't like, and even then, dislike isn't the point. It was in Bad Oeynhausen, Germany: Mineral waters were set up like a bar, with taps available for trying any number of waters. "I tapped this one water and after I sipped I thought, *My God, what is happening,*" he says. "It was intense with iron. It tasted like blood. Would I drink it on a daily basis? Never! But that's me, and there is no best water. It depends on *you,*" he says, leaning on the word and pointing at me through the screen.

At the end of the day, Riese says, it's about choices. Because if more choices equal more knowledge, and knowledge is power, then surely some good can come of his work. If we pay more attention to where water comes from and care about its source, then we will think differently about it when we go home and turn on the tap, he reasons. And if we think differently, then maybe we will act differently: We'll plug up the sink instead of letting the water run, and we'll shut off the water when we're brushing our teeth. We will finally treat water with more reverence.

"I really want to change our behavior to water and toward water," says Riese. "That is really my passion—why I want to drive this idea home that water is not just water—because maybe we will start to rethink it. Because there are more than 700 million people out there that don't have safe drinking water. That cannot be."

Since 2006, Riese has been involved with the Hamburg, Germany–based charity, Viva con Agua de Sankt Pauli, which helps some of the world's poorest people gain access to clean drinking water, and whose tagline is *Wasser für alle—alle für Wasser!* (Water for everyone—everyone for water!) Riese has collaborated with them on festivals and events in Germany and the United States, and last year on his November birthday, hosted a fundraiser for the nonprofit to raise awareness of water inequality around the world. He says he will "absolutely" do so again this year, and again, and again.

Our Man in Hollywood

Despite misconceptions, Riese is not the world's only water som-melier, nor would he want to be. "The more the merrier, in my opinion," he says of his 200-and-counting fellow water sommeliers. "The more we are, the more we know about water, the more we will appreciate water, and the better it is for this planet."

One of Riese's most well-known peers is Texas-based Michael Mascha, who has a PhD in anthropology and communication sci-ence from the University of Vienna and who founded the web-site finewaters.com in 2003. Like Riese, Mascha is from Europe (Austria, to be precise) and like Riese, Mascha has a particular moment in time that he can point to as evidence of the beginning of his walk into waterworld: In 2002, a doctor informed him that he had a heart defect and that he needed to stop drinking alcohol if he wanted to live. He went all in on water. Unsurprisingly, also like Riese, Mascha has long espoused the belief that water is rife with potential, if only people would listen.

"You can discover a beautiful world if you start paying attention, and your life will be so much richer if you understand that you can have different waters that pair with food," he says. "You can have totally different experiences with it."

In 2018, Mascha and Riese joined forces to cofound the Fine Water Academy, which provides courses, lectures, readings, and certifications to those interested in becoming water sommeliers. In the past two years, nearly 100 people have received the designa-tion after going through three months of remote training, tuning in everywhere from Bhutan to Brazil. In the past year specifically, Mascha says, interest has skyrocketed: enrollment has jumped and traffic to his website increased 1,000 percent. When I ask how he thinks Riese's work has helped contribute to this growth, he laughs.

"Good question, but I think you know the answer," he says. "He's our man in Hollywood."

In the coming months, on his website, Riese plans to begin selling "Martin 101" boxes, which will have a curated selection of waters from around the world and can be shipped to homes across the country. (All water should be room temperature and preferably poured into glass, and not plastic.) Riese will also open

up bookings for virtual water tastings, so that interested parties can question him directly when comparing and contrasting the selections. It is his hope that the tastings will spark interest and conversation.

A few days after I first speak with Riese, I collect a number of different waters with various TDS levels to taste with my family members. I share nothing with them ahead of time. Predictably, opinions vary: My mother, who lived in Germany for seventeen years and who is accustomed to harsher mineral waters, notes the size and taste of the bubbles in Roi. My nine-year-old niece says confidently that FIJI Water has an "earth flavor." My sister, who remembers childhood trips from our home in Germany to the Czech Republic spa town of Mariánské Lázně, praises the Queen's water as effervescent, with "gentle" bubbles on the back of the tongue. My six-year-old nephew, after sampling water from Australia with a TDS of 1,300, squints at me. "I'm used to swallowing pool water, and that's what it tastes like," he says. When I share this anecdote with Riese by email, he replies, as ever, with enthusiasm.

"I love to hear that," he writes.

Contributors' Notes
Other Notable Food Writing
of 2020

Contributors' Notes

Navneet Alang is a technology and culture critic based in Toronto. He holds a PhD that was technically in English literature but was secretly about Twitter. He writes a newsletter called *The Purposeful Object* and can be found tweeting far too much at @navalang.

Bill Buford is the author of *Dirt*, about the five years he lived in Lyon, France, with his family while training to be a cook. He is the author of *Heat* and *Among the Thugs*. For eighteen years, Buford lived in England, where he was the founding editor of the literary magazine *Granta* and publisher of Granta Books. He moved to the United States in 1995 to be the literary and fiction editor of *The New Yorker*. He has been a staff writer there and is a regular contributor. With the BBC, he made two one-hour films about his time in the kitchens of Lyon called *Fat Man in a White Hat*. He was born in Baton Rouge, Louisiana, educated at UC Berkeley and King's College, Cambridge, and now lives in New York City with his wife, the wine educator and writer Jessica Green, and their twin sons.

Jade Chang is the author of *The Wangs vs. the World*, a very good novel. (Would you like to listen to her speak? Try *You've Already Changed Your Life*.)

Dayna Evans is a writer from Philadelphia. Her work has been published in the *New York Times*, *New York Magazine*, *Eater*, *Vice*, *Taste*, *Vogue*, *Glamour*, *GQ*, and more. She is also the founder of Permanent Bake Sale, an initiative to raise money for grassroots organizations through bread sales. The rest of her writing can be found at daynaevans.com.

MacKenzie Chung Fegan writes about food, drinks, and culture for such publications as *Bon Appétit, Vice,* and the *San Francisco Chronicle,* and hosts the podcast *Glitter & Doom.* She lives in Brooklyn with her queer family and perfect dog. You can find her online at mackenziefegan.com and on Instagram at @mackenzie_fegan.

Soleil Ho is the restaurant critic for the *San Francisco Chronicle* and a cohost of its food podcast, *Extra Spicy.* You can find her on Twitter at @hooleil.

Amy Irvine is a sixth-generation Utahn and descendant of notorious, adventurous Mormons. Her memoir *Trespass: Living at the Edge of the Promised Land* received the Orion Book Award, the Ellen Meloy Desert Writers Award, and the Colorado Book Award. A collection of linked essays, *Desert Cabal: A New Season in the Wilderness* is a feminist response to western wilderness icon Edward Abbey's *Desert Solitaire* and was included in *Orion*'s 25 Most-Read Stories of the Decade, *Outside*'s Adventure Canon, and *Backpacker*'s New Wilderness Classics. Her second memoir, *Almost Animal,* is forthcoming. Irvine lives and writes off-grid, on a remote mesa in southwest Colorado.

Foster Kamer is a writer and editor living in New York City whose work has been published in the *New York Times,* the *Wall Street Journal, New York Magazine,* and every single issue of *Gossamer,* among others. He also publishes a fortnightly newsletter, *FOSTERTALK,* and is working on his first book. Finally, he'd like to thank Nancy Noto, a PPPX for life, for getting him that job picking up the phone—and apologize to Dean, Maya, and especially Keith for being so patently terrible at it.

Jonathan Kauffman is a James Beard Award–winning writer, based in Portland, Oregon, who focuses on the intersection of food and culture, and a former *San Francisco Chronicle* reporter. An inadvertent food historian and lifelong hater of carob, he is the author of *Hippie Food: How Back-to-the-Landers, Longhairs, and Revolutionaries Changed the Way We Eat,* a history of the natural foods movement of the 1970s.

Priya Krishna is a reporter for the *New York Times* Food section, and the author of the best-selling cookbook, *Indian-ish.*

Katherine LaGrave is the digital features editor at *Afar.* Her writing has appeared in numerous print and online publications including *New York,*

Outside, Condé Nast Traveler, Vanity Fair, Vogue, Topic, and the *New York Times.* Katherine grew up in Germany, Indonesia, and Japan, and has worked in Greece, Haiti, and England. She currently lives in New York City.

Beth Landman began her career in journalism at the *New York Post,* where she served as the newspaper's restaurant columnist. She then moved on to *New York Magazine,* where she co-wrote the Intelligencer column before becoming the magazine's beauty editor and contributing cover stories as well as other features. She is currently beauty editor at *The Purist* and a travel contributor to Forbes.com, as well as a regular contributor to the *New York Post* and eater.com, and has contributed to the *New York Times,* the *Wall Street Journal,* Bloomberg, and *Business Insider* among other publications.

Sheila Marikar, a Los Angeles–based writer, is a regular contributor to the *New York Times, The New Yorker,* and other publications. She is currently at work on her first novel.

Kaitlin Menza is a magazine writer who most often reports on women, culture, and style. She's written previously for the *New York Times,* the *Guardian, Vogue, Esquire, Marie Claire, New York Magazine, House Beautiful,* and many more, and in 2020 she was nominated for a National Magazine Award for her work in *Cosmopolitan.* She lives in New York with her fiancé, chef Kevin Rose, to whom she proposed later in the pandemic. For more of her writing, visit kaitlinmenza.com.

Kelsey Miller is a culture writer based in New York. She is the author of international best seller, *I'll Be There for You,* a pop culture history on *Friends;* her memoir, *Big Girl;* and the forthcoming *Hysteria,* a study of history's most infamous "hysterical" women and the myths surrounding them. Her work has been featured in *New York Magazine, Glamour, Medium, Women's Health, Vulture, Entertainment Weekly, Literary Hub, Refinery29, A Cup of Jo,* and more.

Ligaya Mishan writes for the *New York Times* and *T: The New York Times Style Magazine* and was a finalist for the 2020 National Magazine Awards and James Beard Awards. Her essays have been selected for the Best American anthologies in Magazine, Food, and Travel Writing, and her criticism has appeared in the *New York Review of Books* and *The New Yorker.* The daughter of a Filipino mother and a British father, she grew up in Honolulu, Hawaii.

After getting her start in the storied William Morris Agency mailroom, **Liza Monroy** left the business side of creativity to pursue her calling as a writer. Her books include the memoir *The Marriage Act: The Risk I Took to Keep My Best Friend in America and What It Taught Us About Love;* the novel *Mexican High;* and *Seeing as Your Shoes Are Soon to Be on Fire,* a collection of personal essays based on one of the "most popular, provocative, and unforgettable" columns for the *New York Times*'s Modern Love column and a voicemail from an ex. Another of her Modern Love installments was selected and read by Malin Akerman for the series' podcast. Monroy's work has appeared in the *New York Times,* the *New York Times Magazine,* the *Los Angeles Times,* the *Washington Post, O, The Oprah Magazine, Poets & Writers, Marie Claire, Longreads, Newsweek, Guernica, Catamaran,* the *Village Voice, Every Day with Rachael Ray, Jane, Self, Psychology Today, Jezebel, Publishers Weekly, Bust,* and numerous other publications and anthologies including *The New York Times' Best of Modern Love.* She lives in Santa Cruz, California, where she's long been at work on her next novel, *The Distractions,* from which she is most often distracted by surfing, vegan cooking, and time with her family.

Rebecca Onion is a staff writer for *Slate* and the author of *Innocent Experiments.*

Leah Rosenzweig is a New York City–based writer, educator, and restaurant server. Her essays explore undisclosed realms of culture, literature, art, and, of course, the food and wine world.

Helen Rosner is a staff writer at *The New Yorker.* Previously she's been an editor at *Eater, Saveur,* and *New York Magazine;* her 2016 essay "On Chicken Tenders," published in *Guernica,* received a James Beard Award. She lives in Brooklyn.

Mayukh Sen is the author of *Taste Makers: Seven Immigrant Women Who Revolutionized Food in America,* published in November 2021. He has won a James Beard Award and an IACP Award for his food writing, and he teaches food journalism at New York University. He lives in Brooklyn.

Ruby Tandoh is a food writer currently living in London. She's the author of *Eat Up!* and *Cook as You Are,* and has written for *The New Yorker, Eater,* the *Guardian,* and *Taste.*

Eric J. Wallace is a career freelance journalist and devotee to the never-ending search for the *Good Life*. His work has appeared in more than fifty noteworthy publications, including *Outside, Backpacker, Canoe & Kayak, Wired,* and more. He is presently a contributing editor for the internet's greatest fount of culinary wonder, *Gastro Obscura.*

Britt H. Young writes about food, tech, and disability. She is a PhD candidate in geography at UC Berkeley. She tweets at @BHYRights.

Other Notable Food Writing of 2020

KAYLA STEWART
>A Harlem Restaurant That's Withstood Gentrification, a Pandemic and Time. *The New York Times,* July 30

PATRICIA STORACE
>Asparagus and the Culinary Saint. *Book Post,* June 11

RACHEL SUGAR
>Starbucks: A Reconsideration. *The Goods by Vox,* February 27

OMAR TATE
>The Restaurant Bail-Out Won't Save My Pop-Up. The Government Won't Save Black America. *Esquire,* April 30

NICOLE TAYLOR
>A Juneteenth of Joy and Resistance. *The New York Times,* June 18

NICOLA TWILLEY
>The Race to Redesign Sugar. *The New Yorker,* September 28

KAROLINA WIERCIGROCH
>Home Cooking in Kyrgyzstan. *Whetstone Magazine,* Fall

THE BEST AMERICAN SERIES®

FIRST, BEST, AND BEST-SELLING

The Best American Essays

The Best American Food Writing

The Best American Mystery and Suspense

The Best American Science and Nature Writing

The Best American Science Fiction and Fantasy

The Best American Short Stories

The Best American Travel Writing

Available in print and e-book wherever books are sold.

Visit our website: MarinerBooks.com/BestAmerican